Sarajevo
Self-portrait

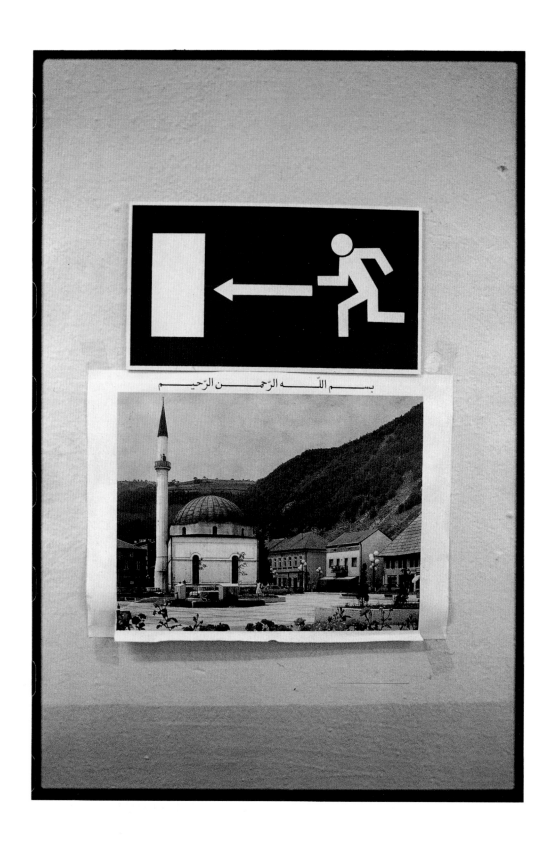

Nihad Pušija
Exit sign at a refugee center, Brandenburg, Germany, July 1993

Sarajevo Self-portrait:

The View from Inside

by Leslie Fratkin

Images and words by nine photographers from Bosnia:

**Kemal Hadžić, Danilo Krstanović, Milomir Kovačević
Nermin Muhić, Mladen Pikulić, Nihad Pušija
Damir Šagolj, Šahin Šišić, Dejan Vekić**

**Interviews with and portraits of the
photographers by the author**

Umbrage Editions

Milomir Kovačević
Sarajevo, 1994

Contents

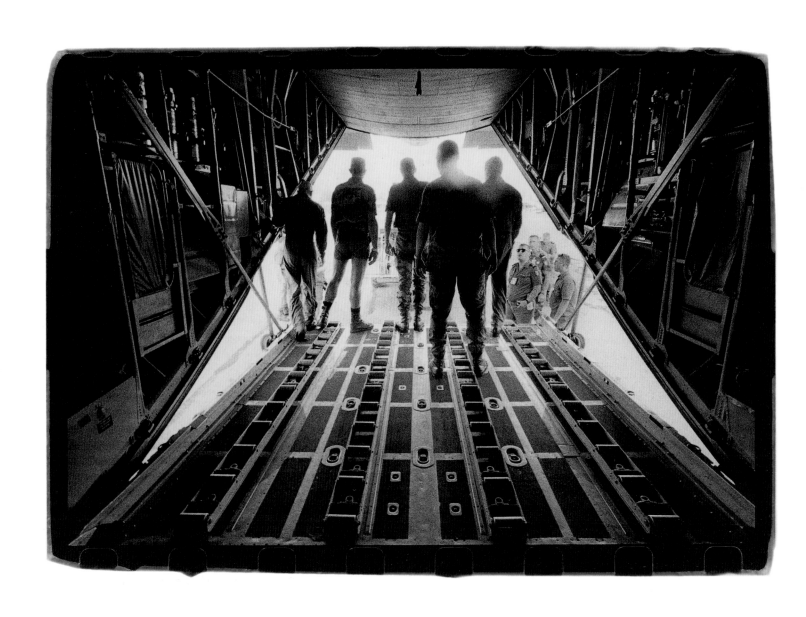

Leslie Fratkin
A NATO plane lands in Sarajevo, July 1997

Introduction
by Leslie Fratkin

I first went to Bosnia in the fall of 1995 to photograph a film festival that, incredibly, had been organized and originally scheduled to take place in Sarajevo during the war. I'd met Miro Purivatra, the festival's director, just two weeks earlier while working on another story in Slovenia, the first of the former Yugoslav republics to break away. Miro had just made the long, difficult trip up from Sarajevo that morning, the latest of a handful of times he'd managed to get away during his city's nearly four-year-long siege. He told me he'd come to see friends and meet with filmmakers—and to walk streets without snipers aiming down at his head.

We talked for hours that night about his tired city's struggle to cope under siege and about the trials of organizing something as complicated as a film festival in the middle of wartime. Miro spoke in the tones of someone simultaneously aware of how shocking his stories sounded to the uninitiated, and utterly exhausted by the mundane routine of actually living them. His festival—complete with visiting filmmakers, two world premieres, even a few minor celebrities—was to have taken place months earlier, but had been rescheduled several times due to broken cease-fires and intermittent heavy shelling.

I was completely transfixed. I barely said a word all night, and even though I had a 6 A.M. flight back to New York the next morning, I decided to accept Miro's offer and go to Sarajevo instead. Six days later, armed with little more than my American passport and a bag full of film, I was on my way.

There isn't a single minute of that trip I'll ever forget: the day-after-day of driving through shattered Yugoslavia, a blur of destruction just outside the glass; the endless miles of burnt villages followed by the eerie quiet of Mostar after curfew. Glowing in the light of a full moon, perfect in its total destruction, the ruins of that once-beautiful city looked more like a movie set than a place where people could live. We slowly wound our way up and over Mount Igman in a blinding snowstorm, huddled under blankets in the back of an armored personnel carrier. Our route—the only way in or out of Sarajevo at that time—was the narrow switchback road carved into the mountainside for the men's downhill run in Sarajevo's 1984 Winter Olympic Games.

Finally, when I'd already seen so much, when I thought I'd seen more than I could ever absorb, we drove past a ruined blocks of flats with broken, empty windows and their guts ripped out by war. Lining the edges of the abandoned airport, they loomed in the darkness like a spectral gateway into Sarajevo. We had arrived.

But the minute our journey ended, as soon as those heavy metal doors opened and we could finally unfold our cramped bodies and step out onto the city's snowy streets, it was clear this was not the place I'd been expecting. I had prepared myself for something else, for what I'd imagined a city at the end of its rope would be like: suffering and threadbare.

Instead we were immediately surrounded by well-dressed filmmakers and festival volunteers welcoming us with cheek-to-cheek, European-style kisses and warm, perfect English hellos as they rushed us inside, all the while asking, how was your trip, have you eaten, are you hungry, what can we get for you. There were pots of hot coffee and fresh pastries waiting and the conversation was lively. Talk quickly turned to films I'd never seen and, do you know so and so, he lives, I think, just around the corner from you in New York? Everyone was infinitely more sophisticated than I'd expected, better traveled, better dressed, better read.

The joke was on me. I'd come all the way to this war zone from New York City, but clearly I was the biggest rube in the room. This was a real place—not a Hollywood film or some eight-second clip on the evening news—but a place filled with people's stories that, at least until their world became so irrevocably eclipsed by this war, were not so very different from my own.

And so my war tour began. Like the hundreds of other foreign photographers who had crossed those constantly shifting Balkan borders before me, my eyes struggled to take in what my brain could not understand. How did this happen? How could the world know what was going on, yet still look away? From the minute my eyes opened every morning to the minute my head hit the pillow at night, I struggled to retain it all, to record it in my head. I heard story after story. Sometimes, I could not believe my ears as talk turned almost effortlessly from ski holidays in Switzerland to a matter-of-fact description of

taking a sniper's bullet in the head: "I was lying in my bed, trying to sleep off a three-day New Year's party—believe me, there's *no* party like a New Year's party during war!—when it came through the window, but thank God I'm okay now, except for the headaches of course, probably due to that bullet still lodged behind my right ear...." Or standing in the old Lav cemetery, the one with the big stone lion in the middle, its ears and nose chipped off from three and a half years worth of sniper bullets, and listening to a description of a typical wartime burial: how snipers would wait for the mourners to gather so they could open fire and add new bodies to those freshly dug graves.

The stories never ended, yet almost every frame of film I'd brought with me went unexposed. As moved as I was, something just didn't seem right. I could see and hear everything, even smell what this city had become. But I would never be a part of it. It was as if an impenetrable glass wall stood between myself and Sarajevo. No matter how moved I was or how much I cared, I knew these stories were not mine to tell.

■

One night at a reception following the screening of some films, I met two young men carrying cameras just like mine around their necks. Their names were Dejan Vekić and Damir Šagolj and, aided by a few glasses of wine and some broken English, we started to talk. When I told them I was a photographer from New York, they laughed and asked me where my vest was—all the other foreign photojournalists they'd met wore that ubiquitous vest with the bulging pockets. Then Dejan pulled some small photos out of his pocket; just something he'd recently been working on, he explained. The print quality was awful—he'd obviously had less than great darkroom conditions in which to make them. But the images were riveting. After so many years of only half-seeing the thousands of photos published daily by an endless stream of foreigners sent to Bosnia to document somebody else's war, Dejan's images shocked my eyes. They grabbed my heart, and told me more in a single image than every other published photograph, every article, every sensational, yet oddly unmoving, news clip I'd ever seen. These photographs told the story I wanted to hear.

I've returned to Sarajevo many times since that first trip. Yet as much as I've heard and seen and tried to understand, I know this: I am still on the outside. I can go to a war—as many courageous photojournalists did at great risk to their lives in Bosnia and around the world—but until it happens to me, I cannot know what it is like to live inside a war.

The world's media machine came to Sarajevo at the beginning of the siege and left when it ended, but the city's history did not begin and end with this war. It was a vibrant, multiethnic place with a rich artistic, architectural, and intellectual tradition, home to some 200,000 people who lived well, traveled widely, and for the most part, never bothered to define themselves by their religious beliefs, birthplace, or family name. This is the city that hosted the 1984 Olympic Games so successfully that the Olympic committee still considers the Sarajevo games to be one of their most outstanding.

Much of old Sarajevo is gone now. More than 10,000 people were killed and virtually every building shows damage from the war. Walking through the streets of Sarajevo today, it's easy to look up and see fresh paint and new glass, flower boxes and satellite dishes, scaffolding around buildings with signs announcing reconstruction courtesy of one foreign country or another. It is harder to look down at the scars left from countless bullets, shrapnel, and shells. The marks are everywhere—on sidewalks and street corners, in all the parks and schoolyards. Not a single square foot of the city has been left untouched. As you stroll through Sarajevo, enjoying the sunshine and beautiful hills around you, your feet have just passed the very spot where somebody's life was quite possibly destroyed by the hellfire raining down from those same hills.

■

Now that the bodies have been buried and the rubble swept away, now that the media's gaze has focused on new crises elsewhere in the world, Bosnians everywhere are taking stock of what has happened to their lives. They are trying to rebuild a future. But in order to do that, they are forced to look at what has been lost and how much is left with which they can start again.

I began to meet and work with the nine photographers in *Sarajevo Self-portrait* after returning home from that first trip in 1995. Dejan and Damir, both still in Sarajevo, introduced me to other photographers; people who knew what I was working on suggested several more. In Sarajevo's tight-knit photography community, these names would come up again and again:

Milomir Kovačević, whose presence throughout the siege is legendary. Always seen in the same hand-knit sweater, and never without his camera, he gave away

prints by the hundreds, whether as gifts or for urgently needed documents enabling somebody's frantic escape. That sweater is so frayed now it's unwearable, but pinned to his wall in Paris, it serves as a reminder of everything left behind;

Mladen Pikulić, who, after a busy prewar career of commercial and studio photography, took his camera into the streets for the first time and, choosing to shun photographs of the dead and injured, found his story of the war in the faces of its youngest victims;

Nihad Pušija, whose story takes place not in Sarajevo but in Germany, where he escaped to in 1992. There he has obsessively documented the lives of the thousands of Bosnian refugees and gypsies, having found their stories similar to his own;

Kemal Hadžić, who told me that it wasn't until the war began that he found himself acting like a true artist. As an officer in the Bosnian army, he made powerful portraits of his fellow soldiers on the front line;

Šahin Šišić, known by all as ever-smiling and always on the move. A photographer and filmmaker, no matter which particular tool he holds in his hands, he makes even the smallest details jump from the frame with life;

Danilo Krstanović, who says little, preferring to let his images speak for themselves. Although his job required him to record Sarajevo's most horrifying images, Danilo best appreciates the healing, even life-saving, effects a sense of humor can have in the darkest moments of a war;

Nermin Muhić, who sees his work as evidence of yet another life that managed to survive; he discovered an uncanny ability to make the quietest moments and the simplest details speak volumes about both himself and about his neighbors during wartime;

And of course, Dejan Vekić and Damir Šagolj, who opened the doors to their world and allowed me to look inside. For nearly four years they documented every inch of Sarajevo's destruction. According to Damir, they felt somehow safer with their cameras in their hands.

All nine photographers share the same tragedy—bearing witness to their world coming undone—yet each found different solutions to cope with the disaster constantly hovering over their heads. Each of these courageous men continued making pictures throughout the course of the war in Bosnia and the siege of Sarajevo, photographing the ruins and documenting the loss of their

own neighborhoods and homes, their families, and their friends. Their motivation to make photographs wasn't fueled by recognition or awards; they kept shooting because they had no other choice.

More than anything, this book is theirs. But as a fellow photographer and member of the global journalism community, I feel a responsibility to make sure their story—the inside story—gets heard. It's not only important that journalists risk their own lives to report the storms raging throughout the world—it's crucial if we are to know what's going on. But it is also important, for journalists as well as their audiences, to listen closely, to see past the photograph's frame, to hear not just the voice-over but the actual voices of those with a story to tell.

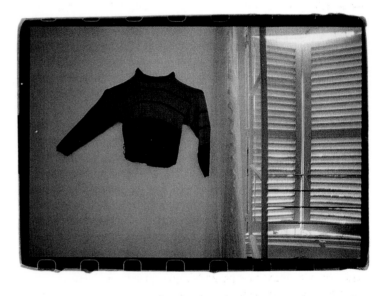

It is through the work of these Sarajevan photographers and others, that my eyes are now open. The lessons of Sarajevo confirm that tragedies like Bosnia happen in other places, other cities, other countries, all over the world. I hope the stories in *Sarajevo Self-portrait* will open other eyes, too.

Leslie Fratkin
Milomir's sweater, Paris, France, July 1997

9

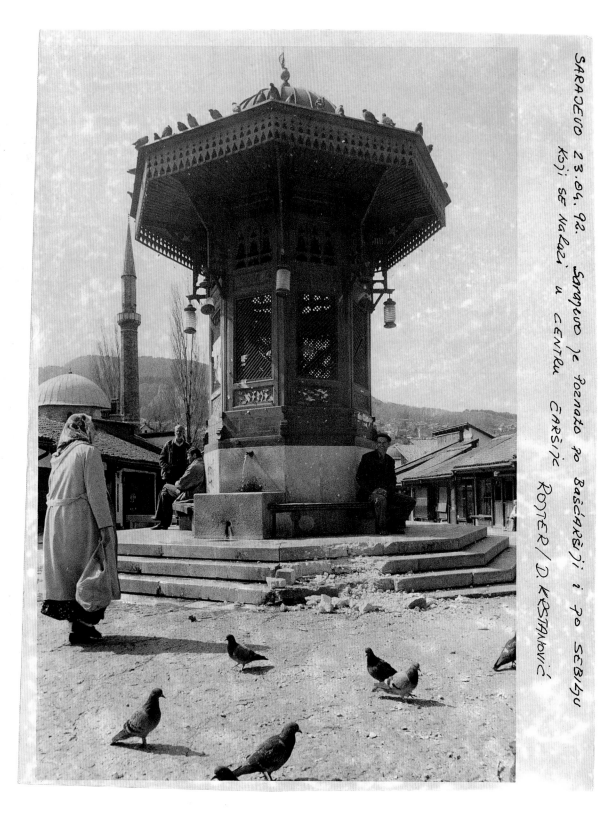

SARAJEVO 23.04.92. Sarajevo je Poznato po Baščaršiji i po SEBILJU
Koji se Nalazi u CENTRU ČARŠIJE
ROJTER/ D. KRSTANOVIĆ

Danilo Krstanović
Baščaršija, Sarajevo, April 1992

Essay
by Tom Gjelten

Linger over the photographs in this book, because their meaning is conveyed subtly. So many wartime pictures from Sarajevo have been published already that you may assume you have seen them all before: soldiers, buildings in flame, blood on the sidewalk, children playing with toy guns. But there is more here—an element of intimacy that other chronicles have not captured.

Kemal Hadžić says his photographs of fellow soldiers are, "family portraits taken by a family member." And on second glance, you see that these men must all be civilians. The man with the ammunition belt draped around his neck is not brutal enough. The one with the receding hairline and the wrinkled brow surely has more on his mind than his soldierly duties.

Like Kemal himself, they have been summoned to the front-line, prepared or not, to defend their city and their families. With him as their photographer, they have nothing to prove or hide, and he shows them as they are.

This is photography by people who are in the war, not just watching it. What distinguishes their work from that of visiting photographers (who were free to leave Sarajevo when they could stand it no more) is its connection to their personal war experience, to their anger, to their occasional celebration, and to their fears. And they acknowledge it. Several say they photographed during wartime in part because they felt safer with cameras in hand. "At least you're behind the picture, not in it," explains Damir Šagolj. Caught by a mortar attack, Danilo Krstanović set his camera on automatic focus and clicked his way through the carnage, thinking later he'd have gone mad if he had put his camera down. Look at these pictures now, knowing the context, and you see beyond the image.

Danilo, who was forced to use rainwater and urine to process his film, did not take his photography lightly; he thought about what he was doing and often had a purpose in mind when he took pictures. "The quality of ideas is richer on our side," he says. Danilo sought to capture the balance of the Sarajevo experience, the happiness sharing space with the terror, illustrated beautifully by his photo of the young married couple walking jauntily down a street targeted by snipers. Nihad Pušija, mindful of the power of images, refused to photograph the young girl who was shot dead in front of him, because he did not want "to feed the beast of fear" in his people.

In my own visits to Sarajevo, I was impressed by how the war experience clarified priorities, overwhelming esoterica and frivolity, for artists as for everyone else. I recall a one-day sculpture exhibit held in a downtown movie theatre that had been partly destroyed by shelling. The posters advertising the show featured a little map indicating which streets to follow in order to avoid sniper fire. The exhibit was opened just one day, for just a few hours. The manager explained that he was anxious to return the gallery space to its regular function, as a sheltered passageway for people rushing to and from their downtown destinations. Art deferred to life in wartime Sarajevo.

I am reminded of that as I study these pictures and read the interviews. Milomir Kovačević had to light a photographic exhibition in Sarajevo with candles. Each photo was on display "only as long as the candle in front of it burned." It was for lack of electricity, but the circumstance underscored the reality that his photographs depicted, turning the display into "a requiem of sorts." These photographers never allow their art to soften, glorify, or stylize the war as it actually happened to them, their families, and their neighbors.

Several of these photographers worked at the Sarajevo newspaper *Oslobodjenje*, which was published every single day of the war, through three and a half years of shelling and sniper fire. For me, the staff of *Oslobodjenje* exemplified the heroic Sarajevo spirit. I was always amazed by the determination of Sarajevans to establish and stick to daily routines, to dress as smartly as they could manage, and to maintain at least a symbolic commitment to normal life, all in order to resist depression and despair. Nowhere was that attitude demonstrated more impressively than among the reporters, editors, clerks, and photographers of *Oslobodjenje*, who showed up for work day after day.

But even beyond their courage and tenacity, the *Oslobodjenje* staff represented for me the idea of multi-ethnic cooperation that was so grievously threatened by the war in Bosnia. The newspaper was one of the very

few remaining enterprises in Sarajevo where Serbs, Croats, Muslims, Jews, and self-described "Bosnians" and "Yugoslavs" worked together and believed deeply in the cosmopolitan ideal that Sarajevo had historically represented. *Oslobodjenje*'s struggle was not just for physical survival; more importantly, it was a fight to sustain a model of interethnic life in Sarajevo.

This socio-political battle was even more challenging than the military effort. Nationalists on all sides were determined to remind Bosnians of their respective ethnic identities, and to persuade them they were safe only when they stuck together with their own kind. Unfortunately, they were somewhat successful, even in Sarajevo.

True, it remains an ethnically mixed city; Serbs who left during wartime are returning in large numbers. A Serb presides over one of the local government councils in the city. But interethnic tension remains high. Many of the most educated, cosmopolitan residents have abandoned the city. The *Oslobodjenje* journalists I knew best eventually moved away, as have most of the photographers represented in this book. Six of the nine are now living outside Bosnia.

Among the exiled Sarajevans and even among many of those who remain in the city, there is a deep sense of loss. The place they remember so fondly no longer exists. One of my Sarajevo friends left the city in the final months of the war and moved to Canada. After several months, feeling frustrated and not adjusting well to his new life, he returned to Sarajevo—only to find he was no longer comfortable there, either. He thought about moving somewhere else. I asked where he would really like to live. "In pre-war Yugoslavia," he said.

He speaks for many who want to go back in time. Sarajevans and other Bosnians are constantly comparing their wartime experiences to their lives prior to the war. The Sarajevo photographers in this book clearly share that yearning for the bygone era. Amidst the rubble, Milomir Kovačević found and photographed the shattered portraits of Marshal Tito, the last leader of the whole "Yugoslav" people. Kemal Hadžić poignantly expressed his own before-and-after obsession with his Mostar postcard series. Damir Šagolj focused on the Arizona market in the no-man's land of northern Bosnia, where Bosnian Serbs, Croats, and Muslims mix and trade freely. "It reminds them of how Bosnia used to be," Šagolj says, explaining why photographs of that scene are among his personal favorites.

The inter-mixing at the open-air Arizona market is also a reflection of what life in Bosnia will ultimately become again. The Serbs, Muslims, Croats, and others who live in Bosnia were deliberately turned against each other by demagogic leaders who manipulated old fears and grudges for personal political gain. The people of this country share the same blood and speak the same language, and their destiny is to live together.

That process of reintegration has begun. Serb refugees who are returning to their former homes in Sarajevo are leaving the communities in Serb-controlled areas to which they had fled during the war. For the past several years, these Serbs have been occupying the homes of the Muslims and Croats who had been expelled from those communities. As the Serbs now vacate those homes and return to Sarajevo, Muslim and Croat refugees will, in turn, be able to reclaim their former homes. The brutal wartime shifting of populations may over time be undone.

But the scars remain. I am struck that five years after the end of the war, these nine Bosnian photographers, in choosing the work to represent themselves, return so often to images of the damage done to their city and their people. The view from inside Sarajevo is of a place that has survived its wounds with courage and elan but will be a while healing.

Tom Gjelten, who covered the Bosnian war for National Public Radio, is the author of *Sarajevo Daily: A City and Its Newspaper Under Siege.*

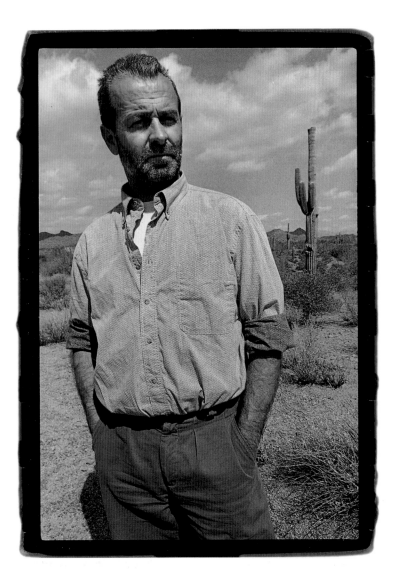

Kemal Hadžić
b. Ključ, Bosnia and Herzegovina, 1947

After graduating from university in Banja Luka, Hadžić moved to Sarajevo and taught high school science. It was there that he renewed his childhood interest in photography. He was involved in various photo clubs in Sarajevo and began taking his own pictures again, working for both commercial and artistic venues. When the war began in Bosnia, Hadžić joined the army, but he continued to take pictures. Since 1970, Hadžić has participated in over 150 group exhibitions in the former Yugoslavia and abroad, and received almost eighty awards for his work. He left Bosnia in 1995 and currently lives in Phoenix, Arizona.

Outside Phoenix, Arizona, March 2000

Kemal Hadžić

My first encounter with photography was pure magic. It happened in fifth grade, and I was hooked immediately. It wasn't just the photography actually, but the photo instructor at the school was really excellent, also. When that teacher quit, I didn't have the means to keep practicing, so I lost interest. Years later, after I graduated from college and could afford to buy my own equipment, I returned to photography. That's when I started to focus seriously on my own work.

I went through a few different phases in my photography. In the first serious stage, I was involved in the various photo clubs in Sarajevo. I was devoted to the aesthetics of amateur photography and exhibited quite a bit with the clubs. My success in these group exhibitions encouraged me to think about photography as a profession.

I joined a photo club called "The 29th of November," which helped to fully solidify my decision to be a photographer. Later, those experiences also helped me revitalize the university photo club, CEDUS. I helped educate this generation of photographers—the generation included in this book. It started with the students, like Mladen Pikulić, Milomir Kovačević, Šahin Šišić, as well as some others, just dropping by to ask me questions. I was working in the university's library at the time, and they would come by with photographs to get some feedback on them. Many of them were very young and were students who went to the high school where I taught applied science. CEDUS had existed as a group of photo-enthusiasts at the end of the sixties, but as the participants got older, and started families, the group became inactive, even though it still existed in name. Once I joined in 1975, I had some influence, and new members started joining—like my students and others who knew me. I got people interested in renewing the club. We did everything from remodeling the studios to recruiting and educating new members. Within a period of five or six years, the club became one of the top amateur photo clubs in the former Yugoslavia. We went so far as to organize and participate in international exhibits.

The second phase of my photography started at the end of the seventies, when I began to have second thoughts about amateur aesthetics. I started to think about photography in a more conceptual way. This was not the kind of photography that photo clubs generally focused on or encouraged. People didn't understand what I was doing and the juries stopped selecting my work for exhibition. I remained a member of the club for another five or six years, but I mainly did my work on the side and didn't exhibit it.

From around 1978 or so, I started doing commercial photography for posters, record covers, brochures, catalogs, etc. This, combined with my vision of photography as a fine art, drove me further away from the photo club. As it happened, my changing attitude toward photography was noticed by an avant-garde art group called Zvono, or "The Bell," that formed in 1982. They invited me to become a member, which I accepted. I continued taking photos, but also worked on paintings, installations, and collaborative performances with the group, up until the 1990s.

The day the war started, I was living in a section of Sarajevo called Hrid. The very first mortars thrown on Sarajevo hit the nearby neighborhood on the hill across the river Miljacka, in Vratnik or Kovači. I was really shocked by those initial twenty or so grenades. My first thought was that it was war, and that I didn't know a thing about war. I had no idea what was going to happen next. I was totally confused. That was one of the hardest days of my life. I didn't believe that war could happen in Sarajevo or in Bosnia in general. I guess I was naïve. I think that most honest people were naïve about it. It was a small number of extremists that created this hell that then lasted four years.

The war didn't just affect my photography—it affected my whole life. If there hadn't been a war, my life would have been completely different. Before the war, I had a studio. I lived an easy life. I socialized with people I liked, with other artists. Once the war started, I realized that it was my duty to join the defense of the city and reported to the Territorial Defense (the Bosnian equivalent of the U.S. National Guard). I had the opportunity to take photographs; I had access to sites and could photograph them at anytime. I carried my camera with me at all times while on duty, on the front lines and in the rear, even on scouting operations. The photographs I took became part of the army's archives and are now part of the history of the war. The army uses them for

things like posters and calendars. But I was never a photojournalist per se—I didn't even have the right equipment. For example, I didn't have a telephoto lens. The war caught me completely by surprise. I didn't have enough film; for the whole first year, I shot maybe twenty-five rolls of 35mm film. That was all I had. I went around asking other photographers for basic chemicals and followed recipes in old books. Finally, in 1994, I received a care package from a fellow photographer in France who I'd met here, but until then, I had to improvise. I even traded foreign photojournalists some of my negatives for film: one good shot for two or three rolls of film. These photos got published, sometimes with my credit line and sometimes without. The first year that my daughter was in the United States, she saw photos of mine in *Newsweek* and one in *Time*. God knows what happened to them all.

Those photographers were doing their job. They had been sent to Sarajevo on assignment. Today I suppose they're in Chechnya or somewhere else. They go from war to war, taking pictures. I couldn't do it and I would not want to. It's another type of commercial photography. But those images don't have their own angle, their own attitude. I believe that my photographs were different because I was the one living that war as opposed to just doing a job. In the presence of a professional agency photographer, people act how they think they are supposed to act. The soldiers I photographed didn't see me as a foreigner or a journalist, but as part of themselves. The quality of the portraits in the series "*Portret Bezimene Raje*" (Portrait of Nameless Folk), for example, is affected by the fact that I lived with those people as a fellow participant in the war, experiencing harsh weather, lack of food, sleepless nights. So perhaps I've created more sincere portraits, more truthful ones than those taken by photographers who were simply visitors to the war. I have captured the life of a warrior, the psychology of a fighter, genuine, unposed. They are family portraits taken by a family member—not a professional hired by the family. Yes, these are my people, men that I was in the war with. During the war I cried over people whose names I didn't even know, but with whom I'd shared everything while on the front lines, marching in columns. These people become your brothers and fathers and sisters and mothers and children, everything.

My photographs, especially the ones from 1994 and 1995, are art made by a man who lived through the war. The foreign photographers never felt it, nor could they ever feel it. They will never be in my skin, nor I in theirs. It's possible that they could have taken photographs like mine, but they were simply not interested in that because it wasn't their goal. That's the difference: they photographed their assignments and I lived the life they were photographing. I was on the inside, they were on the outside. It's a crucial difference.

In the beginning of the war, I wasn't coping very well. I couldn't behave like an artist, even though I was taking photographs. At first I was just a man defending his family and neighbors—that's where my feelings were. For the first two years, it seemed so temporary. I just accepted the situation and my first priority was survival—for my kids, my family, myself, and my city. But after a while, you get used to it and can start to behave more like a human being. At the end of 1993, I assigned myself the task of thinking seriously about what was happening in the city, in Bosnia, and in my life, and to start reacting to it as an artist. It was a conscious decision, though I had to wait until I felt it and started to see things through different eyes—until I was ripe for it. I started to notice things I hadn't been able to see before. I wanted to capture the mood, the atmosphere of those times. I sought out days when the streets were wet, moments of emptiness. Yet reflected in these lifeless streets, you catch a gleam of light, of optimism. You'll also find in the foreground these sewer manhole covers, which point to the netherworld. The dark side and the optimism exist in accordance. That was the rift in which Sarajevo existed at the time. Sarajevo lived, and yet there was no life.

The Mostar series was initiated with the help of Zdravko Grebo, who helped me arrange transport to Mostar at the time a treaty was being signed between the Muslims and the Croats. I didn't know what I'd do when I got there, but I knew I wanted to be there and hoped that I'd know once I arrived. Once in Mostar, I met a librarian who collects postcards of the city. Some of them are almost one hundred years old. One day we were looking at his collection, and I was struck by the idea of walking around Mostar and trying to see what would happen if I took photos of those exact same locations, in the exact

same way. I chose some seventy places, and out of those, I found twenty-five possible perspectives that were very intriguing. And so I recorded the present situation of wartime Mostar, 1994, based on the old postcards taken prior to the war.

In a sense, it was through the war that I started acting as a real artist. I wasn't working except for my volunteer duties with the army; there was no other business, and I could devote myself, my whole life, to my art. And even today, photography is still the most important thing to me. The war deprived me of certain things; I was wounded, I lost a great number of friends—known and unknown—but I discovered a certain freedom through it, too. My freedom before the war came from a sense of financial and social security. During the war I had to give up money. I was free from any kind of commercial work associated with photography and thought solely in artistic terms. Today I'm free—and penniless. I have a job that gives me enough to live. I don't worry about having enough for food or bills: in Bosnia we call it a "carefree life." My job isn't intellectually engaging (I'm a security guard) so I use that time to think about art and photography.

I left Sarajevo on September 14, 1995, as part of a cultural delegation to Prague. The occasion was a month-long exposition of Bosnian culture, and the whole thing kicked off with an exhibition of my postcard series. I was supposed to be back by the end of October. While I was in Prague, the Dayton Peace Accord was signed. After that, I came to America and stayed.

The photographs taken during those last years in Sarajevo remain very important to me. They are documents from a very difficult period, from a time when life was lived parallel to death. Those three and a half years were perhaps the most intense of my life. These photos may not speak to people who were not in the war, to people who haven't experienced war. But I'm very fond of these images and I go back to them often, remembering good and bad things.

I'm very aware that my life now is affected by postwar trauma. It's better to be aware of it than to be in denial. Those who are not conscious of the trauma suffer from its negative effects. My philosophy is that you're either born knowing how to be happy and how to appreciate and feel good in your own skin; or you're born in misery and spend your life being miserable.

Today, I feel that I'm a happy man. These photographs sometimes seem like fragments of a dream. I feel as if my life in the United States has been a second birth, and these years, from the war onward, have been a second youth. That's exactly how I behave: very irresponsible, very playful, very wild, but very happy, because I'm a free man.

Phoenix, Arizona
March 8, 2000

Kemal Hadžić
From the series "Streets," 1994
Overleaf left: Ulica Sarači (Sarači Street)
Overleaf right: Ulica JNA (Yugoslav National Army Street), renamed Ulica Branilaca Grada (Defenders of the City Street) after the war
Second overleaf, left: Ulica Logavina (Logavina Street)
Second overleaf, right: Baščaršija

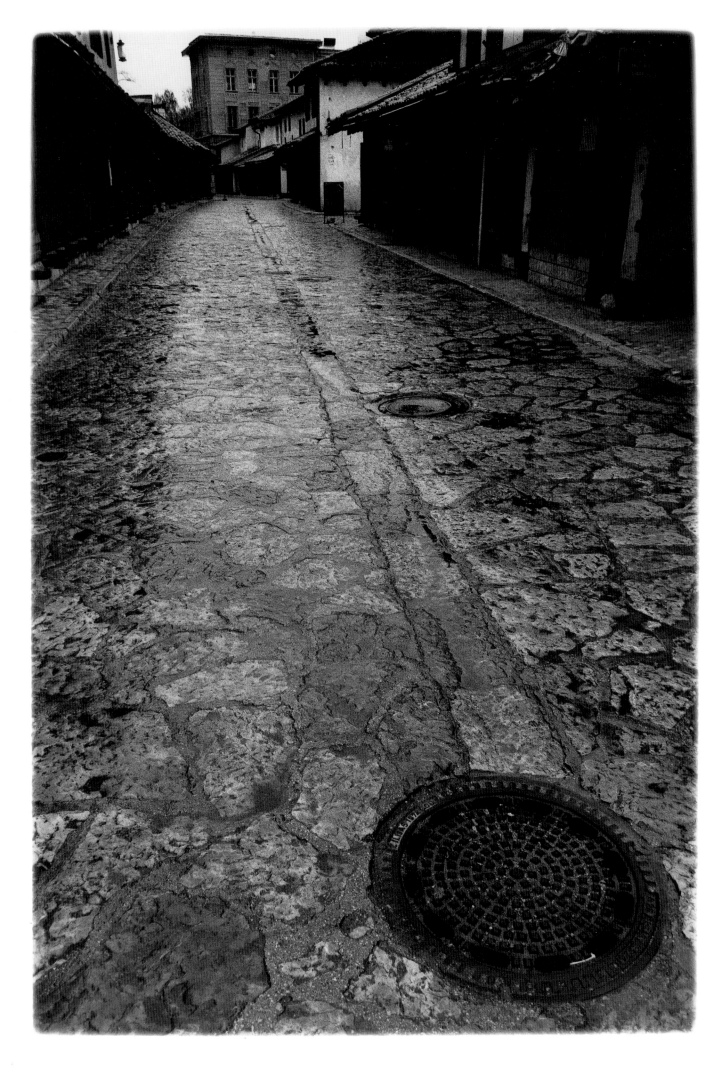

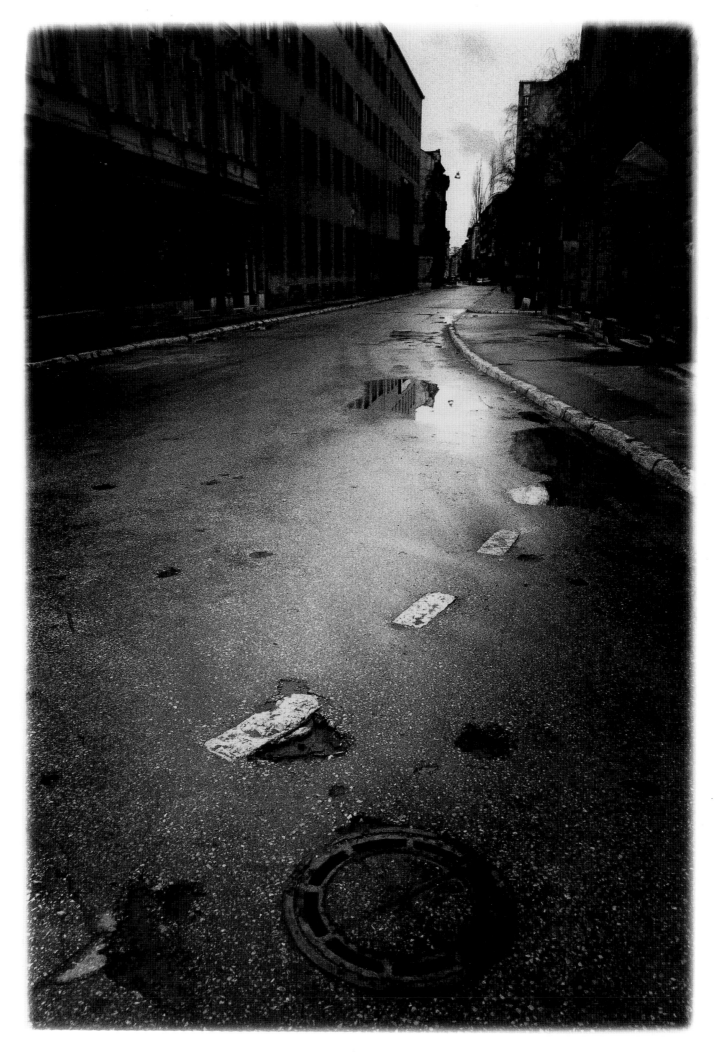

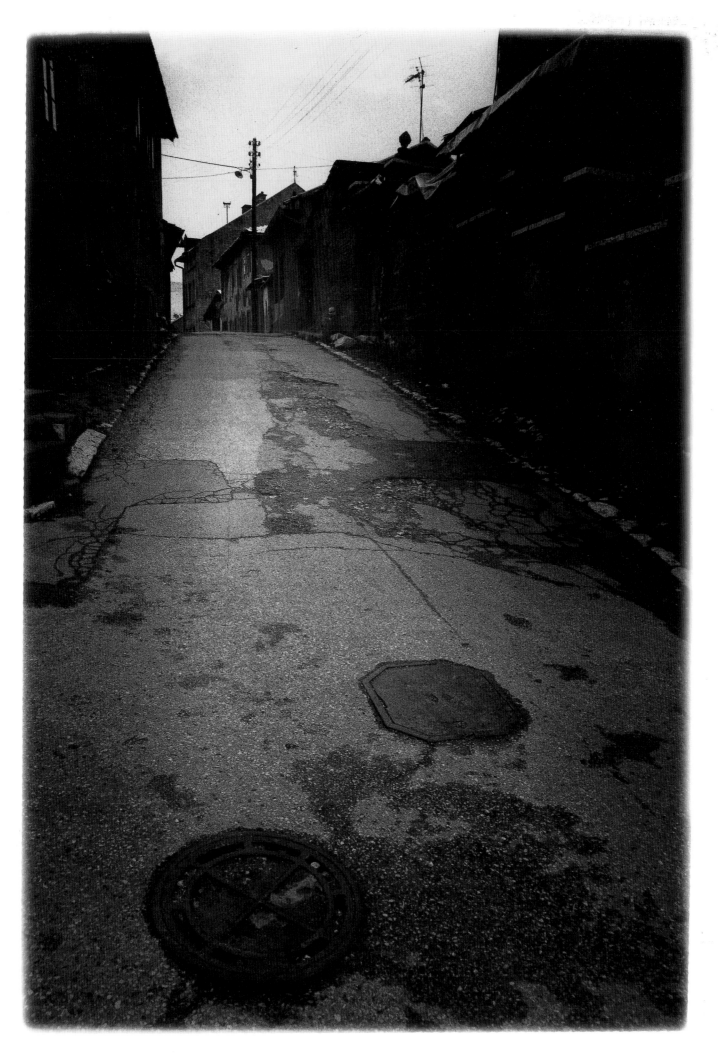

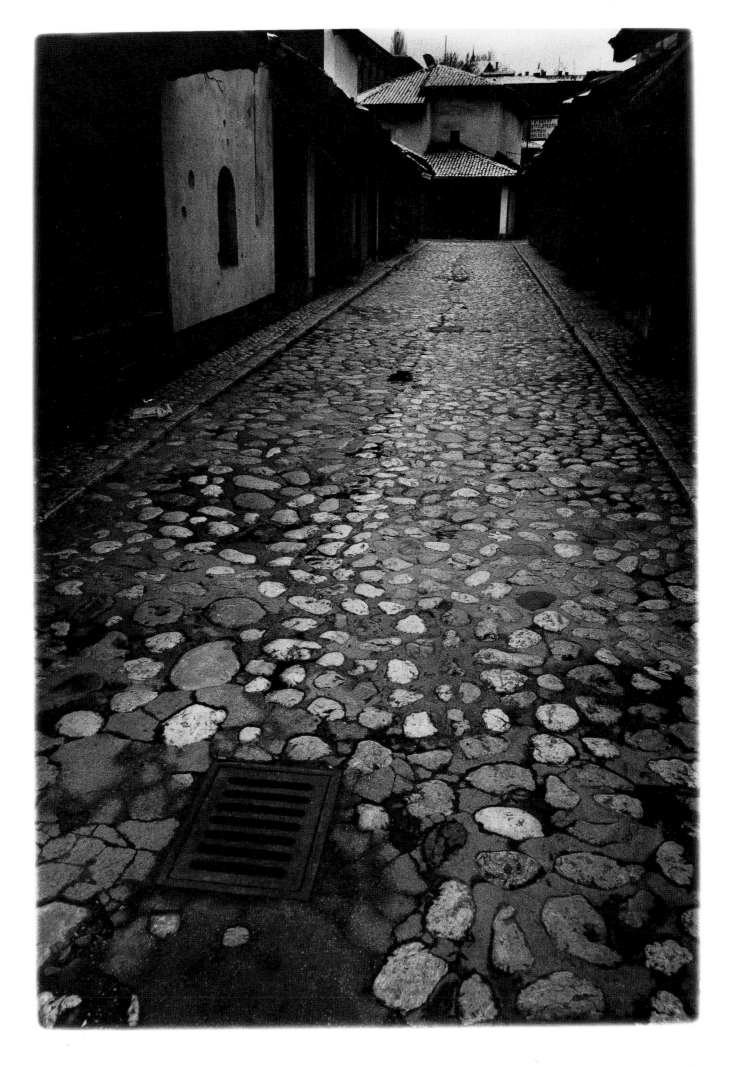

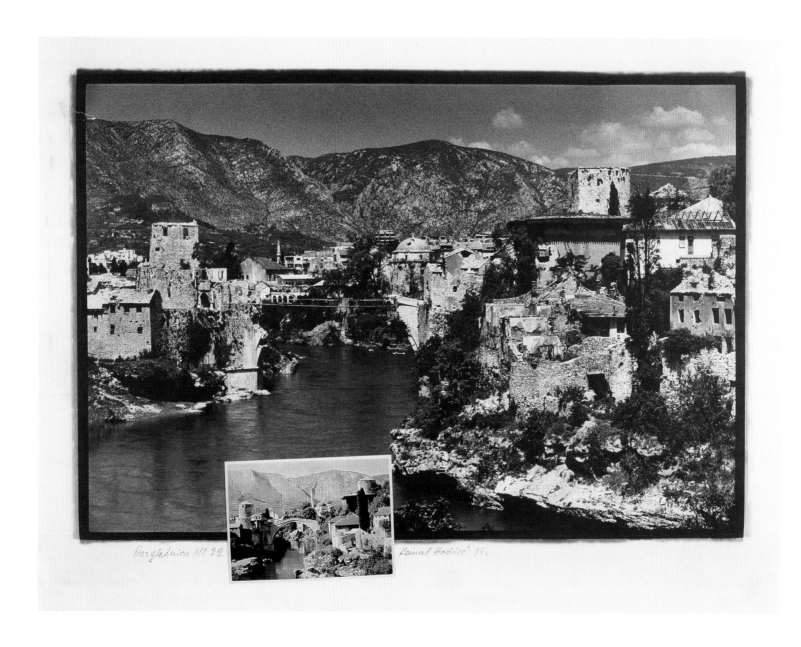

Kemal Hadžić
From the series "Postcards," Mostar, 1994

Prewar postcard images of the Mostar bridge, juxtaposed with
photographs of its ruins during the war. The 500-year-old
bridge, for which the city of Mostar was named (*mostar* means
bridge), was one of the Balkan's finest examples of Islamic
architecture until it was destroyed.

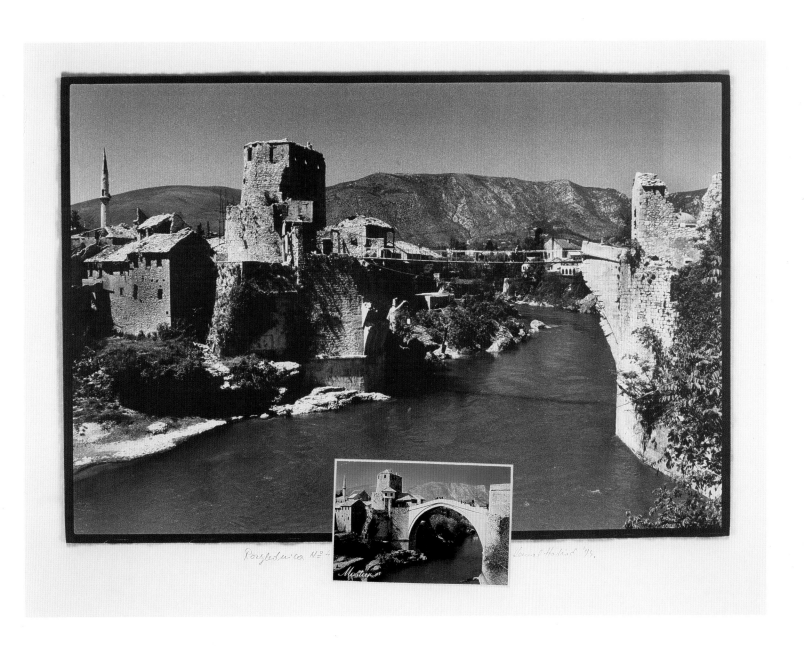

Pozdravnica № 4 Lenus Horkic '94

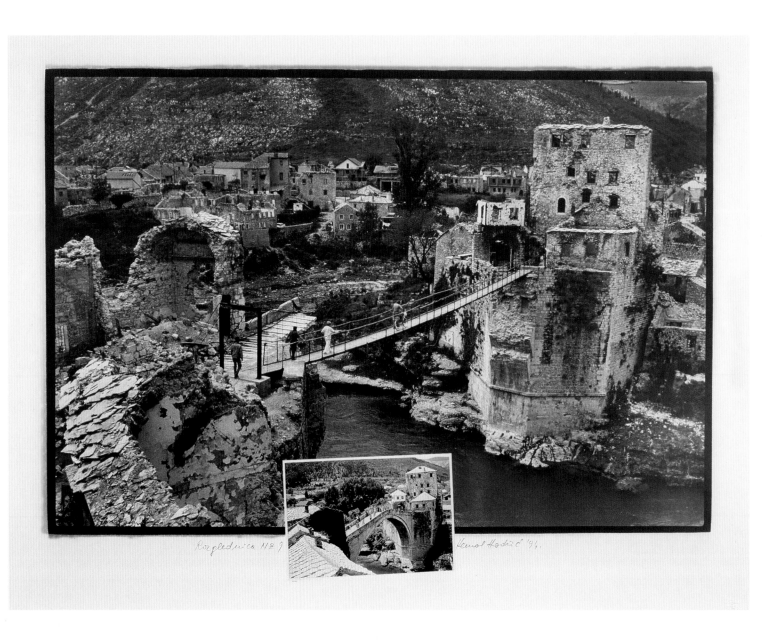

Razglednica No 9 Kemal Hadžić '94.

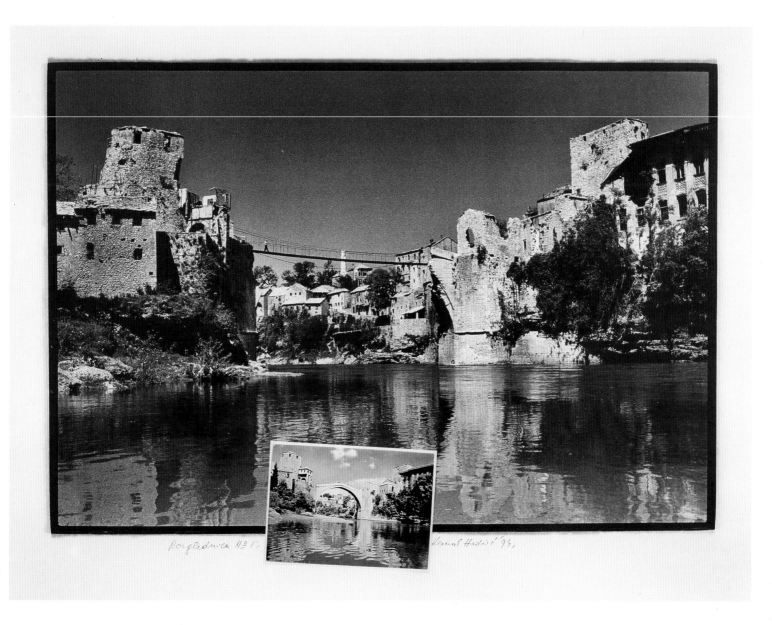

Following pages: Kemal Hadžić
From the series "*Portret Bezimene Raje*," (Portrait of Nameless Folk), Spring 1995

These portraits were taken during Hadžić's time served as an officer in the Bosnian army.

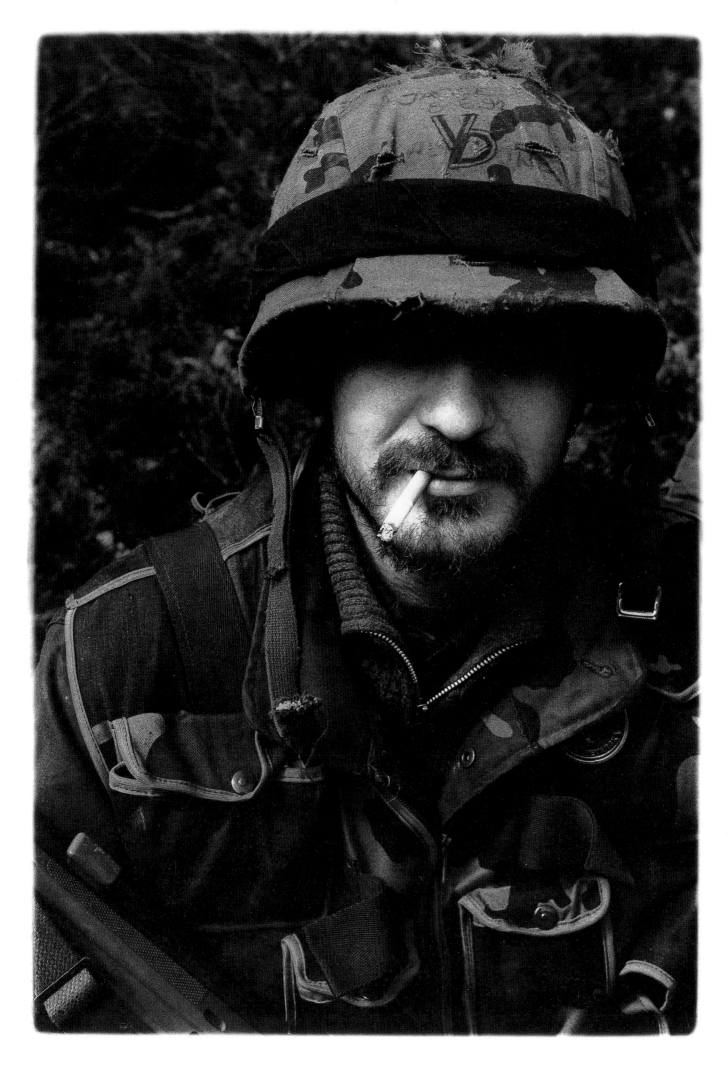

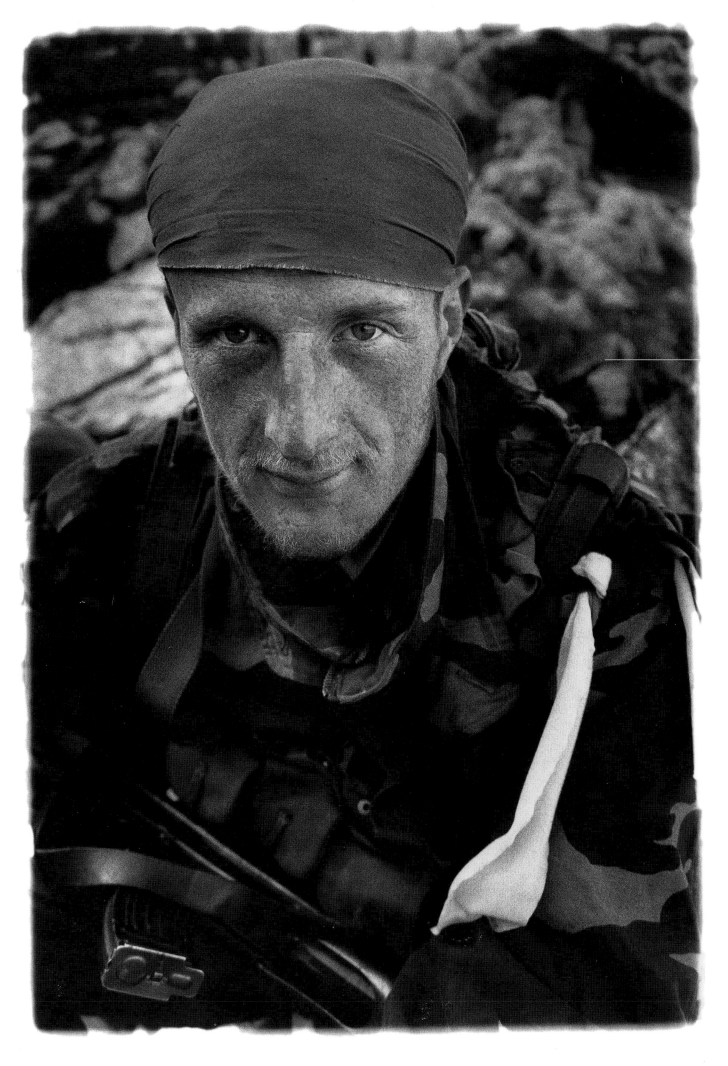

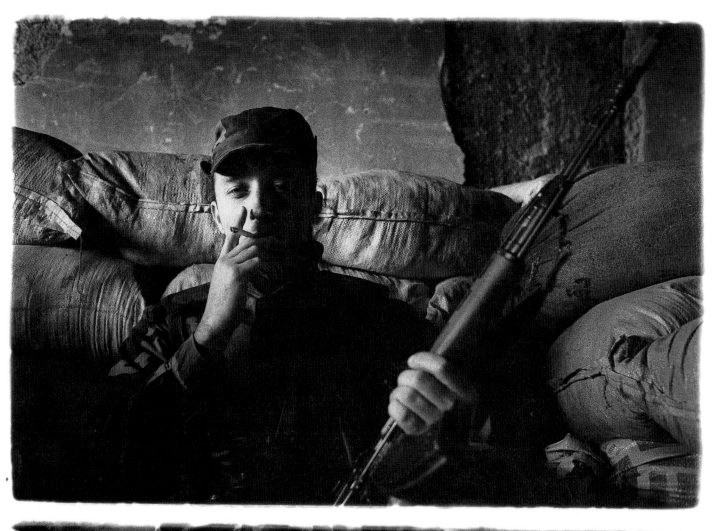

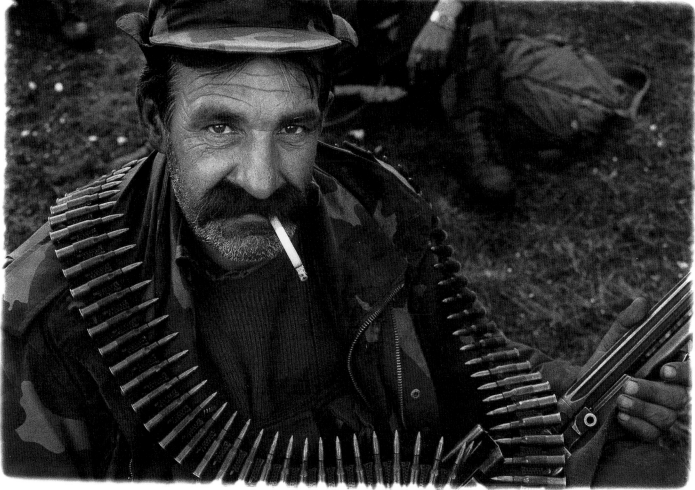

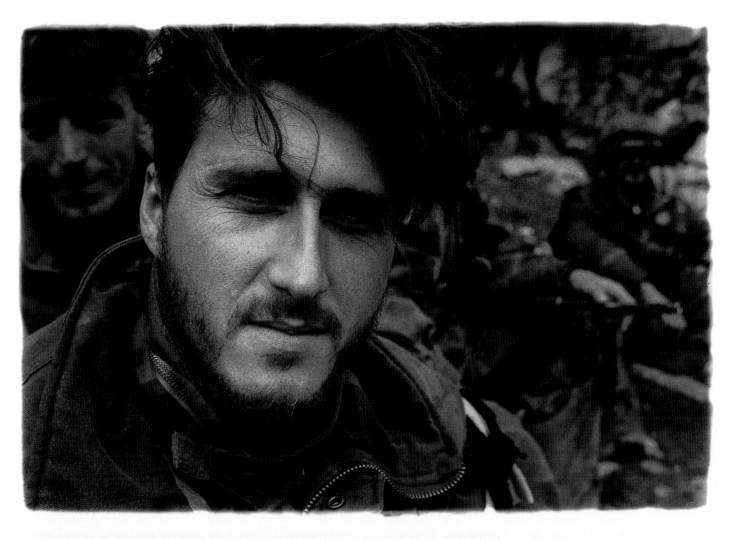

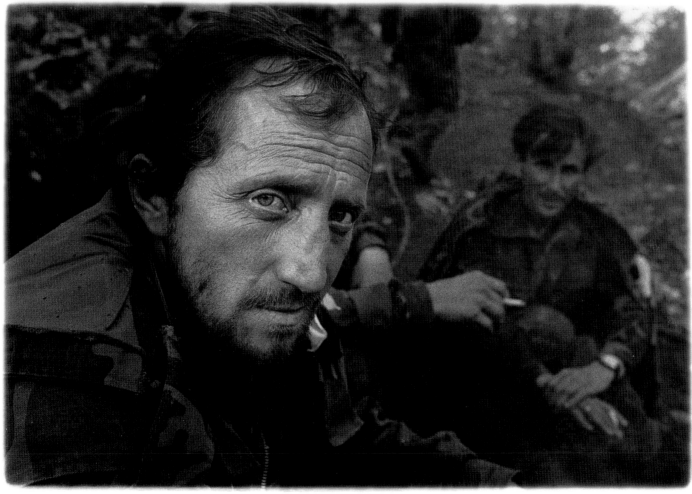

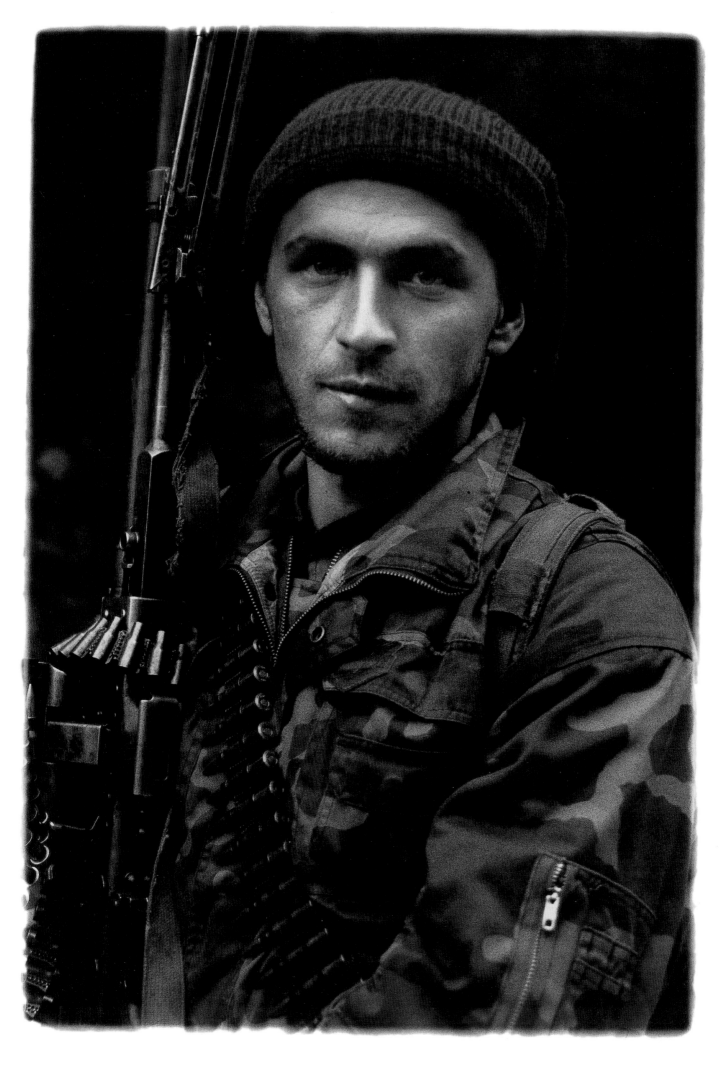

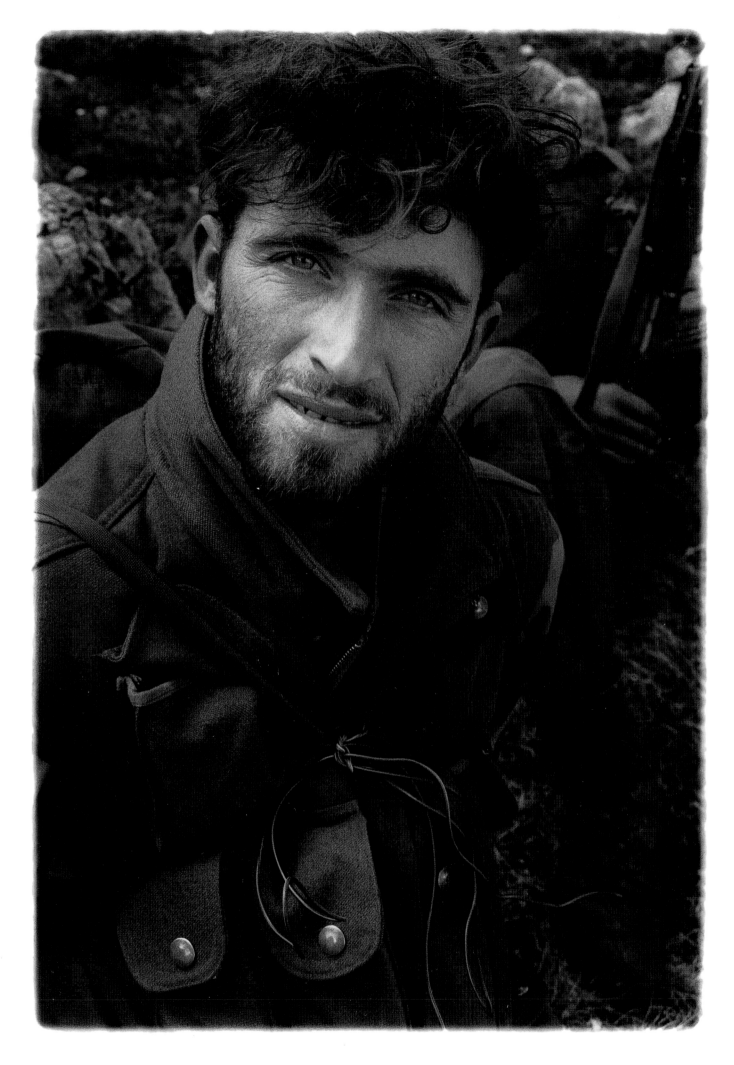

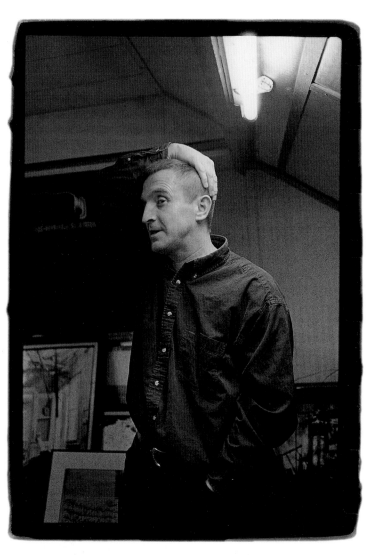

At home in Breda, Netherlands, January 2000

Šahin "Šile" Šišić
b. Višegrad-Medjedja, Bosnia and Herzegovina, 1961

After attending grammar and high school in Sarajevo, Šišić studied film at the Academy for Film and Drama in 1988 in Zagreb, Croatia. He graduated in 1988 and a year later, his first short film, *Margina 88,* won the gold medal at the Yugoslav Documentary and Short Film Festival in Belgrade and the Golden FIPA (Festival International de Programmes Audiovisuels) Award at Cannes. Šišić has worked on several projects as director and director of photography, collaborating with TV crews from all over the world on various films through-out the war. In 1995, his thirty-minute documentary film, *Planet Sarajevo,* received much attention and won several prizes at film festivals worldwide. He lives with his wife, Suada and daughter, Amina in the Netherlands. He is currently writing the screenplay for an autobiographical feature film entitled *Black Line.*

Šahin Šišić

Before the war began, I was doing a lot of photography—it was my hobby, my love, everything. But I also did some film work: I directed, wrote a screenplay, and did some camera work for a drama series. If I have a movie camera in my hands, I think in terms of the moving image; if I have a still camera in my hands, I think through that lens. They're two different things, really. I've done work I feel good about with both. There are a few shots I know I've made with stills that would not be possible to capture with film.

Some of the first work I did, some twenty years ago, was on the gypsies, before the war. I traveled all over the place—Priština, Sarajevo, Rijeka, Kosovo, Gnjilane, Zagreb. I spent a lot of time with them, watching them live their lives.

There's one series I took just before the war—looking at it you get a sense that something ominous is about to happen. I started to hear all this bad news about fighting taking place over land, our territory—the strongest pushing around the weakest. But I didn't believe that a real war would actually start at all—and I especially didn't believe that it would start in Sarajevo.

The first bombing that took place, that first May bombing, was a total shock. I don't have any of it on film. I didn't even think about making any kind of photographs. There was something else going on inside of me. It ceased to be important that I make an important film. What was happening outside was bigger than all of that and there was this monologue that started working in my head, demanding answers to all sorts of questions that I can't begin to answer, even now, right here at this table: why would you cover a city with as many bombs as they did? How does fascism get so out of hand?

I was watching, carefully, of course. But it wasn't my first instinct to pick up a camera. I began to realize, however, that if I'm watching from behind a camera, somehow I wasn't as scared. The camera made me feel stronger. Now, I always have my camera with me. It's my lifestyle, even if I'm not photographing but only observing. Once I left my camera behind to go and get a supply of water. The bombing started up

again, and you know, I was really afraid without the camera right there with me. It became a talisman, a lucky charm, a protector.

In Sarajevo, I knew everyone connected to film and photography. I was working at a TV station. Somehow I always knew where to go to get new film, to develop film—which could be tough. Once I was washing my film in the same place where people were coming to get drinking water, though I realized that's not the best way to do it—standing in line just to get some water to wash my negatives. It takes a lot of water to develop film properly. I guess that's one way I could tell that I wasn't really feeling the reality of the situation around me.

I remember one time I ran out of film, and I was so angry about the blood bath going on in front of me and not being able to photograph it. There was this guy next to me, another photographer who had ABC written on his helmet. I went up to him and just demanded—I didn't even bother to be polite—that he give me some film. He saw right away that I was ready to fight him for it—that I would even have destroyed his camera. He didn't say a word—just gave me two rolls.

You know, a lot of outside photographers would come in for a couple of weeks to try and document what was going on here. They came in with the photo they wanted to take already sketched out in their heads. And they were here to take that one picture—not to find out what this was really all about. For some of them, it was just a job—a business. I met them all. Sometimes I helped them out, showed them some places and things they wouldn't know about otherwise. A few friendships even developed out of it. But they didn't usually understand the whole picture, or even part of it. I had to get them out of trouble sometimes too. I let them know where and when the really dangerous situations were happening—"Go here, don't go there!" There was this one crazy photographer from Paris who was jumping around all over the place trying to shoot something "special." Wherever there was a bombing, he'd be there. I found it a bit strange, because, you know, I wasn't chasing after tragedies. But he was always running around, wanting to get his lens in there closer and closer. He wasn't afraid of anything, and he

really wanted to get into the thick of it. I finally start-ed to respect him.

The two pictures of blood on the sidewalk were taken after a really awful massacre in Vase Miskina, May 1992. I'm sure you've seen photographs taken by pho-tojournalists from around the world that give you the broad picture of this tragedy. These are the details... the small moments. I took my time. I could do what I wanted.

The other photographers from the outside had a different job to do. It was a little like they were exploiting some of the situations for their own purposes. They had to get something on the plane to Milan or wherever, to their agencies by the next day or even the same day.

For me, I was trying to make shots that would make me feel less nervous for my soul. I didn't need to get these images fed right away into the newspapers or anything. I always left the option open not to develop the film if I didn't feel like it, maybe never even show them to anyone. I can't tell you why I took these photo-graphs. It was just an instinct to shoot.

That first year of the conflict was really incredibly tough. People didn't have any experience with war. It was all totally new. After that, I got out of Sarajevo. When you are out of the war for a long enough time, you feel less and less compelled to go back. You expect the war will stop by itself. Of course, you want to help, to support your country, your family, but you want to find other ways of doing it than being there.

I've lost friends and family to this war. Once I heard sniper bullets whiz by a few centimeters above my head. That attack was a total shock for me, and I was absolutely frozen. I wanted to run, but I couldn't move my legs or my hand. I was almost wounded when some shrapnel hit me, but by sheer luck it went though my leather jacket without touching me. I really put myself on the line to get some of the pictures, and I often asked myself whether I should have put down my cam-era and done something else to help.

But I also felt like I had to do something to help me survive my own life, to do what I had to do to feel nor-mal. For a while I was doing the most basic photogra-phy—taking pictures for passes (those I.D. cards you need for every checkpoint). I have a collection of about twenty or thirty of these, each one representing different schemes to get out of Sarajevo. Everyone I knew wanted a photo—just a small photo.

Some of the people I had known, and, unfortunately, some of them never got out. Some of them died. As for me, I got out thanks to one man from an Austrian tele-vision station, who was able to make me a pass in half an hour. The next day I was on the plane. He had been pleased with some work I had done for them, and he offered to help me fly to Zagreb if I'd bring more film to be developed.

The war officially ended in 1995 with the Dayton Peace Accords but it's hard to say it's over. It doesn't matter that Clinton came and made a show and smiled. People are still deeply dissatisfied. My father is still not able to return to the place where he was born because it is in the Serb half of Bosnia. He used to go to this one place near our house, every week like clockwork. When he lost that, he looked like he had lost every-thing. By watching my father, I can tell that there's still a long way to go. Because the end, the real end, is when you get to return to your house, to your land.

As for myself, it's a difficult question about whether I should go back to Sarajevo or not. I've spent a lot of energy on this war—six years—from age thirty-one to thirty-seven. It's been a kind of mental block. During the war, I would only take jobs that were connected with Bosnia. I'm only now beginning to feel like myself again, the way I was before, to write again, to prepare an exhibition.

Photography gave me a tiny grip on something—to make some photos that will be evidence. This war did happen. And I found that it's important to be able to leave some kind of a message—but through my own eyes. It's not a patriotic thing, per se, just a little note: "This is what happened. Here's how I saw it."

War also gives you energy, but it's mostly a negative energy. Sometimes that energy stays with you, and you feel it gnawing at you. You're not in your own home, you're not speaking your own language, you always need something—food, shelter even—you miss your friends, you miss your family. You're not in control of the big picture.

You have to find a way to cleanse your soul—it doesn't matter what kind of tragedy has happened. You don't want to forget, but you have to be able to move on.

Breda, Netherlands
December 28, 2000

Šahin Šišić
Overleaf: Slaughtered sheep, Sarajevo, 1991

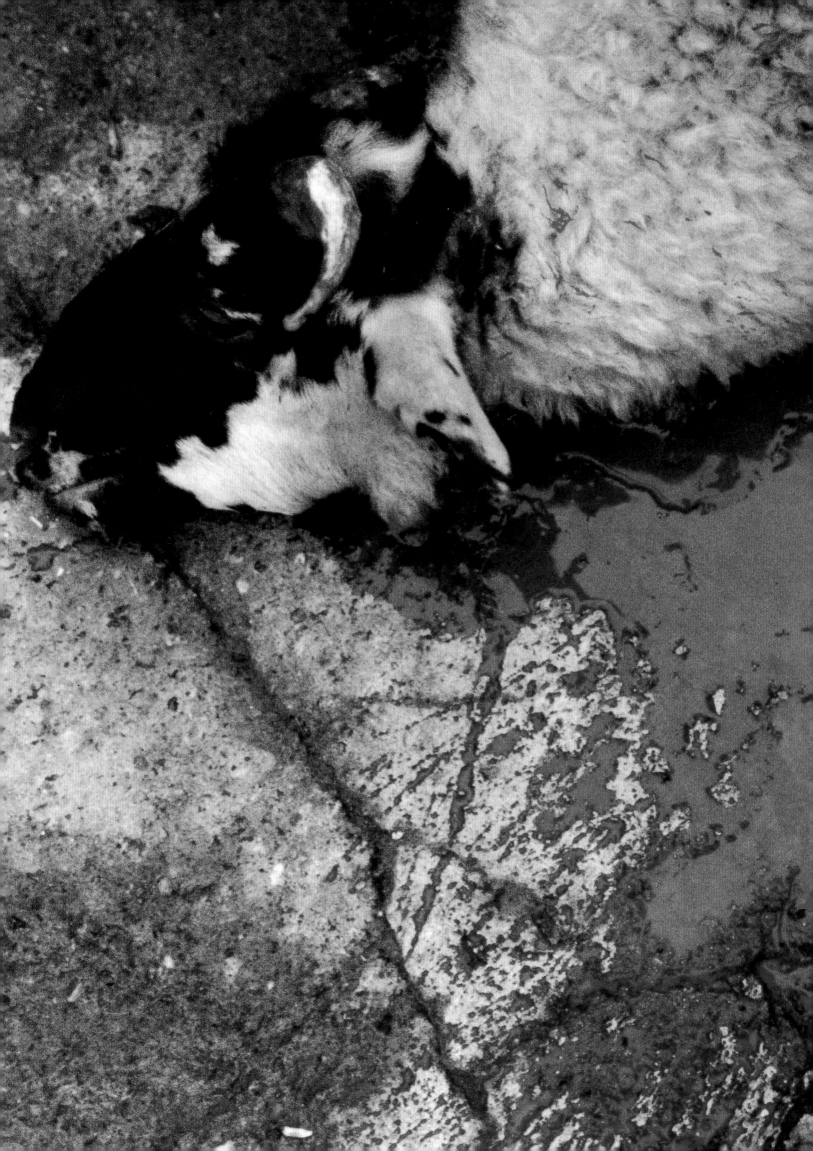

Šahin Šišić
Above and opposite: Breadline massacre, Vase Miskina,
Sarajevo, May 27, 1992

These images were made minutes after a mortar attack
landed on this quiet pedestrian mall, killing at least seventeen
people and wounding dozens more. The victims had been
waiting to buy bread.

"These are the details...the small moments."

Šahin Šišić
Overleaf: Djure Djakovića Street, Sarajevo, 1992

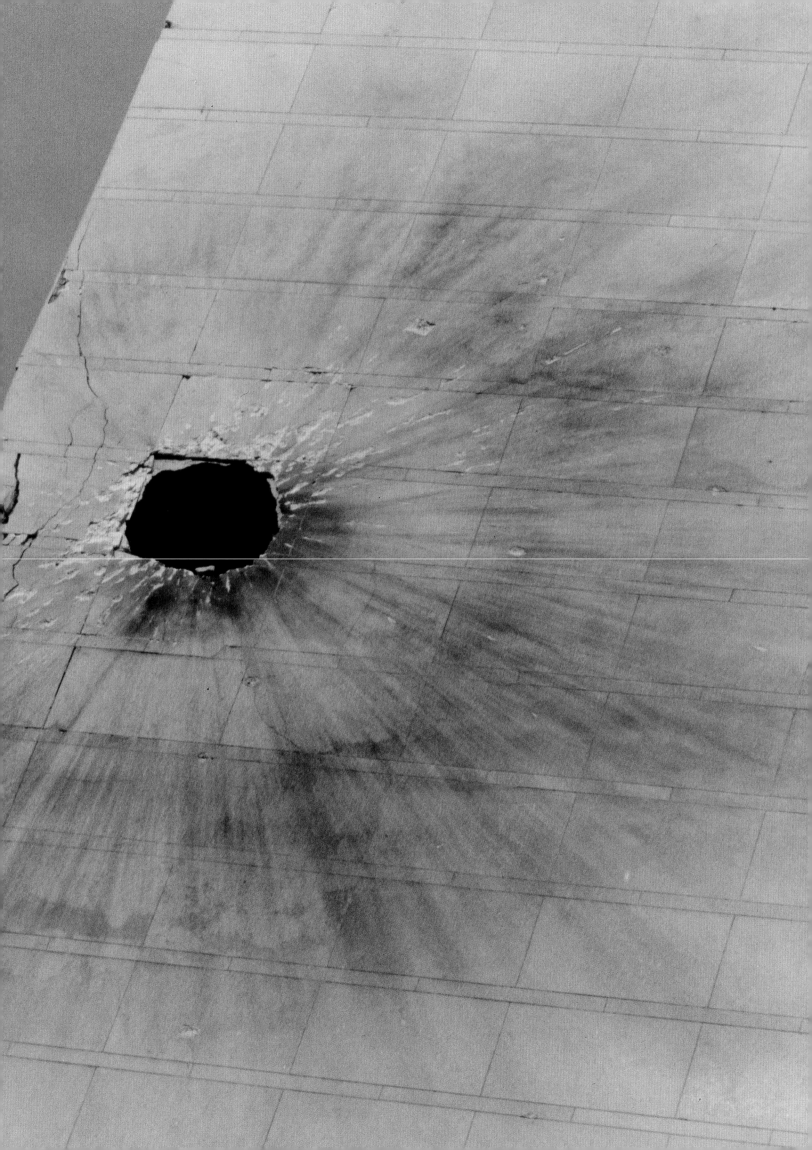

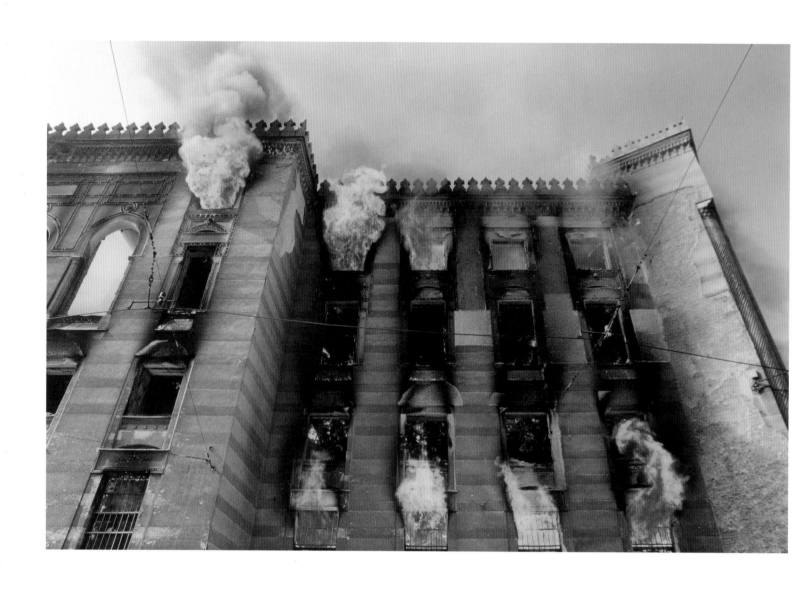

Šahin Šišić
Above: Gradska Vijećnica, Sarajevo's national library,
in flames, Sarajevo, Spring 1992

Opposite: A baby's grave, Sarajevo, Spring 1992

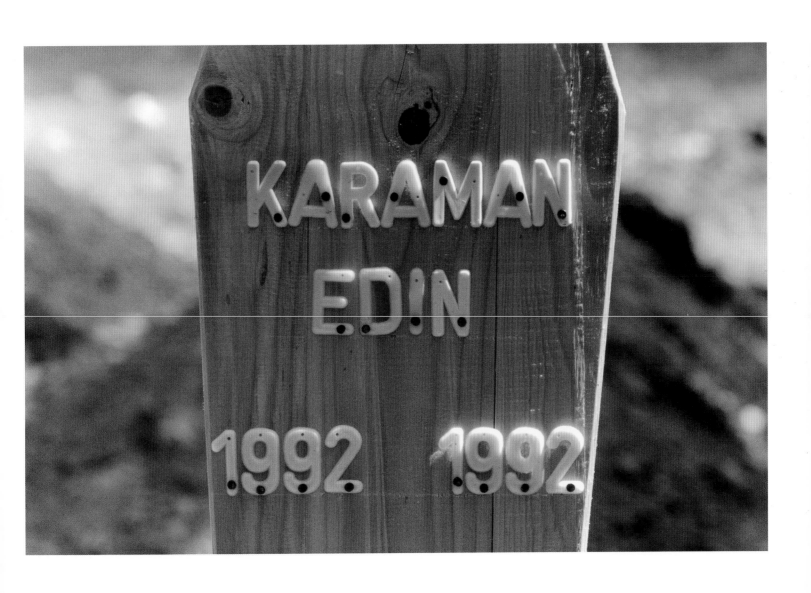

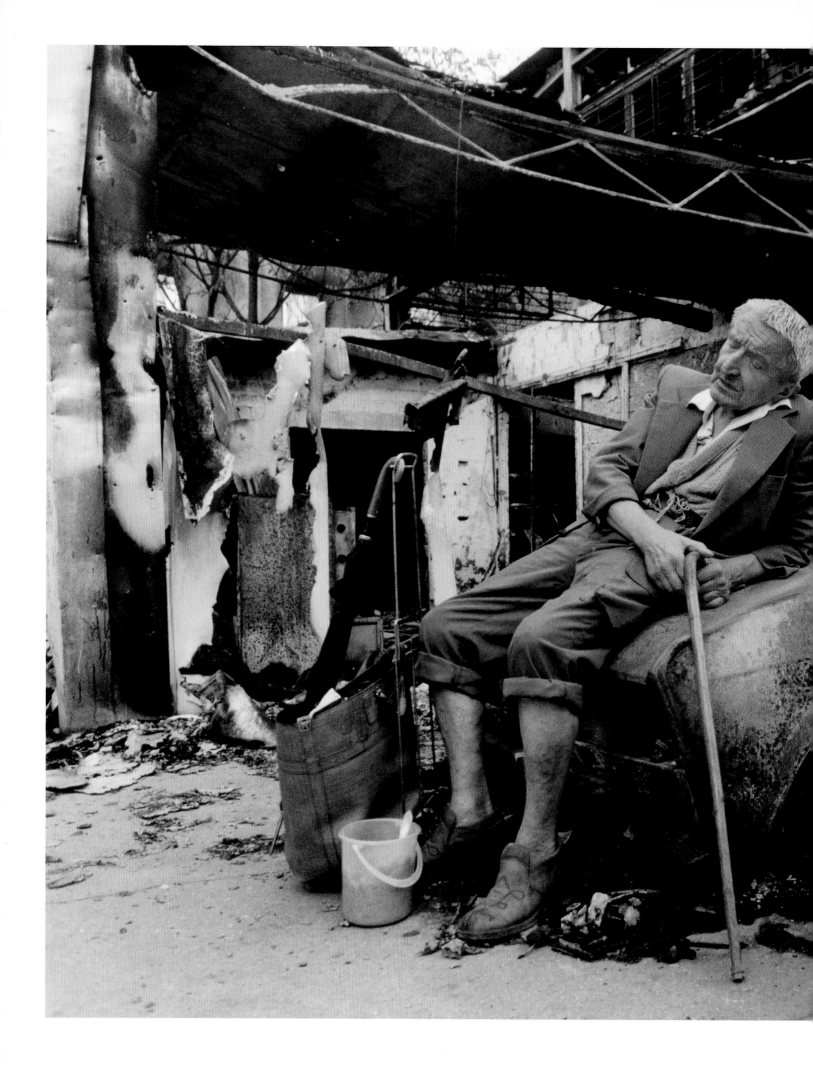

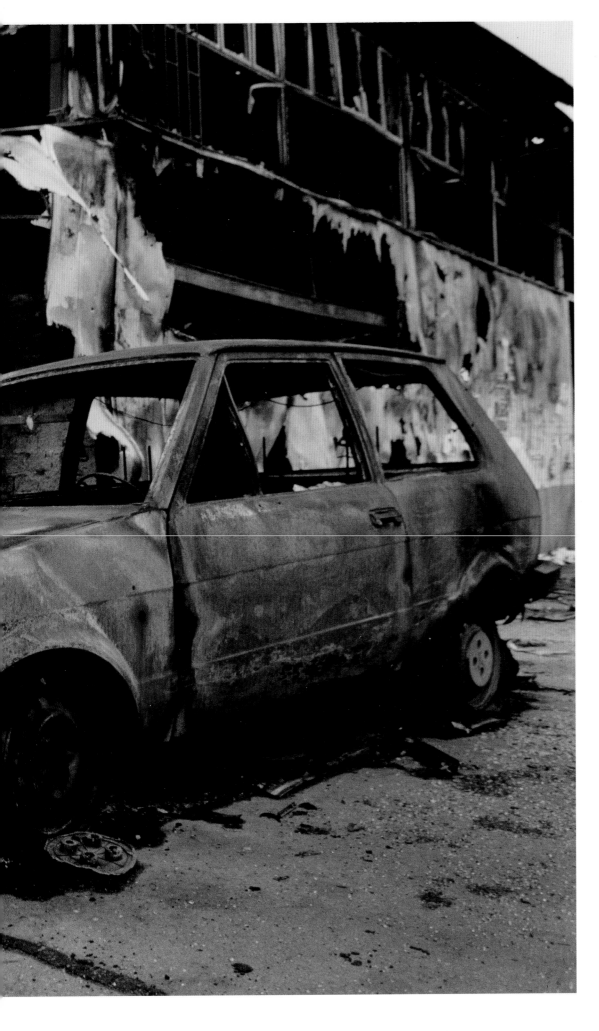

Šahin Šišić
Sarajevo, Spring 1992

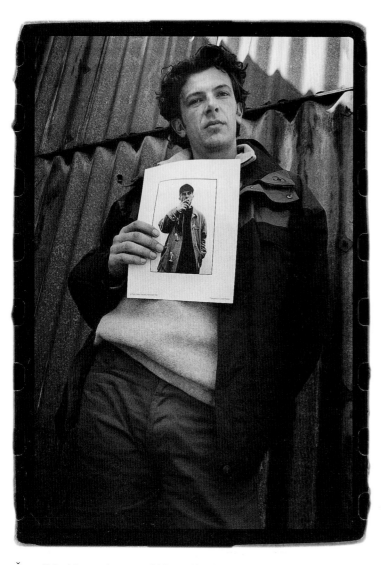

Šagolj holds a picture of himself taken in the fall of 1995, on the day Fratkin and he first met. Šagolj weighed 62 kilos then, he weighs 82 kilos now.

Damir Šagolj
b. Sarajevo, Bosnia and Herzegovina, 1971

After spending several years in Russia, Šagolj moved back to Sarajevo in 1991 and began working as a photographer and photo editor for several local magazines. During the war, he freelanced for various international news agencies and also took photographs for the State Commission for Getting Facts on War Crimes along with Dejan Vekić. In 1996, he joined Reuters News Agency, where he is today, covering the former Yugoslavia and the region. He and Vekić opened a photography studio in Sarajevo, where they continue to work today.

Damir Šagolj

I got interested in photography at the same time my friend Dejan Vekić did. At first, it was purely as a hobby. A mutual friend of ours, Goran Kukić had a studio and was really nice about letting us use his equipment. We were kids at the time, and Goran gave us a few odd jobs. We'd develop his film, mix chemicals, set up lights, etc. In time, we started doing everything for him.

Then in 1986, I moved to Russia with my family. My father was a journalist for *Oslobodjenje*. Now he's the editor-in-chief. In Moscow, I made friends with some people who were studying at the Moscow Academy of Film. They were mostly studying photography from a film perspective. During the two years I was there, we made some short films and other things for two years, as well as some basic photography. I moved back to Sarajevo shortly before the war and got back into photography with Goran and Dejan. I guess I was originally interested in journalism because of my father.

My father never told me, "You should do this, you should do that, you should be interested in photography." He always pretended he didn't care; he didn't want to influence me too much. But just being around his work influenced me. He's been back and forth to Moscow a few times, but he was here in Sarajevo during the war. My mother worried a lot because my father was always away on an assignment in some hot spot, my brother worked as a policeman, and I was in the army. I wasn't part of the infantry, but I worked at the Bosnian Army's Press Information Center. I didn't exactly volunteer, but it was obvious that I had to be somewhere. It was cool. I could work with their computers, I could take pictures, do a little bit of writing, travel. I was in uniform, but I came home every night. Mostly I did press-related things for them. Toward the end of the year, I was mostly dealing with foreign journalists. It was never a formal position, but no one else there was taking care of the visiting journalists, and since I was interested in photography, I tried to help them out, explaining to them where they could go, where they shouldn't go, and why. In this way, I met most of the foreign photographers coming through town. I stayed in the army longer than most. They didn't want to let me go because I did so many different things for them. It was a very flexible situation, and they never gave me a hard time. I'd show up once a week or so and they'd give me assignments.

After the army, in 1996, I started working for Reuters. I also worked with SIPA press, the French agency, for a little bit, before starting at Reuters as a stringer.

Early on, I also did a little bit of work photographing for the State Commission for Getting Facts on War Crimes. They had taken over Goran's studio where Dejan and I had been working. One day we walked in and were like, what the hell's going on, who are you? Dejan and I didn't want to give up the place, so we got involved in the whole war crimes thing. We weren't really crazy about it, but it grew on us. We didn't make any money at all—it was just something to keep busy. And we were really busy, documenting everything that went on in town and around town, photographing the destruction and the killings.

There were times when we'd recognize some of the bodies we had to photograph. It was pretty hard. It felt terrible, of course. That's one of the times I found it very useful to have a camera; the camera is a great place to hide behind. Even now, whenever I'm in a difficult situation, I find it very useful to just hide behind the viewfinder. It's not exactly an escape but at least you're behind the picture, not in the picture. Of course the photographer is always a part of a photograph. But at least, as the person behind the lens, you can distance yourself for a minute or two. You feel like, okay, this is not my war. It's a coping mechanism. You somehow feel less vulnerable, safer. Like if stones or bullets are flying over your head you can just jump behind your camera and suddenly you feel better. You become the person taking the pictures—and they're not supposed to want to kill the picture-taker, they're supposed to kill each other! Of course, you feel that for a second, and then you find yourself on the floor. Dejan and I found ourselves in crazy situations more than a few times. We had some close calls. We pretty much stuck together. It helped. I think I would have gone mad otherwise.

I remember being in Moscow watching CNN sometime in 1991, and all this stuff was going on in Croatia. I called my dad and asked what I should do. Should I go back to Sarajevo? I had been on the move a lot: a few months in Moscow, a few months in Sarajevo. He said it was up to me, but he predicted it was going to get pretty tough in Sarajevo. I decided I didn't want to sit there and watch

whatever happens on TV. I got back just a few months before the war. I had to be there for my family—and also my friends. Our solidarity kept us alive.

This may sound a little strange, but we had a pretty good social life during the war. I guess those were the best parties I'll have in my life because you didn't really know what would happen to you tomorrow, so everything you had—your energy, your money if you had any—you just took those things and threw them into having the best time. You never knew what could happen to you the next minute or tomorrow. You risked your life in dark dangerous streets to get there, and once you did, you realized that outside was one of the most dangerous cities in all of Europe. There were parties in people's houses, in abandoned buildings or clubs—if you can use that word to describe a place with no electricity and nothing to drink. You just went to see people—people who had become very close to you. It was much better than staying home and closing yourself in. You'd go mad sitting there, watching your old man straining to catch the news on a portable radio, just to hear which army advanced another few hundred meters.

Now that it's over, I don't go out so much. You don't feel the same urgency to be around people like that. Or if we need to, it's for different reasons. The war is still affecting everyone, no doubt about it. It's an unspoken rule that we try hard not to tell the stories. We don't talk about the war with each other—we don't tell stories of how difficult it was, how brave we were. Never. Not at all. That's behind us. We learned from it, why would we go back? I can't say I've forgotten it, nor am I over it, but we just don't sit around reminiscing.

Of course I had no idea what I was getting myself into back then. I knew that things were going to happen, but I couldn't have imagined what things. It was such a shock when I heard the first detonations. Dejan and I were at the Olympic museum working on some paintings. We figured it was fireworks or something. I'd never heard such a sound before: a really pregnant sound of concrete and steel—very different from an explosion in the hills or a forest. I thought war was like a front line with groups of people behind it, one side red and one side blue. They fight and then they go home at night, have dinner, have a regular life. At first we just thought it was an inconvenience—you couldn't go to the seaside or something. We had absolutely no idea what was in store for us.

The experience completely changed my life. I doubt I would have been a photographer without the war. It had always been more of a hobby to me. Computers and electronics were supposed to have been my career. I don't know. It's really difficult to speak in terms of what would have been, should have been, or any of that. I see things differently now—it definitely helps me now when I go to other places to shoot. The conflict in Yugoslavia did not finish with Bosnia. I understand better what's going on in places like Kosovo, Albania, Macedonia, and other places I've covered as a photojournalist. I know it's a little different, but I feel a lot calmer in those places than I would have without my Bosnian experience. I don't freak out when faced with guns or snipers.

During the war Dejan and I spent a lot of hours really just wasting time. We'd walk two or three hours a day. We had a car, but there was no fuel, or what little was available was very expensive. I probably spent as much time trying to get water and other basics as I did photographing. It'd take an hour to walk from home to work because you didn't want to walk on the roads, so we would take a hidden route, like the abandoned railroad tracks and things like that. It took longer, but it's not like you had to be at work promptly at eight o'clock. No one was going to say anything if you were half an hour late. It was nerve-wracking. You never knew when someone would show or not show, and there were no telephones either. That drove my mother crazy!

As for the foreign journalists, and other photojournalists in Sarajevo, I didn't interact with them much. I just was not interested. Why should I talk to them? They're just more guys with cameras—another guy with another tool. I don't think there's a big difference between my pictures and those of outside photographers. And if there are differences, it's not because of who I am as a Bosnian per se or where I'm from. Those differences are there because of the different ways I think or how I feel as an individual. I'm telling you, there were some foreign photographers who felt so much more Bosnian than some actual Bosnians, who had stronger emotions about this place than anyone else. I knew a photographer from

France who was harder than hard-line Bosnians on certain issues. If I, as a Bosnian, go somewhere else like Priština or Kosovo, it would be the same as if I were shooting something in Sarajevo. But what is true, is that you can't truly understand this war if you haven't been through it.

Of course, if you live here day after day, you get used to what's around you. I pass by the ruins of the *Oslobodjenje* building a hundred times a day and I never think about the tragedy of it anymore, how awful the destruction is. Some other guy, coming straight from the airport, might see that same site and go crazy taking pictures of it. But after a while, you get used to it. That's the difficult thing—and you can't blame yourself. I should really feel something more looking at, say, Danilo's photographs from the marketplace massacre and the guys who were slaughtered that day. It was awful, but I just don't have any emotions or connections to it on that level.

The strange thing is, around 1993 or something like that, there was an exhibition of someone else's photographs from a different war—Somalia or Rwanda or somewhere. And those images really struck me and became important to me. It was ironic, looking at pictures hanging in some art center in Sarajevo, surrounded by war, and being really touched by photos of someone else's war.

I do remember that day in May 1992, the first real slaughter of the war when the bread line was shelled. We were sitting in my parents' apartment, looking at the shots of the street on television. I remember my father was crying because he recognized a friend of his who had been wounded. We were all completely out of our minds then. Ninety percent of Sarajevo had to have recognized someone in that massacre. That was when it really began to dawn on us, some inkling of what we were in for, and how serious it was.

I consider myself to be a Bosnian. My father is from a Bosnian-Croat family, and my mother is from a Bosnian Muslim family, but she never went to a mosque or anything. If somebody asks me what I am, I say I'm nothing. Or, really, I'm Bosnian. That's my nation even though there is no such thing. People feel obliged to claim themselves as something, to belong to something.

Some of my favorite photos are those I took of the Arizona market, which is a black market located on a former frontline in the town of Brcko. It's on the main road from Sarajevo to Croatia. It's a huge flat field with nothing but mud on it. In early 1996, the market just cropped up by itself because of its status as a no-man's land. The Dayton Peace Accord couldn't decide who it belonged to, so they declared it as its own district. It's like a state of it's own. But there's no electricty, no water, no infrastructure, no laws, no police, no tax—nothing. People from both sides of Bosnia come and go without being checked by the police.

Sarajevo, Bosnia and Herzegovina
February 27, 2000

Damir Šagolj
Overleaf: An infant's funeral, outside Sarajevo in the village of Svrake, 1996

This thirty-six-day-old infant was the daughter of the local Muslim priest—four members of his family, including his wife, sons, and this baby, had been killed at the beginning of the war. Almost four years later, a mass grave containing their bodies was discovered, and they were given a proper funeral.

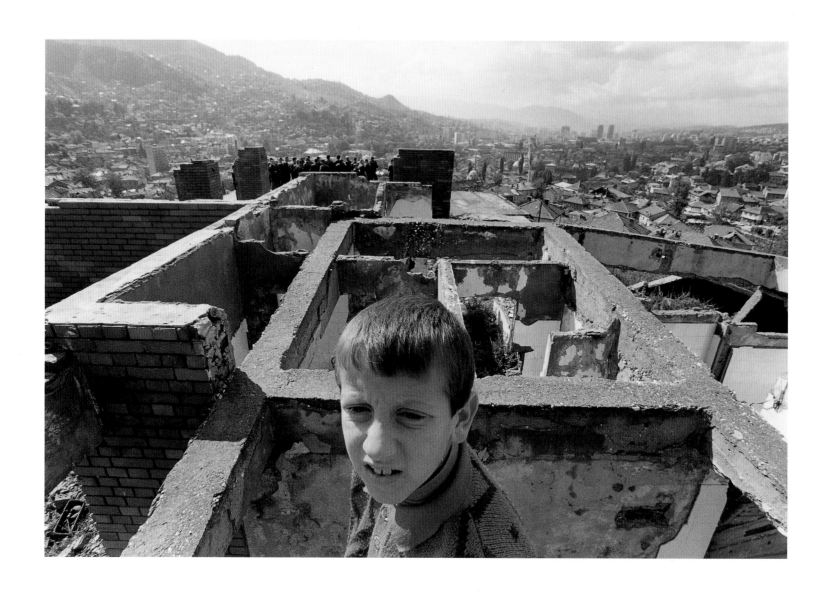

Damir Šagolj
Above: Sarajevo, 1996

Opposite: Sarajevo, 1997

Mothers, wives, and sisters of some of the 7,000 men who went missing after the fall of Srebrenica stage a demonstration demanding that more be done to determine the whereabouts of their men.

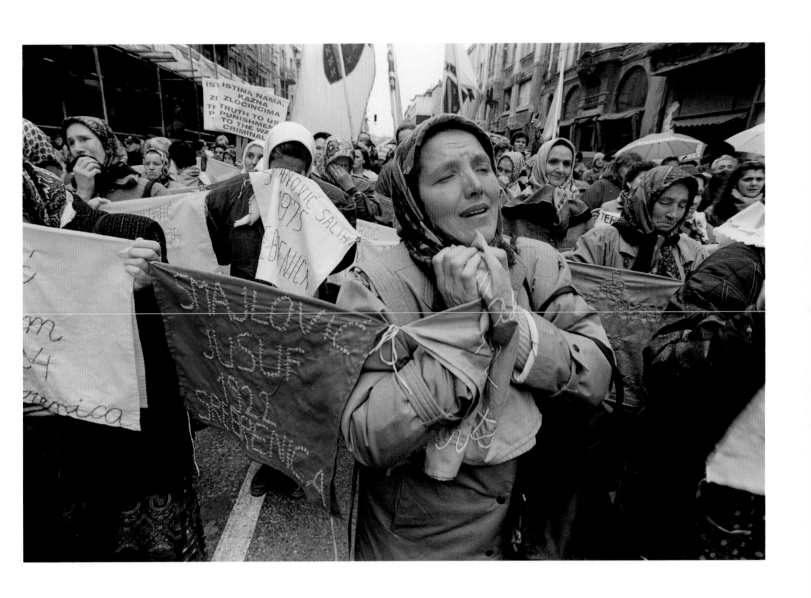

"I thought war was like a front line with groups of people behind it, one side red and one side blue. They fight and then they go home at night, have dinner, have a regular life.... We had absolutely no idea what was in store for us"

Damir Šagolj
Above and opposite: From the Arizona Market series,
northern Bosnia, 1999

The Arizona outdoor market is located in a no-man's land between
the Muslim- and Serb-controlled halves of Bosnia where people
from all sides in the war buy and sell black-market goods.

54

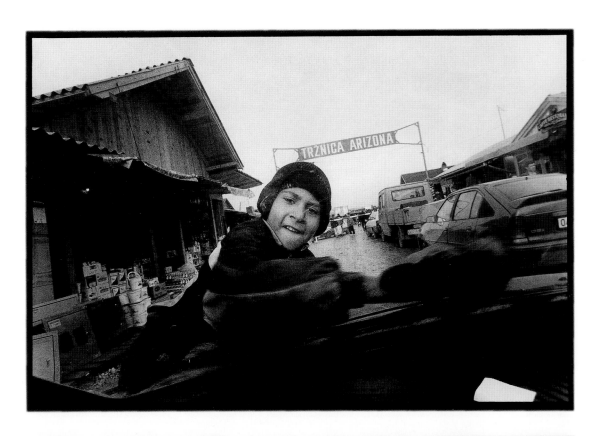

Damir Šagolj
Overleaf: Unidentified bodies extracted from mass graves
near Srebrenica and stored in a tunnel, Tuzla, Bosnia, 1997

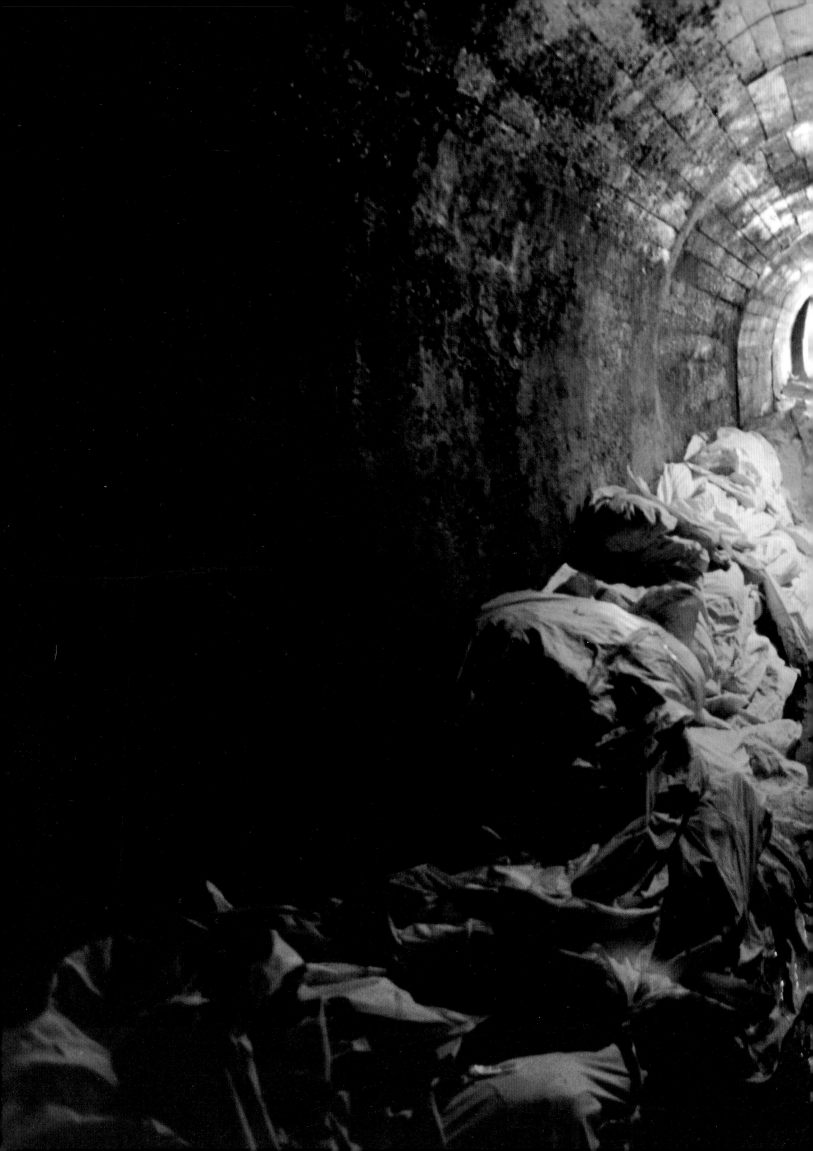

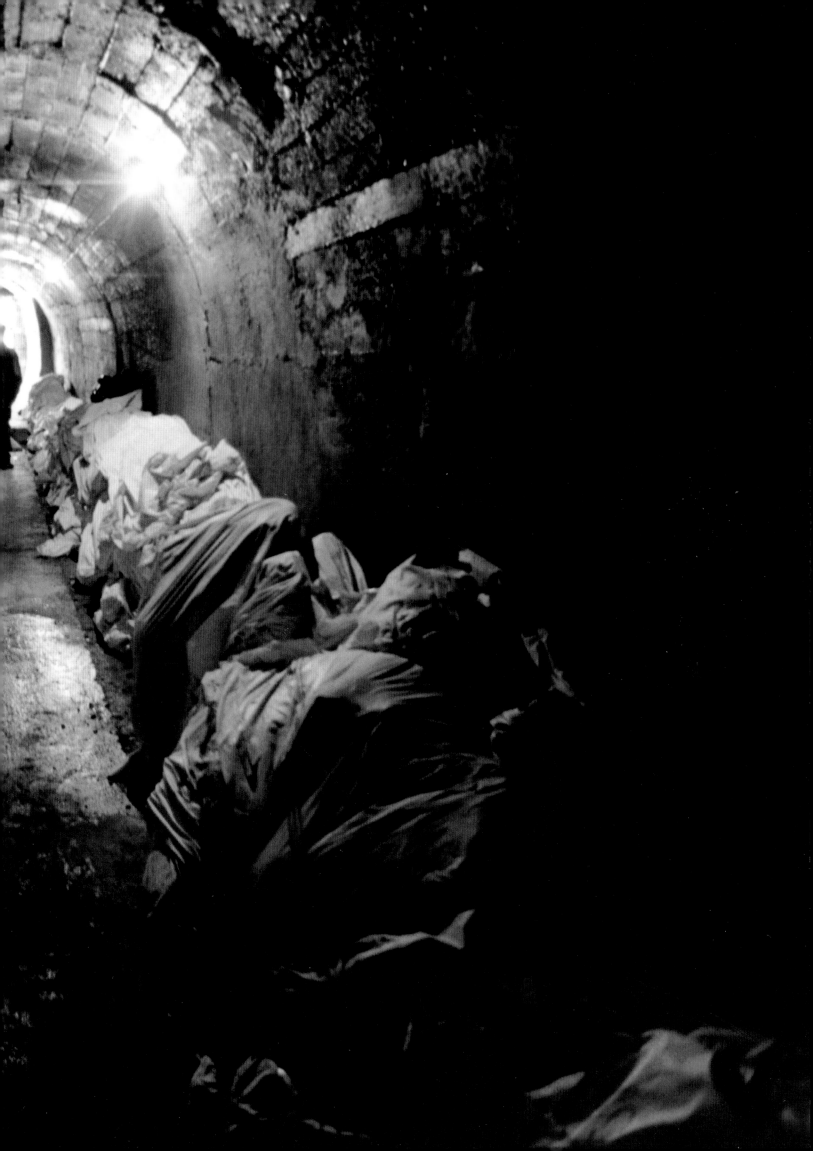

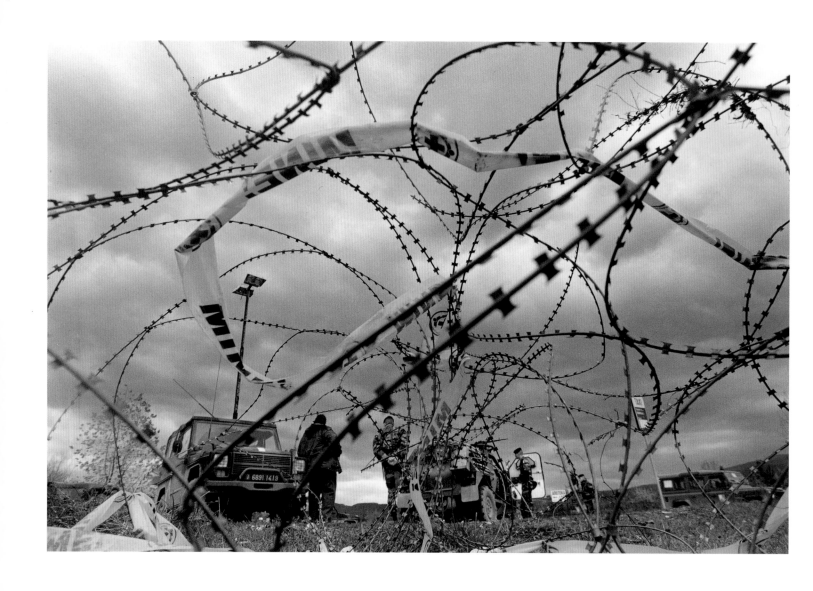

Damir Šagolj
Above: NATO troops look on as landmines are cleared in the
Sarajevo neighborhood of Dobrinja, Sarajevo, 1998

Opposite: The National Championship for Disabled Persons,
Koševo Stadium, Sarajevo, 1997

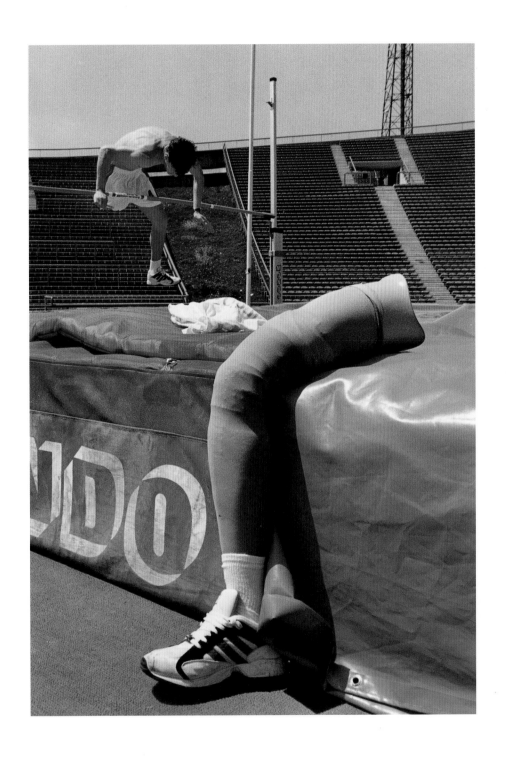

Damir Šagolj
Overleaf: Sunday mass in a ruined church in the Sarajevo
suburb of Stup, 1997

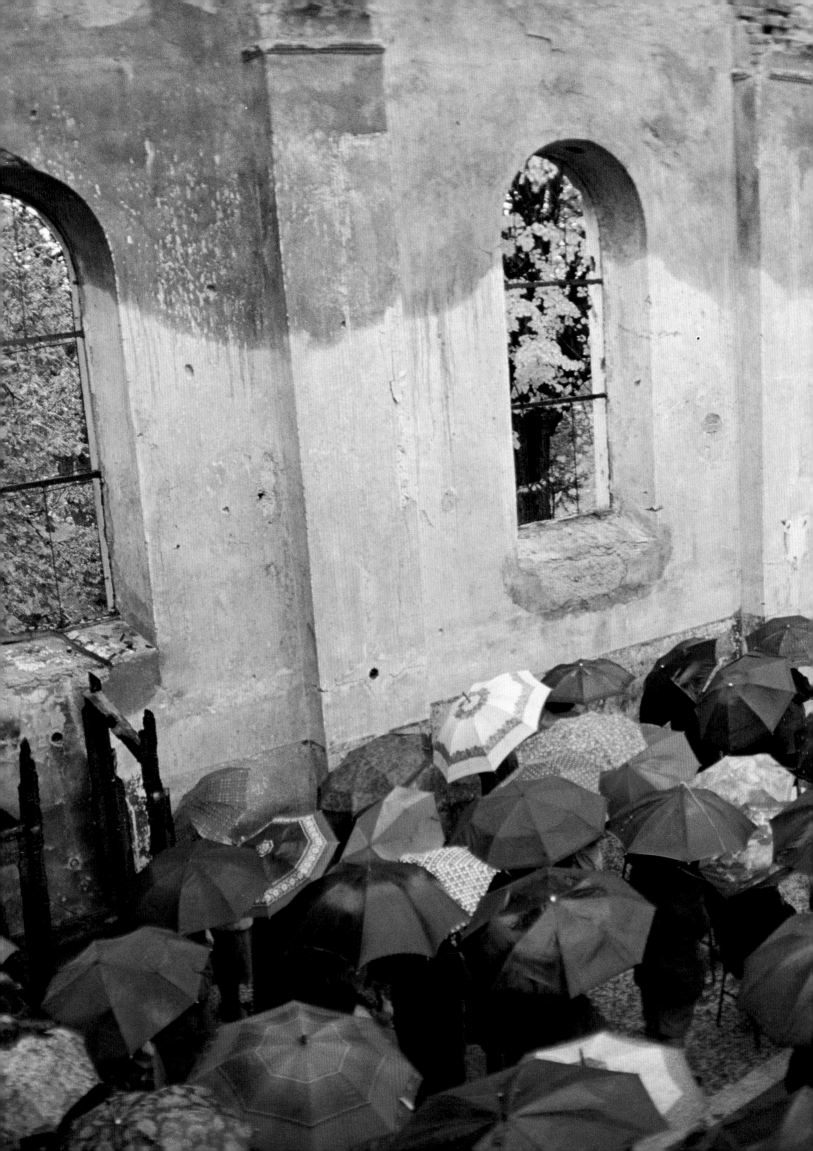

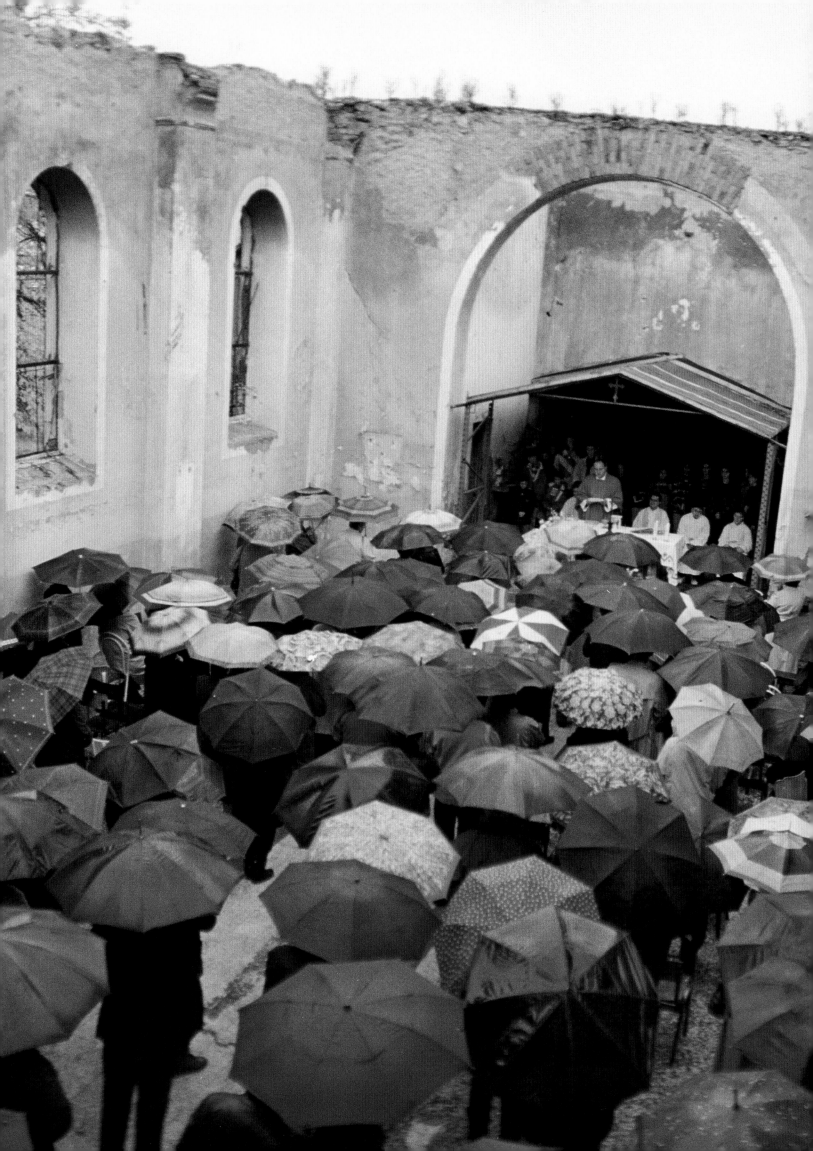

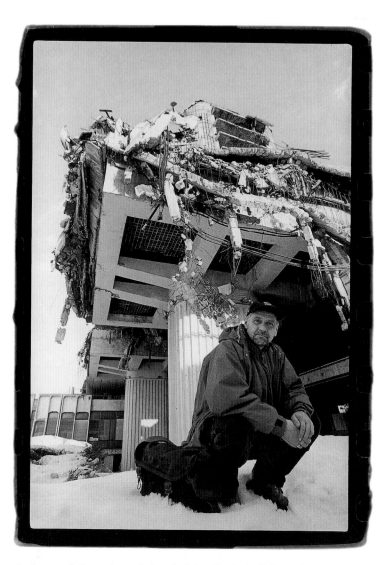

Danilo Krstanović
b. Sarajevo, Bosnia and Herzegovina, 1951

Born into a family of photographers, Krstanović took up the
trade and began his career as a sports photographer for
Sarajevo's daily newspaper, *Oslobodjenje*. Krstanović continued
to work throughout the war, documenting the destruction of
his city. In 1991, while still working for *Oslobodjenje*, he began
shooting pictures for Reuters News Agency. In 1995 he start-
ed working full time for the agency. Krstanović lives in
Sarajevo with his wife, Nina, and his daughter, Renata.

In front of the ruins of the *Oslobodjenje* building, the
newspaper Krstanović worked for during the war
Sarajevo, February 2000

Danilo Krstanović

In my family, there's a long tradition of photography. My father was a photographer, as well as my uncle. Now I'm carrying on that tradition, but I hope that my daughter won't pick it up from me.

In my eyes, my father was the best photographer in all of former Yugoslavia, if not the whole of the Balkans. Because of him, I've been interested in photography since I was really young. Even so, I never wanted to be exactly like him; I've always done a different kind of photography from my father.

My father died in the early stages of the war. He just faded during the war; he gave up. We couldn't have a proper burial because of the snipers. Only my brother and I attended the funeral. He never took any pictures at all of the war. I showed him some of the ones I'd taken, but I never wanted to show him the most brutal ones.

When I think about it, though, except for my father, my family and I were actually very lucky during the war. My daughter continued going to school, I continued to work. My wife, Nina, had the hardest job. She was always waiting for us—only she knows how difficult that was for her. I would have preferred it if the two of them had left Sarajevo and gone somewhere safe.

I once had a close call. I was wearing a bulletproof vest, walking near the *Oslobodjenje* building, which was in my area to cover and document. It was early morning and I was in a trench when I saw and heard a shell. I followed the smoke from it, approximately 500 yards away, I didn't know if anyone was there. As I got closer, I saw this couple had been killed, a husband and wife. They were on their bicyclecoming back from getting milk. I stepped out of the trench to see if they were still alive and to take the picture, when the shooting started again. A bullet to my chest knocked me down. I didn't think about anything, I just felt blown away. It wasn't until later, once I took cover behind a building and wasn't in the line of fire anymore, that I realized what had happened. I was in shock.

Before the war, I was a sports photographer. Actually, I was well prepared to shoot the war. Good reflexes, good instincts. I'd still like to shoot sports photography, but maybe that moment has passed. I've moved out of that frame of mind. Now I think I prefer "life" photography.

I started with Reuters in 1991. I'd worked for both *Oslobodjenje*, the daily newspaper, and Reuters until it got to be too much. I started out as a stringer, sort of like Damir. I'd taken a bunch of photographs for Reuters during the war, and they were always more than fair to me. I helped them a lot in the beginning, especially, before they had their other photographers.

There used to be thirteen of us photographers at *Oslobodjenje* and almost everyone left except me. It did not happen all at once, but month after month there were fewer photographers. People were scared. They didn't leave the city, but they were nervous about being exposed in the city; a few part-timers stayed, like Nermin Muhić and some others.

Everyone would send their film to me and I'd use my magic to develop it, with no chemicals, no water. I have to say—and this may seem a little offensive— but we sometimes used our own piss to fix the photographs. We would use at least a few drops of fixer, and a little water, but then for the rest, we would use piss. We rinsed them well with rainwater. We had to save chemicals any which way we could. Under normal circumstances, you can develop ten to twelve rolls of film with one liter solution of developer. I was able to get fifty rolls out of the same amount, although the last roll would take an hour or so to develop, the chemicals were so old. I found all sorts of ways to make it work. I would only make one print of each shot. If the lines were not dead, first I'd send it to Reuters via telephoto—it's like a photo-quality telefax machine—and then I'd take the same print down for use in our paper. We had no electricity, although at *Oslobodjenje* we did have a power generator that we used for making enlargements. We had one light bulb, and we'd save everything up to do at once when the evening news came on. So in the building, the only two things that were consuming power were the TV set and that light bulb. It's hard to imagine how we did it, now that the whole thing is over.

Eventually people—journalists and photographers—started bringing us stuff: paper, a bottle of developer here and there. I was always forced to be stingy with it, though.

When the foreign journalists started coming to Sarajevo, I have to say that I thought that the Bosnian photographers who stayed here were better than any of them. When it comes to viewpoint, framing, speed of making selections, overall feeling for photography, I still believe that. It's natural; we had a view from the inside. We're locals, we know all the angles, everything. If I were to go to Poland, I don't think I'd be better than a local Polish guy. That's my opinion.

It's not suprising that the photographers with years of experience in war situations, who work for big papers like the *New York Times* or *Washington Post,* are more professional, more knowledgeable, better equipped. But the quality of ideas is richer on our side. We have a better understanding of what happens here, what life is like here. They come in for two weeks, a month, and can hardly wait for their shift to end. They cannot love this city the way I do, and I try to bring that to my photos. I don't know if I'm successful, but I see the connections. The question is: do others see it?

I can pinpoint the beginning of my awareness of the war almost exactly: May 27, 1992, at ten o'clock in the morning. That was the first massacre of the war, the so-called breadline massacre, on Vase Miskina Street. I caught up with this other cameraman from a local TV station who had been there, on the spot, right when it happened. He was sitting on the stairs of the marketplace; we didn't say a word to each other. He downed half a bottle of brandy in one gulp when he started to become aware of what was in front of his camera. By the time I got there, they had pretty much cleaned up the mess, but I photographed what was left. I had a photo published from that terrible day in the *Herald Tribune*, so that date sticks with me, but It wasn't until I saw my pictures in that paper that it really hit me: we were in a war.

I couldn't believe that such a thing would happen in Sarajevo. I shot the war from the very beginning: the barricades, the growing tension, but it was still hard to believe it could escalate to such a degree. Everyone thought it would just be a small thing, over in ten days.

When I look at my photographs from the siege of Sarajevo and the war, with few exceptions, they are sad and gloomy, ugly—even the good ones. That was our reality at the time. My favorite photo from the war is the couple going to their wedding, walking down a street lined with linen sheets to protect them from snipers. I tried to capture a balance all the time. Everything happened at once. In some of my photos, life goes on, while in others, a woman lies in a pool of blood. Death is balanced by youth. I wanted to show that there is love in this city, not just grenades and hospitals. This was very calming for me.

Another important photograph to me is the photo of the man kissing the ground next to a demolished mosque. I was in Misuča, approximately thirty kilometers from Sarajevo. It was the day before Ramadan, or Bajram, and everyone thought that this man was bowed in prayer. Actually, he was kissing the ground, not praying. He was born there; his house was across the street from there, and he was a refugee returning to his home. The area was mostly Serbian before the war—mixed actually—and he had returned to see his ancestral land. It had been three, four, five years—as long as the whole siege lasted. I'd seen him from my car. I used a telephoto lens and started to shoot; I didn't want to disturb him and I had no idea how he would react to me. After that, I went up and talked to him. He was crying, both happy and sad, but tears of joy mostly. I had only taken one or two frames before putting away my camera—maybe I made a mistake, maybe I could have taken the photograph of my career there but I didn't want to disturb the moment for the man. When I sent the photo around the world, I gave it a title like "Bosnian kissing the ground." I didn't want to stir any trouble for him by putting his name with the photo—you never know.

Taking photos of the rest of it—the destruction, the killing—it's not so hard once you have the camera to your eye. The photo I am unfortunately best known for is of a man's body cut nearly in two after the infamous market bombing of August 1995. I had been sitting in a café, about two hundred yards away. I heard an explosion and everything started to shake. At first I was afraid to leave the café, so I just peeked out, brought my camera up to my eye, and walked straight ahead. That was the first time in my life that I set the camera to fully automatic operation, focus, f-stop, everthing. I didn't know what I was taking photos of until I developed the film. Afterwards, I was in a state of shock. It's possible that if I'd put the camera down I'd have gone mad.

It's as if you have a certain capacity for pain that fills and fills until you're beyond the point of feeling it. Those photos, that wash of blood on the asphalt; they're the most horrifying photos I ever took in my life. When I finally got back the film in all it's vivid color and detail, I was really horrified. Unfortunately, now I'm known for these terrifying photographs. I've been photographing for over twenty-five years now, and my whole career can be reduced to two photographs taken during the war: the couple getting married and the marketplace massacre—one worst and one best.

February 2000
Sarajevo, Bosnia and Herzegovina

"It wasn't until I saw my picture in [the *International Herald Tribune*] that it really hit me: we were in a war."

Danilo Krstanović
Overleaf left: *Oslobodjenje*, June 22, 1992
The front page of Sarajevo's daily newspaper features a photograph made by Krstanović of the paper's offices burning after an artillery attack.

Overleaf right: *International Herald Tribune*, May 28, 1992
Krstanović's photograph of the aftermath of the breadline massacre is published on the *Herald Tribune*'s front page the next day.

KB KREDITNA BANKA DD Sarajevo

OSLOBOĐENJE

Direktor
SALKO HASANEFENDIĆ

Glavni i odgovorni urednik
KEMAL KURSPAHIĆ

UREĐUJE REDAKCIJSKI KOLEGIJ

Ponedjeljak, 22. juni 1992.

Sarajevo Godina XLIX Broj 15807
Cijena 200 dinara

PREDSJEDNIŠTVO BOSNE I HERCEGOVINE

SVI U ODBRANU ZEMLJE!

Više se ne može čekati: agresori do sada ubili više od 40.000 ljudi, prisilili na raseljavanje milion i 400.000 stanovnika, a preko 60.000 odveli u koncentracione logore ● Odluka o proglašenju ratnog stanja u BiH u skladu sa pravom građana na individualnu i kolektivnu samoodbranu

S osmijehom do pobjede

Naredba o mobilizaciji

Na osnovu člana 8. Uredbe sa zakonskom snagom o odbrani, («Službeni list RBiH broj 4/92) na prijedlog Glavnog štaba oružanih snaga Republike Bosne i Hercegovine, Predsjedništvo Republike Bosne i Hercegovine na sjednici od 20. na 1992. godine, donijelo je

NAREDBU

o proglašenju opšte javne mobilizacije na teritoriji Republike Bosne i Hercegovine

Naređuje se opšta javna mobilizacija svih vojnih obveznika na teritoriji Republike Bosne i Hercegovine, starosti od 18 do 55 godina, koji su dužni da se sa vojnom opremom i ličnim naoružanjem odmah jave u najbližu jedinicu Teritorijalne odbrane.

II

Naređuje se opšta javna mobilizacija svih ostalih radno sposobnih građana Republike Bosne i Hercegovine, starosti od 18 do 65 godina (muškarci)

odnosno 18 do 55 godina (žene) da se bez odlaganja jave u jedinice civilne zaštite, koje će u skladu sa odredbama Uredbe sa zakonskom snagom o odbrani otpočeti sa izvršavanjem zadataka.

III

Naređuje se svim imaocima materijalnih sredstava koja podliježu popisu za potrebe odbrane, da sa sredstva bez odlaganja stave na raspolaganje najbližoj jedinici Teritorijalne odbrane, koja će se iskoristiti za potrebe izvršavanja bo'benih zadataka.

IV

Naređuje se svim javnim preduzećima zavođenje neprekidnog radnog obaveze, u cilju obezbjeđenja funkcionisanja života.

V

Naređuje se uvođenje radne obaveze u preduzećima, samostalnim zanatskim i drugim radnjama, koji u toku da obezbijede neprekidan rad i funkcionisanje i radno vrijeme od najmanje osam sati dnevno u skladu sa vlastitom odlukom.

situacijom koju nalaže ratno stanje.

VI

Za izvršavanje ove naredbe odgovoran je Komandant Teritorijalne odbrane Republike Bosne i Hercegovine, koji će preko organa Glavnog štaba i drugih nadležnih organa obezbijediti potpuno i odgovorno izvršenje ove naredbe.

VII

Svako nepoštivanje ove naredbe povlači krivičnu i drugu odgovornost u uslovima ratnog stanja, u skladu sa zakonom.

VIII

Ova naredba stupa na snagu danom donošenja, a objaviće se u »Službenom listu RBiH«.

PR Broj: 1200/92
20. juna 1992. godine
Sarajevo

PREDSJEDNIK
PREDSJEDNIŠTVA
REPUBLIKE BOSNE I
HERCEGOVINE
Alija Izetbegović

Polazeći od činjenice da je na Republiku Bosnu i Hercegovinu izvršena agresija od strane Republike Srbije, Republike Crne Gore, Jugoslovenske armije i terorista Srpske demokratske stranke,

— da je činjenica agresije utvrđena od strane Savjeta bezbjednosti Ujedinjenih nacija, Rezolucijom broj 752 od 18. maja 1992. godine,

— da se ta agresija nastavlja i nakon usvajanja pomenute Rezolucije Savjeta bezbjednosti,

— da je agresija praćena brutalnim genocidom nad narodom Bosne i Hercegovine, kao posljedica čega je do sada ubijeno preko 40 hiljada ljudi, prisilno raseljeno oko milion i 400 hiljada stanovnika, a njih preko 60 hiljada odvedeno u koncentracione logore,

— da je agresor organizovano nastavlja da razara civilne, privredne, vjerske i druge objekte,

— da je agresor okupirao oko 70 odsto teritorije države Bosne i Hercegovine i da odbija da obustavi agresiju,

— i polazeći od prava na odbranu koje je priznato međunarodnim zakonima.

Predsjedništvo Republike Bosne i Hercegovine, na osnovu amandmana 11. tačke 5. stav 3. na Ustav Republike Bosne i Hercegovine, na sjednici održanoj 20. juna 1992. godine, donijelo je

**ODLUKU
O PROGLAŠENJU
RATNOG STANJA**

1. Na teritoriji Republike Bosne i Hercegovine proglašava se ratno stanje.

2. Proglašavanje ratnog stanja ima za cilj da se, na osnovi prava građana na individualnu i kolektivnu samoodbranu, omogući efikasnije angažovanje svih ljudskih i materijalnih potencijala i domovini i inozem-

stvu radi njihovog stavljanja u funkciju oslobađanja Republike Bosne i Hercegovine od agresora, kao i radi uspostavljanja narušenog pravnog poretka i stvaranja uslova za povratak svih prognanih stanovnika Bosne i Hercegovine na njihova ognjišta,

3. Ovlašćuju se oružane snage Bosne i Hercegovine da preduzmu potrebne mjere na organizovanju opštenarodnog otpora radi ostvarivanja postavljenih ciljeva.

4. Republika Bosna i Hercegovina će se pridržavati odredaba međunarodnog prava i međunarodnih konvencija koje regulišu ponašanje država u ratnom stanju, te u skladu sa članom 51. Povelje Ujedinjenih nacija, uvažavati odluke i inicijative Savjeta bezbjednosti koje on donese radi uspostavljanja i održavanja međunarodnog mira i sigurnosti. Republika Bosna i Hercegovina će zajedno sa Savjetom bezbjednosti UN, Evropskom zajednicom i drugim međunarodnim institucijama nastaviti da traga za mirnim rješenjem sukoba u Bosni i Hercegovini putem pregovora koje će biti u skladu sa njenim dostojanstvom, nezavisnošću, integritetom i cjelovitošću. U tom pogledu ona ostaje otvorena za svim relevantnim inicijativama.

5. O ovoj odluci Predsjedništvo Republike Bosne i Hercegovine će obavijestiti Savjet bezbjednosti Ujedinjenih nacija.

6. Ova odluka stupa na snagu danom donošenja i objaviće se u »Službenom listu RBiH«.

PR. BROJ: 1201/92
Sarajevo
20. juna 1992. godine

PREDSJEDNIK
PREDSJEDNIŠTVA
REPUBLIKE
BOSNE I
HERCEGOVINE
Alija Izetbegović

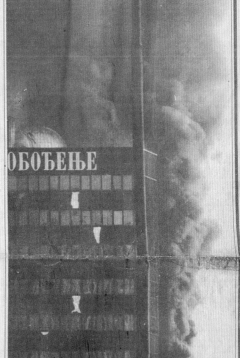

Vatra pod zaštitom granata

Evo kako je preksinoć izgledalo »Oslobođenje«. Naš foto – reporter Danilo Krstanović »zalegao« je na obližnjoj livadi, izlažući se snajperskoj baraži, i uspio dokumentirati jedan od dosad najvećih sarajevskih požara (uz onaj u Glavnoj pošti i onaj na UNIS-ovom neboderu na Marijin-dvoru).

Da podsjetimo još jednom, poslovni neboder »Oslobođenja« pogođen je prekjučer, nešto prije 17 sati, s nekoliko projektila iz pravca četničkih uporiš-

ta u Nedžarićima, Lukavici i rejonu Aerodroma. U toč ogromnim naporima našlh radnika kojima su priskočili u pomoć vatrogasci, uključujući i Profesionalnu brigadu, neboder je gotovo u potpunosti izgorio, a vatra je lokalizirana tek u ranim jutarnjim satima. Ipak, »Oslobođenje« izlazi i izlaziće i dalje – njučerašnji broj je bio samo nekoliko sati kon sto su novinari i grafi čari odložili šmrkove i dohvatili pisaće mašine i tipometre.

Akcija spašavanja »Oslobođenja« odnijela je, nažalost, jednu žrtvu: podmukli snajperist oborio je vatrogasca Aliju Adžamiju (brigada s Alipašinog polja) koji je ubrzo izdahnuo. Još jedan vatrogasac lakše je ozlijeđen u borbi sa stihijom.

Odlukom Kriznog štaba preuzima obavezu školovanja djece tragično poginulog vatrogasca Alije Adžamije.

3. strana

SAD I SUKOBI U BiH

Bejker prijeti novim pritiskom

Ako sankcije ne urode plodom, pribjeći će se nekoj vrsti multilateralnog pritiska, istakao američki državni sekretar

VAŠINGTON, 21. JUNA (ROJTER) — Američki državni sekretar Džejms Bejker izjavio je danas da ako sankcije ne urode plodom, nečemo isključiti mogućnost potrebe pribjegavanja nekoj vrsti multilateralnog pritiska, a potom optužili branitelje Bosne i Hercegovine

Bejker je pritom isključio jednostranu upotrebu američkih vojnih snaga.

Govoreći o sadašnjoj situaciji u Bosni i Hercegovini, šef američke diplomatije je izrazio umjereni pesimizam. Govoreći o UN su tek uvedene i mi ćemo nastaviti sa njihovim sprovođenjem, rekao je Bejker u intervjuu na

programu TV mreže El-Bi-Si. Međutim, dodao je on, ako sankcije ne urode plodom, nečemo isključiti mogućnost potrebe pribjegavanja nekoj vrsti multilateralnog pritiska.

Bejker je pritom isključio jednostranu upotrebu američkih vojnih snaga.

SAD ne mogu i neće biti svjetski policajac, ali to ne znači da moramo ostati potpuno po strani dok se zbiva taj pokolj, zaključio je Bejker.

zbog novog kršenja primirja i povlačenja osoblja UN zaduženog za humanitarnu pomoć u Sarajevu. On je dodao da u krvavi obračunu u tom regionu traju stotinama godina i da će biti veoma teško održati ih pod kontrolom.

Rat i mir

Gojko BERIĆ

Bosna i Hercegovina je i zvanično u ratu. Odluka njenog Predsjedništva da stvarnost konačno nazove pravim imenom za neke analitičare ovdašnjih zbivanja došla je kasno. Drugi, međutim, smatraju da za to nije izabran pravi trenutak, pošto svijet čini napore da uspostavi mir na ovim prostorima. Svaki stav može pri tom biti argumentovan i svako mišljenje može biti predmet sporenja, osim činjenice koja je iznad svih drugih činjenica: da je državi Herceg-Bosni onaj rat nametnut divljačkom agresijom velikosrpskog šovinizma.

Kome razumnom nije stalo do mira, do zaustavljanja ljudskih patnji i stradanja? Stvari su, na žalost, otišle suviše daleko, pa intelektualističko prizivanje pacifizma nema više nikakvog smisla. Nestati su i posljednje iluzije o tome da će će agresor prestati sa svojim zločinima, otići odakle je i došao i prepustiti se sopstvenoj moralnoj smrti. Njegova kapitulacija silom sada je jedini mogući ishod ovog rata. Mostar je najupečatljiviji dokaz kako samo snažan i hrabri otpor agresiji može postati metafora mira.

Ovdje su dugo, dobrim dijelom i problematičnim medijskim istrčavanjima, pothranjivane iluzije o tome da će čitavu stvar riješiti američki avioni. Svijet je, međutim, više volio da to učinimo mi sami. Indijski general Nambijar dočekan je u

Sarajevu gotovo udvorički. Ali čim je zapucalo, on je otišao u Beograd. Njegovi vojnici su projurili kroz Pofaliće u svojim bornim kolima, ne želeći da pomognu ranjenim civilima koju su nemoćno ležali na asfaltu. Doživjeli su zvižduk hrabrih teritorijalaca izloženih kiši metaka. Ništa tako ne može da razjari kao ljudska ravnodušnost!

Novo veliko razočarenje za Sarajlije je kanadski general Mekenzi. Njegovo čuvnoričko izjednačavanje krivice u pokušajima da se onemogući deblokada sarajevskog Aerodroma, stvara mnoge sumnje. Zapad nije savršen, i ne interesuju ga mnoge nijanse poput činjenice ko je prvi pucao. On možda na rasporedu će mu se ovdje zapravo radi, VII general bi svakako morao da zna da rafal koji je iz automata ispalio neki teritorijalac nije isto što i neprekidno bombardovanje Sarajeva teškim artiljerijskim udaranjem. Pristrasnost je nešto drugo?

Bosanci i Hercegovci čeznu u ovom trenutku za mirom i slobodom više nego za bilo čim drugim. Iz akta o novokomponovana vlastfraktiki teži prekidu rata. Tome će se prije ili kasnije morati pregovorati. Ali, ni najveći pacifista ne bi sebi mogao dozvoliti moralni luksuz da o tome pregovara sa ljudima za potjernice, raspisane za Karadžićem i kompanijom. Morbidni masovni zločini nad Muslimanima u ime projekta velikosrpskog carstva, unaprijed oduzimaju politički i ljudski legitimitet svakome ko bi pristao da je jedna strana kojoj se bori i kojoj pristaju na cijenu razgovorima od 18. da će se upoznati svijet o tome ko se ne slaže i ne prihvata utjete.

Kao drugo, u protestu za čitanja je i pitanje zašto je ekip UNPOFOR-a uvijete agresora privatila svoju ulogu, slijepo vjerujći agresorskoj četničkoj vojsci koja u BiH predstavlja paravojnu organizaciju nepostojeće dŕžave i

što UNPROFOR toliko vjeruje četničkoj vojsci, koja u BiH predstavlja paravojnu formaciju države koja ne postoji

SARAJEVO, 21. JUNA (BH PRESS) — Ministar odbrane Bosne i Hercegovine Jerko Doko uputio je danas novi protest generalu Mekenziju, pukovniku Vilsonu i Organizaciji ujedinjenih nacija. Protest se odnosi na nepoštivanje ugovorene obaveze da se danas od strane UNPROFOR-a izvrši kontrola lokacija stacioniranih agresorskog ar tiljerije.

Ministar Doko izražava svoje uvjerenje da je to etnička strana namjerno onerogućila, budući da joj nije u interesu otvaranje Aerodroma za saobraćaj, kao ni mir u BiH.

Prva činjenica zbog koje je ekipa UNPROFOR-a i protestirala je što je upozorena na neophodnost da se na polukružniku od 20 kilometra od Aerodroma, prista na agresorske uvjete, potcrtavajući razgovorima od 18. da će se upoznati svijet o tome ko se ne slaže i ne prihvata utjete.

Kao drugo, u protestu za čitanja je i pitanje zašto je ekip UNPOFOR-a uvijete agresora privatila svoju ulogu, slijepo vjerujći agresorskoj četničkoj vojsci koja u BiH predstavlja paravojnu organizaciju nepostojeće države.

Treće, a takođe pitanje za-

NOVI PROTEST JERKA DOKE GENERALU MEKENZIJU I UJEDINJENIM NACIJAMA

Kome služi UNPROFOR?

Zaista je neshvatljivo zašto UNPROFOR toliko vjeruje četničkoj vojsci, koja u BiH predstavlja paravojnu formaciju države koja ne postoji

što UNPROFOR prešoto boravi u vojsku te nepostojeće države u okupiranim kasarnama koje su vlasništvo BiH?

Kao četvrto, ministar Doko, u protestu pita zašto UNPROFOR ne kaže svoju istinu da je agresor južno od Zvornika odveo 38 vozila humanitarne pomoći, a istodobno general Mekenzi traži od Predsjedništva BiH da uvozila prate. Međutim, kako kaže Doko, većina tih vozila je u Lukavici zbog što se jednostrano označava UN četnički ubaciju na određena područja kako bi se prije 18. ovoj mjesta na zračni prostor nezavisne Bosne i Hercegovine vršili ratno vazduhoplovstvo uzgori avion u borbeno izvidanje iz pravca Banjaluke — Zenica — Konjic.

Peto je pitanje UNPROFOR — zašto mijenja često marširute kretanja, kao i brojnost vozila i ljudstva u kolonama i pokrete najavljuje neposredno prije polaska. Time se udovoljava četničkoj strani od pod svaku cijenu izražive eksces, a potom optu tuž branitelje Bosne i Hercegovine.

Šesta tačka u protestu se i čitanja da je danas u 10.10 sati ratno vazduhoplovstvo uzgori nepripaznija na zračni prostor nezavisne Bosne i Hercegovine vršio avion u borbeno izvidanje iz pravca Banjaluke — Zenica — Konjic.

The Global Newspaper
Edited and Published
in Paris

Printed simultaneously in Paris,
London, Zurich, Hong Kong,
Singapore, The Hague, Marseille,
New York, Rome, Tokyo, Frankfurt.

Herald

INTERNATIONAL

Published With The New York Times and The Washington Post

No. 33,979 22/92 **R PARIS, THURSDAY, MAY 28, 1992 ESTABLISHED 1887

West Floods Iraq With Counterfeit Currencies

Goal Is to Undermine Economy, Destabilizing Saddam's Government

By Youssef M. Ibrahim
New York Times Service

AMMAN, Jordan — Iraq's economy is the target of an American-led destabilization campaign that has poured vast amounts of counterfeit currency into the country, Arab and Western officials here say.

The fake dinar notes are being smuggled across the Jordanian, Saudi, Turkish and Iranian borders in an effort to undermine the Iraqi economy, according to the officials here, who closely monitor the situation in Iraq.

The officials said counterfeit U.S. dollars were being smuggled into Iraq in smaller quantities to further confound the banking system. The officials said the countries behind the separate counterfeiting operations included Western nations, Saudi Arabia, Iran and Israel.

The fake currency is openly discussed in the press and by the Iraqi people. The counterfeiting problem has become serious enough to be loudly denounced by the government, which is

The Arabs want to ease Iraqi hardships from sanctions, the Arab League head says. Page 4.

taking measures to curb it, including instituting life sentences for cooperating in circulating counterfeit dollars or dinars and death sentences for those who smuggle them into the country.

The fake currency has contributed to Iraq's severe inflation problem, which is aggravated by the fact that the Iraqi government is printing large amounts of money to pay inflated salaries and cover the costs of reconstruction after the Gulf War.

In the last few months, the destabilization efforts seem to have shifted into high gear, officials in Amman say, particularly after the United States was reported in February to have authorized full-fledged covert operations against Iraq.

In Washington, a spokesman for the Central Intelligence Agency, Mark Mansfield, declined to discuss the dumping of fake currency in Iraq. "As a matter of policy we don't comment on such allegations," he said.

Along with international economic sanctions against Iraq, the covert measures have had mixed results since the Gulf War ended in February 1991. They have clearly helped weaken the economy to the point where the local currency could become worthless, and they have loosened President Saddam Hussein's grip on the people and forced his government to respond with a stepped up reconstruction program to curtail shortages and restore basic services.

The measures also buttressed the assertion, shared by a rising number of Iraqi nationalists including Sunni Muslims and Christians, that the West and its allies will not be content with the removal of Mr. Saddam, but only with partitioning and destroying the country.

Further weakening the economy is the fact that legitimate Iraqi currency is not backed by any gold or hard currency because those are being used to import goods.

As a result, the dinar, which has a fixed rate of exchange equivalent to $3, has a real value of about 2 percent of that, or 5 to 6 cents.

Some Iraqi travelers interviewed in Amman, including businessmen, said they expected the currency value to plunge much farther soon.

Since Iraq stopped doing business with Britain during the Gulf crisis and began printing its own money on lower-quality paper, counterfeiting has become much easier, sources said.

"People joke about it, and some have become experts in telling which denominations are

See IRAQ, Page 4

Victims' shoes and other belongings lying scattered amid broken glass at the scene of mortar attack in Sarajevo on Wednesday.
Danilo Krstanovic/Reuters

EC Puts Trade Ban On Serbia and Ally

Mortar Attack Kills 17 in Sarajevo Mall

By John F. Burns
New York Times Service

BELGRADE — At least 17 people were killed and dozens of others wounded Wednesday in a mortar attack on a pedestrian mall in Sarajevo, the capital of Bosnia-Herzegovina.

It was the worst attack on civilians since fighting began in Sarajevo two months ago, and it came as Western powers were preparing to impose economic sanctions on Serbia for its role in the killing and destruction in the former Yugoslav republic.

[Peace talks in Lisbon between Bosnia-Herzegovina's ethnic groups collapsed after the attack, The Associated Press reported from the Portuguese capital.

[The European Community mediator, José Cutileiro, said the talks broke down after the Muslim delegation said they could no longer search for a political solution while the bloodshed continued.

[Mr. Cutileiro had been meeting for five days with Serb, Croat and Muslim delegations.]

Although all sides in the Sarajevo fighting have attacked civilians, several factors indicated that the incident on Wednesday, in which three mortar shells fell near a line of Serbs, Croats and Muslim Slavs waiting to buy bread, was launched by irregular Serbian units in hills south of the city.

Among these factors was the reaction of the senior Serbian officer representing the Serb-controlled Yugoslav Army in Sarajevo, who implied that he blamed units of the newly formed army of Bosnia-Herzegovina's Serbian minority for the attack.

The attack, at midmorning, left a scene of carnage exceeding any previously inflicted on the central Sarajevo district, which has repeatedly been hit by mortar, artillery, and rocket fire. Television pictures showed bodies lying near a covered market a few blocks from the riverfront site where Gavrilo Princip, a Serbian nationalist, assassinated Archduke Ferdinand of Austria in 1914, setting in train the events that led to World War I.

The television shots showed people with massive wounds, some with severed limbs, waiting for assistance that was delayed when ambulance crews trying to reach the scene came under sniper fire.

The attack followed weeks of warfare in which Serbian fighters, like their Croat and Muslim Slav opponents but in a more widespread manner, have mounted attacks on civilian populations and on relief convoys, fostering international momentum for Serbia's economic and diplomatic isolation.

About 12 hours before the mortar attack, shells, again apparently originating from the

See ATTACK, Page 4

But an Oil Ban Is Put Off Until Action by UN

By Alan Riding
New York Times Service

PARIS — European Community governments voted Wednesday to impose a trade embargo on Serbia and Montenegro, and they called on the United Nations to include oil in its embargo against the two republics.

The hope is to force an end to Serbian intervention in Bosnia-Herzegovina.

Their move came just three days after they were publicly admonished by Secretary of State James A. Baker 3d for moving slowly to tackle what he called the "humanitarian nightmare" gripping Bosnia since it declared its independence from Belgrade.

The Community decision, reached after a daylong meeting of representatives at its Brussels headquarters, has still be endorsed by foreign ministers. But this is considered a formality, European diplomats said the embargo should come into force on Monday.

Embarrassed by American criticism of its failure to broker a political settlement in Yugoslavia, the Community was evidently eager to act before the United Nations Security Council.

Council members are themselves expected to impose a trade embargo on Serbia and Montenegro later this week.

The Community nonetheless decided against including an oil boycott in its own trade embargo on the grounds that it would have little effect since West European countries — Greece and Britain — account for only 11 percent of oil imports by Serbia and Montenegro.

Community officials argued that only a global oil boycott ordered by the Security Council could cut Serbia and Montenegro off from its main suppliers: Russia and China each provide 22 percent of their oil, Romania 15 percent and Iran 13 percent.

The Community decision to seek such a boycott was backed by Britain, France and Belgium, who are also Security Council members.

At the United Nations, diplomats said that Council members had until now been leaning towards imposing a two-stage trade embargo, with an oil boycott left for a later resolution, in part to satisfy Russia and China.

But they said the Community's move would strengthen the hand of governments, notably the United States, that favored including an immediate oil ban.

The EC sanctions cover two-way trade with Serbia and Montenegro, which at present send over half their exports to EC countries and import 45 percent of their goods from the Twelve.

A Community study said a trade embargo would have an "important impact" on the two

See SANCTIONS, Page 4

Bush and Clinton Both Hope Perot Will Hurt the Other Guy More

By Dan Balz
and Ann Devroy
Washington Post Service

WASHINGTON — At a moment when they might be savoring the successful end of a long and difficult primary season, campaign advisers to President George Bush and Governor Bill Clinton are scrambling to find the silver lining in the spring thunderstorm known as Ross Perot.

The sudden emergence of Mr. Perot as a serious presidential contender has prompted Mr. Bush and Mr. Clinton to adapt their messages and re-evaluate their electoral strategies while hoping the Texas billionaire's likely candidacy either fades as the summer goes on or hurts the other guy more. But it is the Republicans who sound more alarmed at the moment.

"We've got 40 options here on what to do, four competing power centers and no consensus," a senior White House official said. "The

Even off ballot, Perot makes a mark. Page 3.

only thing I can say is, Thank God it's not August yet."

Mr. Clinton's campaign is preparing to steal a page from Mr. Perot's campaign book by using new technologies to beam their candidate directly into voters' homes, but for now both sides are spending their time analyzing Mr. Perot's appeal — the Democrats by looking at all available polls and the Bush campaign by conducting focus groups with voters that have turned up disturbing news for the president.

The focus groups, conducted in five cities since late April with voters who supported Mr. Bush in 1988 but are now wavering, found that a majority interviewed now support Mr. Perot. According to sources, that is in part because of resentment against Mr. Bush for caring more about overseas concerns than those at home, despite seven months of White House efforts to dispel it.

Mr. Perot's independent candidacy and a three-way race upends conventional assumptions about the electoral map.

For Mr. Clinton, the danger is that Mr. Perot's particular appeal in the West will rob the Democrats of such states as California, Oregon and Washington, without which Mr. Clinton probably cannot win the White House.

For Mr. Bush, the fear is that Mr. Perot will undercut the traditional Republican advantage in the electoral college based on the South, where swing voters might defect from the Republicans to his candidacy, and the Democrats have a base that Mr. Clinton could exploit and carry states that have belonged to the Republicans.

Bush advisers are examining three possible scenarios for the general election: a three-way race or two-way contests with Mr. Clinton or with Mr. Perot as their main opponent. Both camps believe Mr. Perot's popularity will decline, but there are doubters inside both campaigns. Most say the outlines of the election will not become clear until the fall.

A major threat to Mr. Clinton is that Mr. Perot's candidacy cuts to the core of the Arkansas governor's presumed appeal as an outsider who will shake up the Washington establishment.

But Paul Tully, political director of the Democratic National Committee, said the advantage for Mr. Clinton over the longer term was that the people most attracted to Mr. Perot,

See PEROT, Page 4

Weimar Mystery: Art Treasure Underfoot?

By Stephen Kinzer
New York Times Service

WEIMAR, Germany — From the surface, nothing about Karl-Marx-Platz in this historic town seems remarkable. It is a broad, rectangular plaza, flanked by two long concrete office blocks built during the Nazi period.

There is growing evidence, however, that Karl-Marx-Platz, earlier known as Adolf-Hitler-Platz, conceals one of the great remaining secrets of World War II.

Experts believe a trove of art stolen by the Nazis, including at least part of the legendary Amber Chamber, may be in a labyrinth of bunkers.

"Many people, myself included, are now convinced that something is down there, possibly the Amber Chamber," said Joachim Vogel, a city spokesman. "The evidence is becoming stronger and stronger."

Since German reunification in 1990, historians and researchers have been free to work in what was East Germany, where the Nazi art collection disappeared.

An American treasure-hunting and geological survey company, Global Explorations of Gainesville, Florida, wants to conduct the potentially expensive underground search, and has offered to

Detail from a wall panel of the missing Amber Chamber, an 18th century gift to Russia.
Hergen East and Europe Photo

undertake all costs in exchange for television and magazine-feature rights.

The president of Global Explorations, Norman Scott, hopes to complete talks with the state govern-

ment of Thuringia in time to open the bunkers this summer.

In a telephone interview, Mr. Scott described evidence pointing to buried art treasure in Weimar.

The art that disappeared in or around Weimar half a century ago was assembled by Erich Koch, the gauleiter of East Prussia and territory occupied by the Nazis.

He looted museums and private collections across Central Europe as the German Army advanced, assembling the booty in the Baltic port of Königsberg. That city was overrun by the Russians and renamed Kaliningrad at the end of World War II.

The Koch collection was never fully catalogued so it is not known which artists are included. The most valuable art in the collection was the Amber Chamber, considered one of the supreme baroque and rococo masterpieces.

King Frederick I of Prussia conceived the Amber Chamber in 1701 as a gift to the Russian royal family, appropriate to seal an alliance.

It was a full-sized room made entirely of amber, including 22 wall panels, intricate bas-reliefs, busts, figures, monograms, coats-of-arms, candelabra, mirrors and inlaid decorations depicting Tuscan

See CHAMBER, Page 4

Red Tape Harms Trade, U.S. Aide Warns Russia

By Fred Hiatt
Washington Post Service

MOSCOW — Deputy Secretary of State Lawrence S. Eagleburger, in a speech delivered in the Kremlin, warned Russian authorities and business interests Wednesday night that U.S. investment in the former Soviet Union was still "severely, if not fatally, hampered" by bureaucratic restrictions and uncertainties.

Mr. Eagleburger, speaking to the Trade and Economic Council of American and Russian businessmen, said the United States was determined to build a "lasting partnership" with the nations of the former Soviet Union as they moved toward democracy and capitalism.

"We need you to succeed," said Mr. Eagleburger, who is the State Department's second-ranking official. "We want you to prosper."

But he cautioned that Americans could not be forced to invest in their country and were unlikely to do so if the business climate did not improve.

"In the short time I have been in Moscow, I must say that virtually all the American businessmen I have seen have told me that their ability to contribute as partners to economic recovery here is severely, if not fatally, hampered by regulatory and fiscal practices they are encountering at all levels of government," he said.

Among the hindrances to investment, Mr. Eagleburger cited constantly shifting and confusing laws and regulations; huge increases in tax rates for foreigners and foreign companies; uncertainty about who owns what and who controls Russia's vast natural resources, with various levels of

government competing for the wealth; and the former Soviet Union's $190 million debt to American companies.

"They cannot do business when, for example, a sudden tax increase wipes out the anticipated profit on a previously negotiated project," Mr. Eagleburger said. "They cannot do business when they are faced with a bureaucracy as yet unable to deal expeditiously and authoritatively with them."

He added that American business exec-

> **'We need you to succeed. We want you to prosper.'**
>
> Lawrence S. Eagleburger, deputy secretary of state

utives would, "in fact, go elsewhere if they must."

Mr. Eagleburger's speech, in the Kremlin Palace of Congresses, was not open to reporters, but U.S. officials made a copy of the speech available.

President Boris N. Yeltsin has promised Russia and the West that he will destroy the old command economy of the Soviet Union and allow Russia to move to a free market. But he faces powerful opposition from entrenched bureaucracies, from local and regional leaders who have seized authority ceded by Moscow and from ordinary people dismayed by rising prices and

See WARNING, Page 4

Winner Take All? Lottery Millionaire Busted in L.A.

Los Angeles Times Service

LOS ANGELES — A man who won $3 million in the California Lottery has been charged with receiving a cache of stolen loot — including five vacuum cleaners — from the rioting last month in Los Angeles.

Sergio Hernandez, 28, who receives $120,000 a year from his 1989 lottery jackpot, faces a felony charge — and a likely one-year jail term — for using

his home to store goods allegedly looted by his brother, county prosecutors said.

"His brother had a bunch of the loot and had to move it, so he said, 'Hey bring it over to my place,'" a deputy district attorney, David Ross, said Tuesday.

"Apparently, it's a very nice place."

Los Angeles County sheriff's deputies received a tip that Mr. Hernandez was stashing riot booty and

raided his home, Mr. Ross said, discovering the five vacuums along with a video camcorder, compact disc player, "a couple of cellular telephones and some clothes."

Mr. Hernandez was released on $5,000 bond on a single charge of receiving stolen property.

His brother, Martin Hernandez, 24, was charged both with receiving stolen property and with robbery, for allegedly joining in the looting of two stores, Mr. Ross said. Bail was set at $5,000.

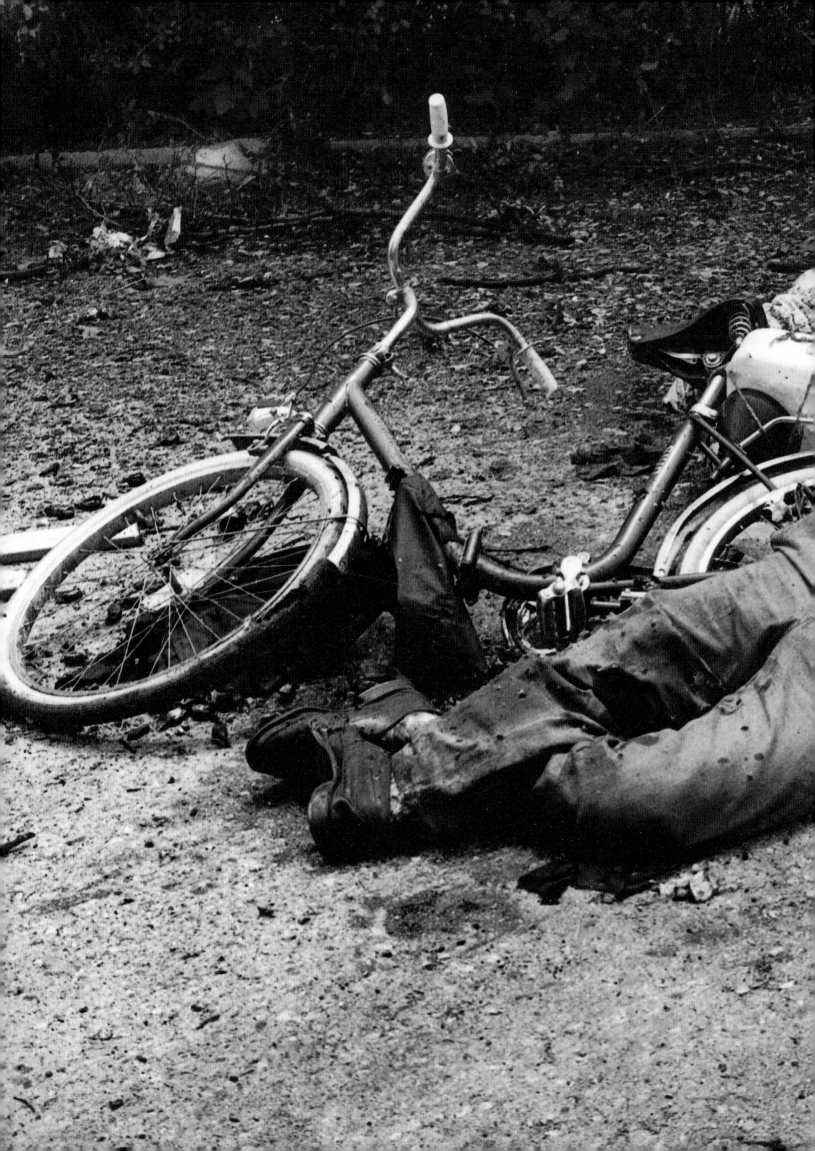

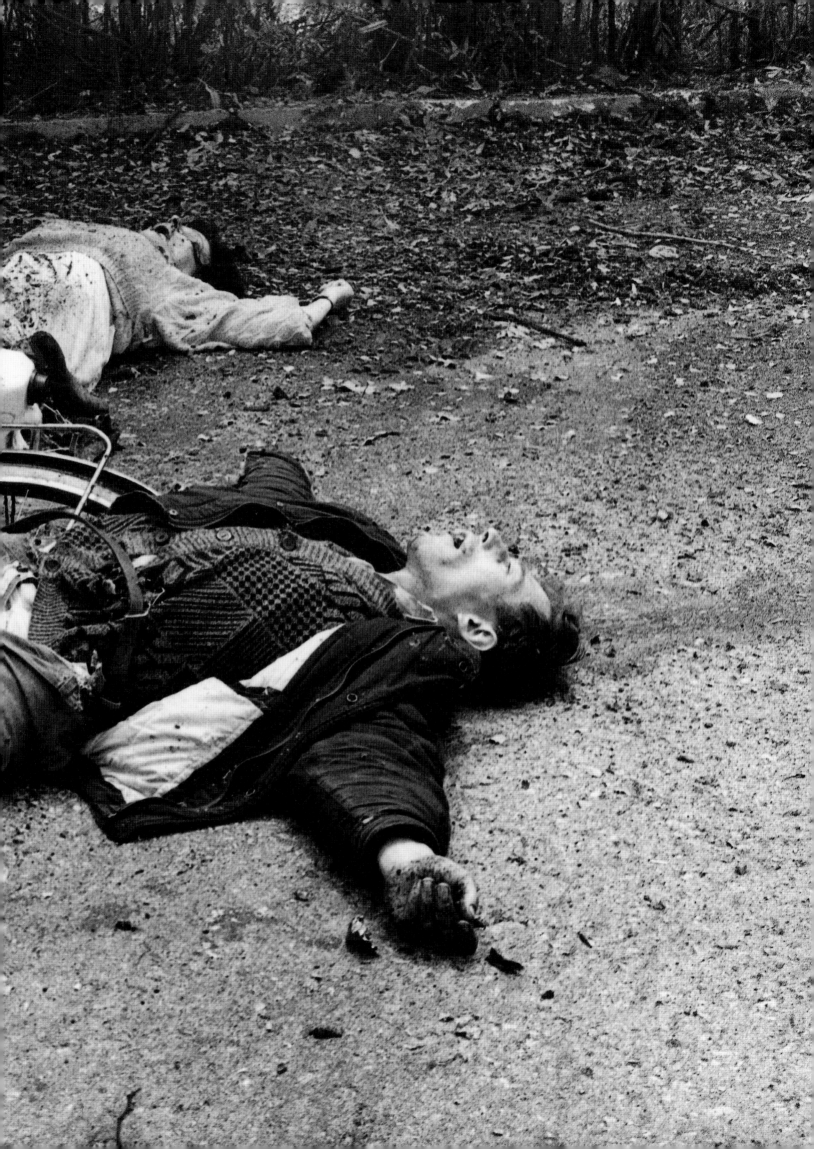

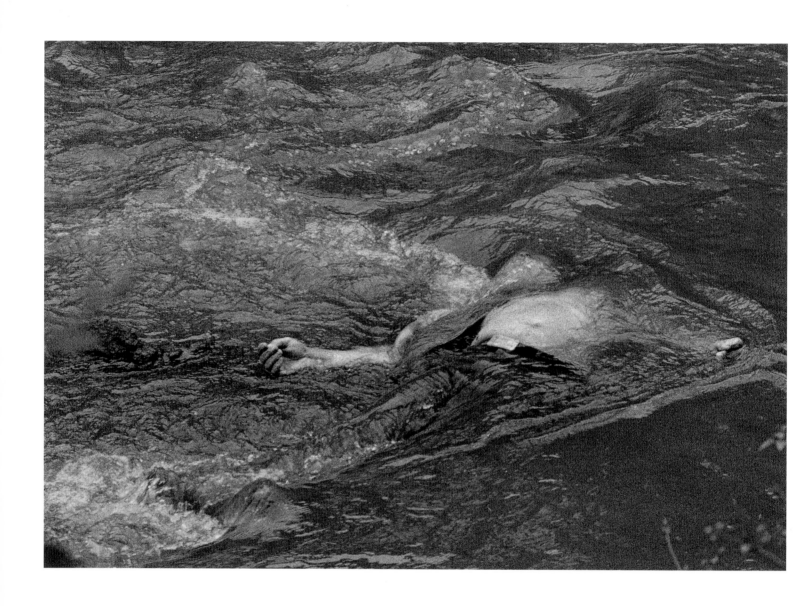

Danilo Krstanović
Previous page: A couple killed on their bicycle
Sarajevo, Spring 1992

Above: Miljacka River
Sarajevo, Spring 1992

Opposite, top: Sarajevo's Zetra sports stadium on fire after
an artillery attack, Summer 1992
Opposite, bottom: Soccer practice at the newly repaired
Zetra stadium, Summer 1999

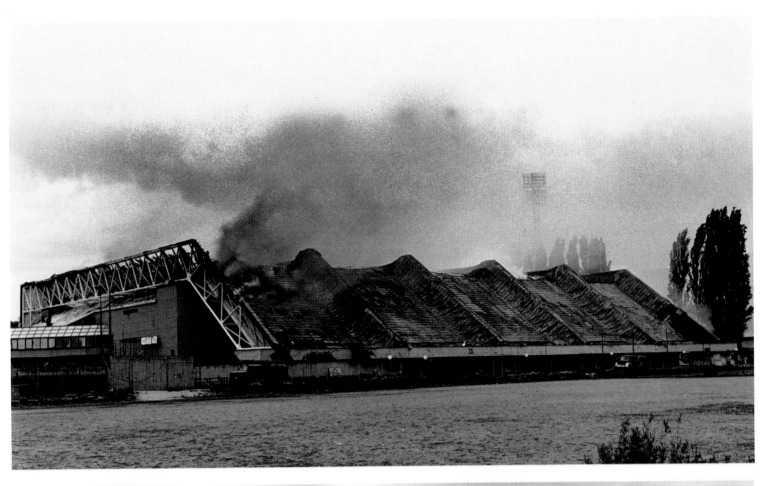

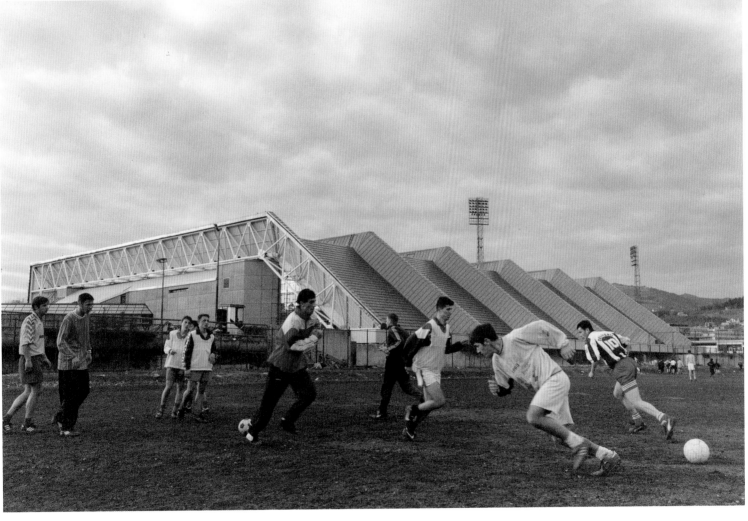

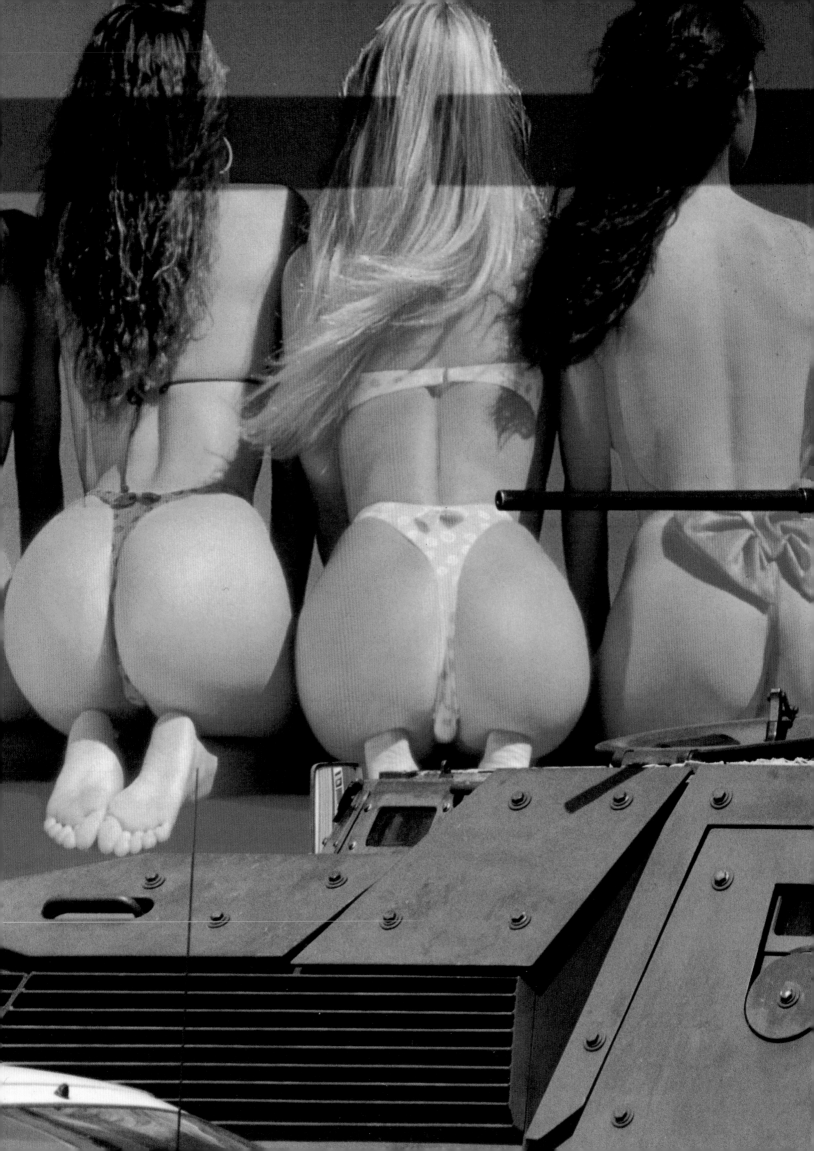

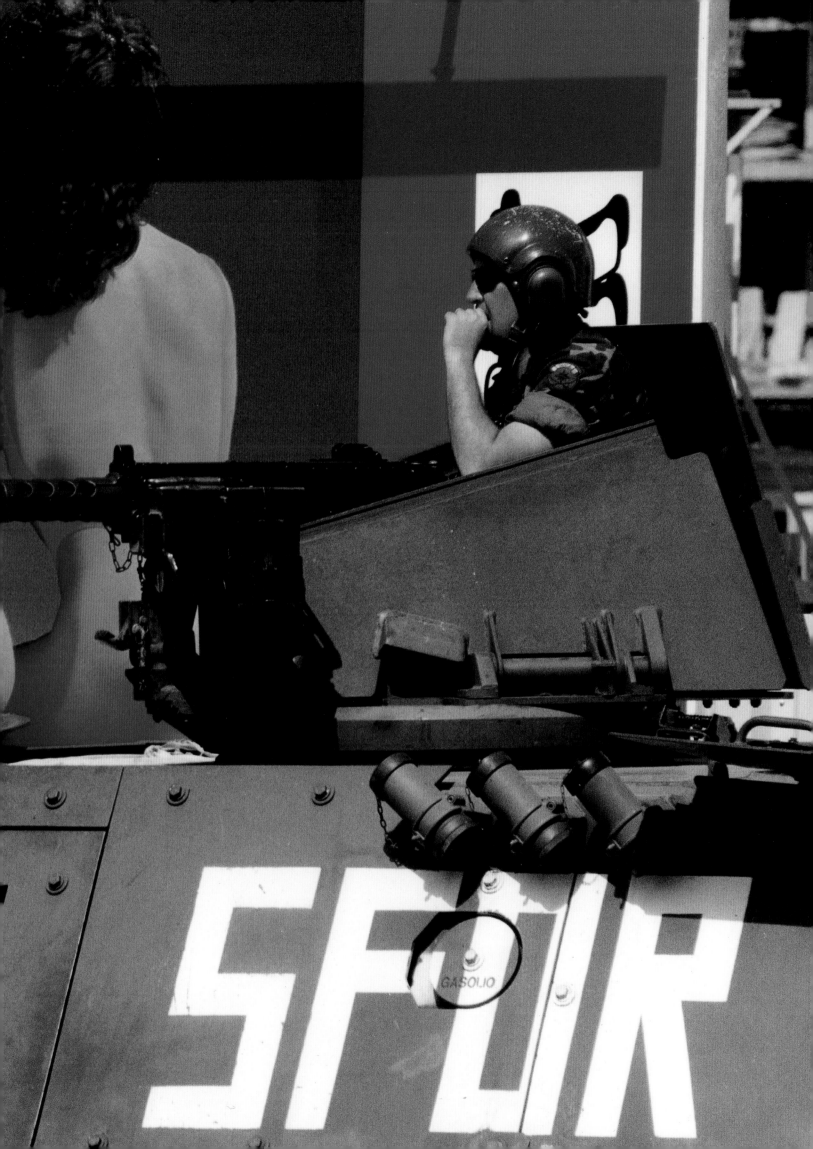

"I tried to capture a balance all the time.... In some of my photos, life goes on, while in others, a woman lies in a pool of blood. I wanted to show that there is love in this city, not just grenades and hospitals."

Danilo Krstanović
Previous page: NATO troops parked in front of an advertisement for suntan lotion, Sarajevo, Summer 1998

Opposite: A young couple on their wedding day, walking down a street protected by a sniper screen
Sarajevo, Summer 1994

Overleaf: Misuča, near Sarajevo, 1996

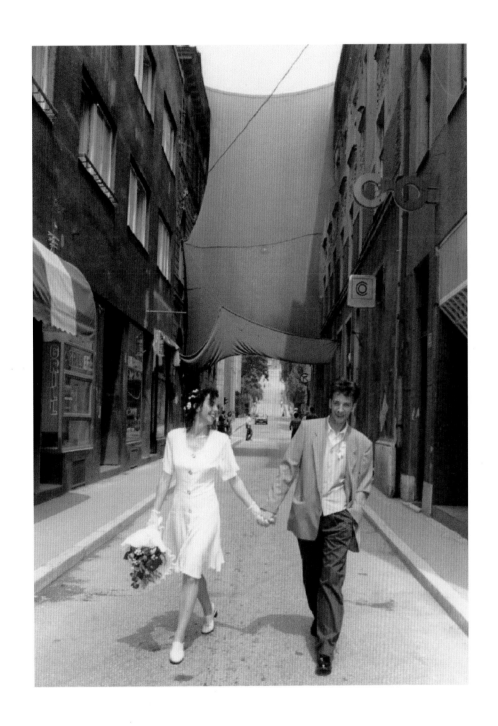

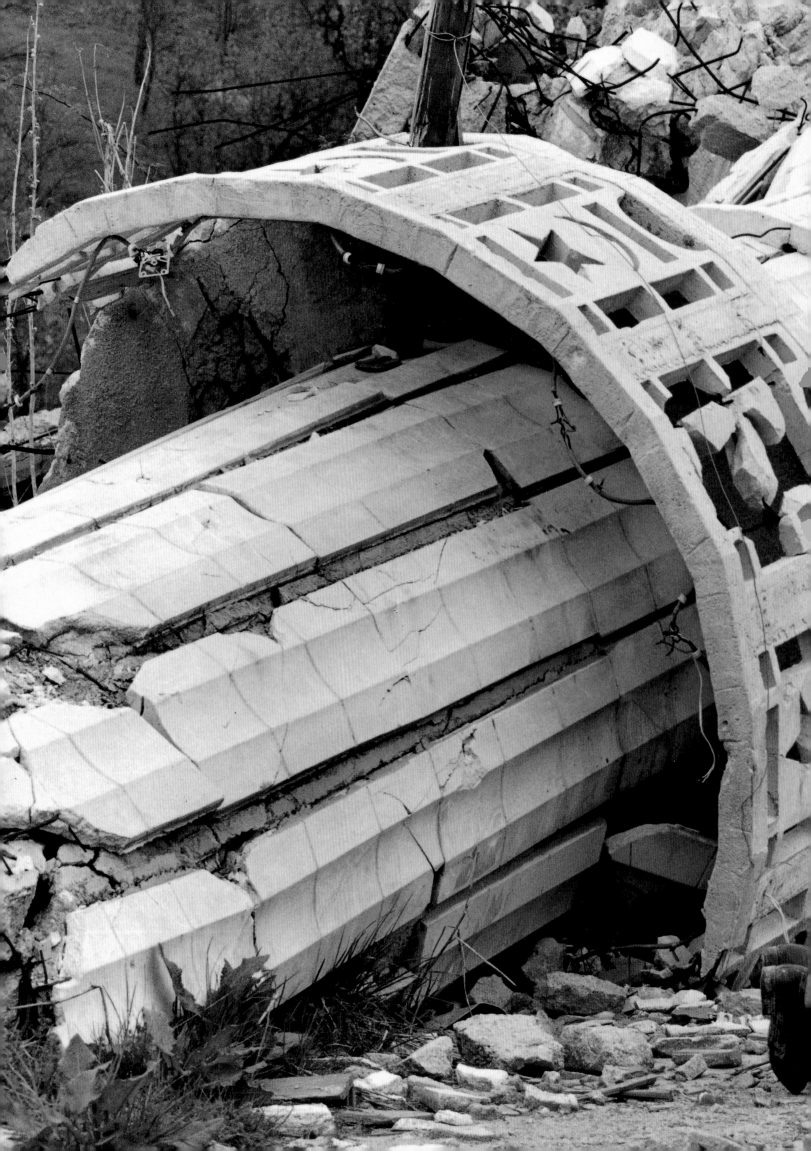

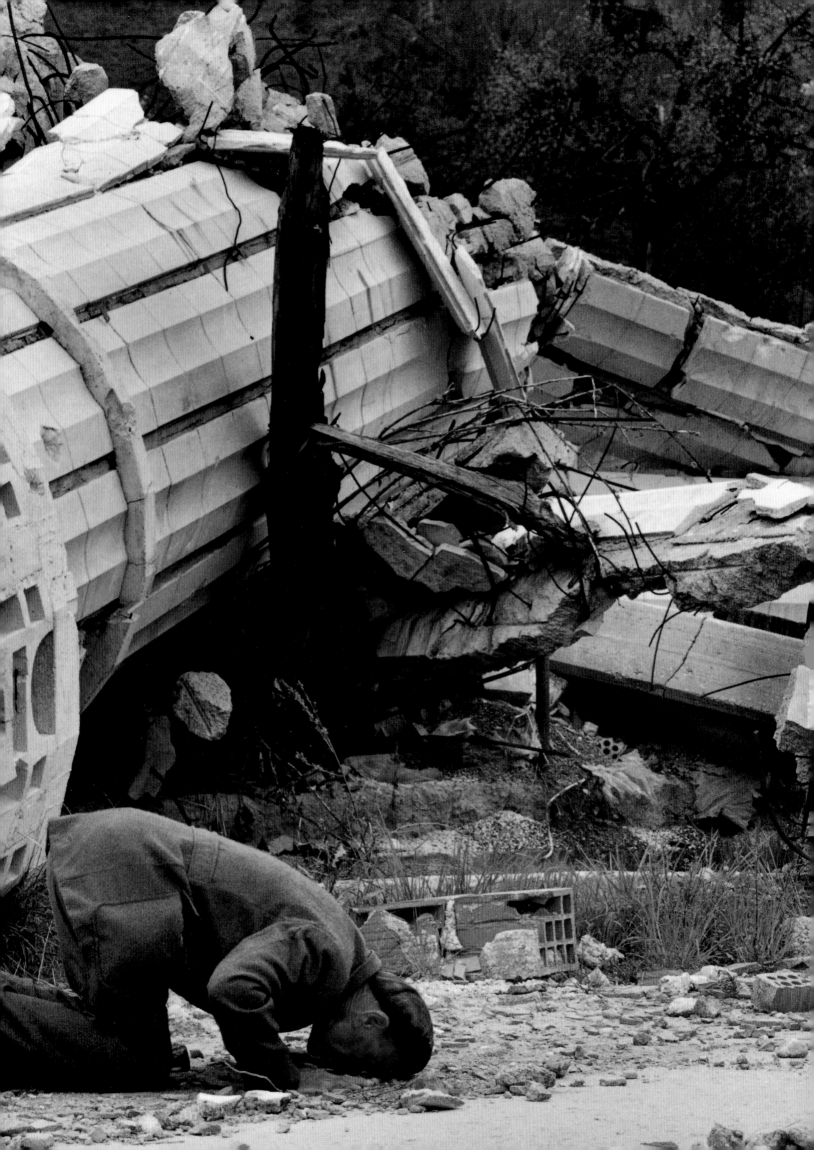

On the Skenderija Bridge, Sarajevo, February 2000

Dejan Vekić
b. Sarajevo, Bosnia and Herzegovina, 1971

Vekić began studying graphic design at Sarajevo's Academy of Fine Arts in 1990, while working part-time at a photography studio. When the war began in Bosnia in 1992, he went back to the studio to collect his belongings and discovered that the space had been taken over by the State Commission for Getting Facts on War Crimes. The commission offered him a job documenting the destruction of Sarajevo. In 1993, five hundred of his pictures were sent to The Hague where the United Nations has established an International Criminal Tribunal to prosecute war crimes in the former Yugoslavia. When the war ended in 1995, Vekić began teaching photography at the art school he once attended. In 1998 he and Damir Šagolj set up a commercial photography studio. He continues to live and work in Sarajevo today.

Dejan Vekić

I first became interested in photography as a student at the School for Applied Arts in Sarajevo. When I was sixteen or seventeen, I decided to visit this private photo studio. The owner, Goran Kukić, took a look at some of my photographs and told me I could help him out as an assistant. He did commercial photography—still does, though he lives in Belgrade now. I did all sorts of things for him. I helped him on his shoots, developed the film, did his printing. Working with Goran was my first real professional experience with a photographer. I bought my first camera, the Zenit, in Moscow around that time. It was unbelievably cheap there.

I was in my second year at the Academy of Fine Arts when war broke out. I didn't realize that everything around me was turning into a war zone until the day the shells actually started to fall. I remember I was doing some silly job for the Olympic museum—making stained glass or something with Damir Šagolj.

The war changed my photography. During the war, my work became something completely different. I worked for the State Commission for Getting Facts on War Crimes. Even when I had finished with their assignments, I would walk through the towns on foot, from one side of town to another, photographing. I had this feeling that I must take photographs of what I was seeing.

I started working for the commission by sheer chance. I went to Goran's to pick up some of my stuff, about a month after the war had begun. Some guys from the commission were there, and they had taken over the studio, turned it into their base of operation. They asked me who I was, and I told them that I worked there. Then they asked me if I'd want to work for them. They told me that I could either take the job, or go into the army and pick up a gun. Everyone was conscripted. You had to be involved in the defense of the city somehow. Working for them sounded like the better deal to me, so I took the job. I got a little bit of money for it—but mostly we were paid in cigarettes or packages of food. One perk was that one way or another they were always able to find film and chemicals. I mean, you never knew what kind of film you might get, including

old stock. It was a surprise everyday. We shot film dating back to 1972—and believe it or not, it was pretty good!

The photos we were taking were meant to be evidence of the crimes committed by the people from the hills surrounding Sarajevo. They were the ones shelling the city, destroying buildings and everything. They sent some of my photos to The Hague. For the first three years of the war, we shot pretty randomly. They always gave us our assignments, but we mainly just went through town shooting whatever we saw. We didn't have a car, so we were pretty much stuck there. We weren't like the foreign press people who were always at the right place at the right time.

I worked with Damir and others who shot both photos and videos. We put together a few exhibits and lots of presentations of the work we did at that time, at places like the Bosnian Cultural Center or the Holiday Inn. At the beginning of the war, you know, a lot of people came saying, "We're friends from so-and-so eastern country." From Turkey or somewhere. "We must take these photographs and show them to people outside so they know what's going on." So we'd make them a bunch of photographs, they'd take them and leave. I have no idea what ever became of those pictures.

I always made a mental distinction between photos I took on assignment (color work), and work I did for personal reasons (mostly black and white). There were too many awful things I had to photograph for the commission. I felt like I really needed to be doing other types of work for the sake of balance. And in working for the Commission, I didn't just shoot photos, I also put investigators in touch with other photographers.

I got to know a lot of the foreign photographers in Sarajevo. I thought they were crazy to be here, but they were just doing their job and trying to do it well. And it's natural that the local people wouldn't like them. The foreign photographers would hang out in bunches, waiting for something to happen—something bad to happen. They had all the best equipment, best resources—always in the middle of the action. I made friends with a few of them, even though I thought that to have come all this way and put their lives in danger

for their careers was a little insane. You could get killed so easily.

It's hard to compare what they were doing with what we were doing, though. They were producing a different type of photography. Our photographs were about evidence. We'd basically shoot the aftermath—at the mortuary or the hospital. I took portraits of witnesses, you know. Portraits of wounded people. Dead people. Demolished buildings. These were not things the foreign photographers were interested in.

My own work from that time was more about trying to capture the eerie atmosphere of the city. It was a ghost city, you know, with nobody on the streets. I was trying to find a sort of calm in the midst of the chaos, to balance out what I was shooting for the commission. Sometimes I would have two cameras with me, one loaded with color for the commission, one with black and white for myself.

Goran's old studio basically became the commission's office. He had pretty good equipment there, even though it was all handmade. He had processors, enlargers, everything we needed. We found some material left over in the old JNA (Yugoslav National Army) barracks. We got water everyday from a truck that had originally been used to clean the streets. We mixed most the chemicals from scratch, using recipes from books. We were really good at black-and-white film processing and printing. The color was a little trickier. We had to invent all sorts of chemicals and developers. I've forgotten all those things already. But it was really interesting and a really good experience. We were always experimenting.

The place didn't look like much—the top floors were completely destroyed, but downstairs it was okay. We were lucky the studio was in the basement. A few times the building was attacked and some people were wounded or killed. One bomb fell right inside one of the windows upstairs. The building is pretty strong, though.

It was hard to be here sometimes, to keep taking photographs. Every time I thought about quitting, though, I reminded myself that it was still better than carrying a gun and being on the front lines. Of course, as it was, I was still a target. But at least I wasn't in the trenches. I think about leaving Sarajevo altogether sometimes. But I've started something here, and usually, I want to finish the things I start. It wouldn't be hard to leave, but it's tough to begin somewhere else. And things can change really fast. Who knows how much longer before things get better.

When I look back at the photographs from that time, to be honest, I have no special feeling. They're a part of my life that I'm trying to forget. All of my negatives were destroyed after the war, unfortunately. They burned in a fire caused by an electric heater in 1995 or maybe the beginning of 1996. I had a few negatives stored elsewhere but they're mostly all gone. I'm trying to get back to the more commercial type of work I had been doing before the war began. My life has been affected in such a big way. I'm trying to convince myself that it's been affected in a good way.

Sarajevo, Bosnia and Herzogovina
February 22, 2000

"The photos we took were meant to be evidence....
We went through town shooting whatever we saw."

Dejan Vekić
Following two overleafs: Documentation of Sarajevo's
destruction taken for the Bosnian State Commission for
Getting Facts on War Crimes, 1992–1995

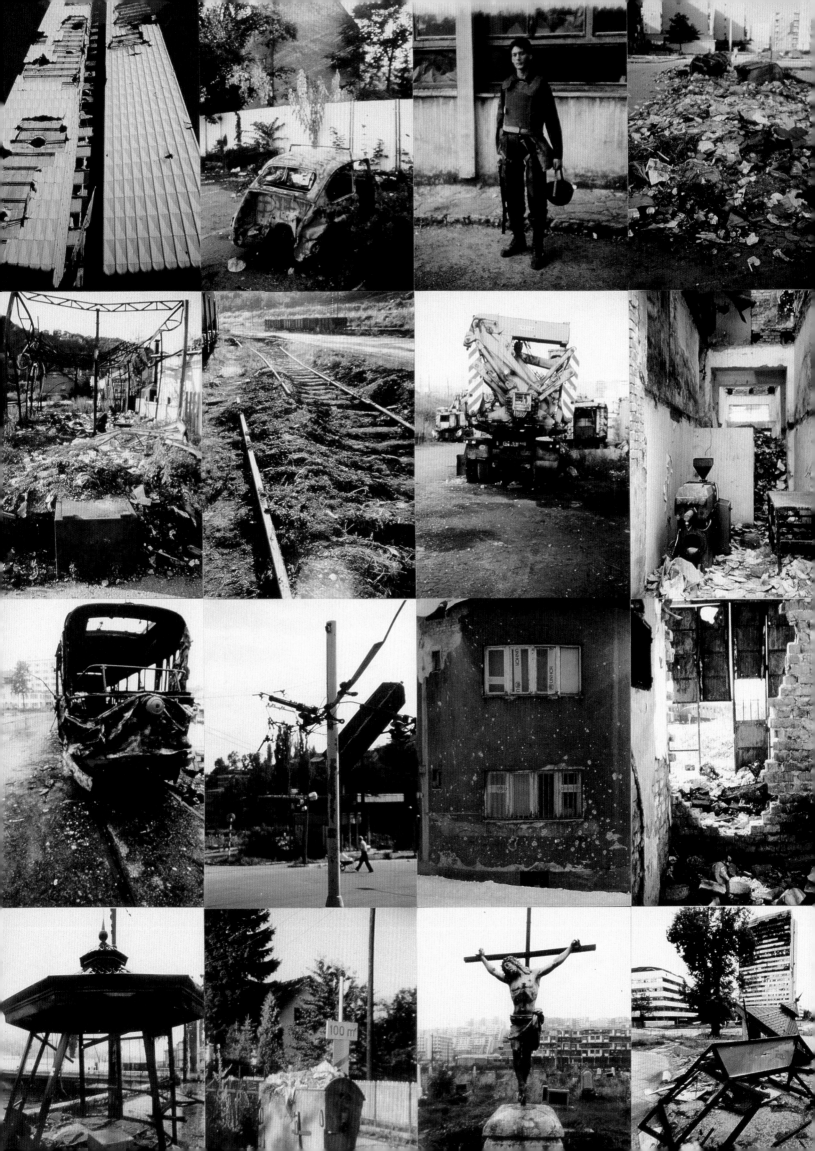

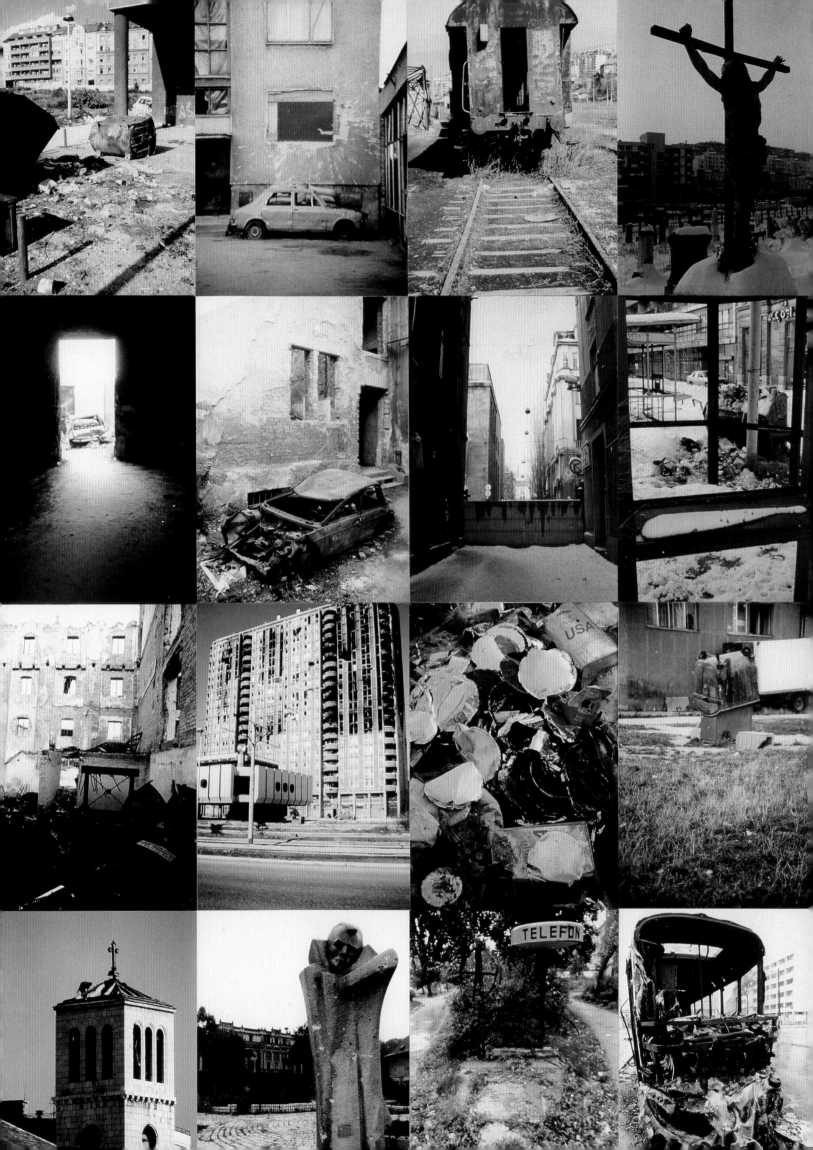

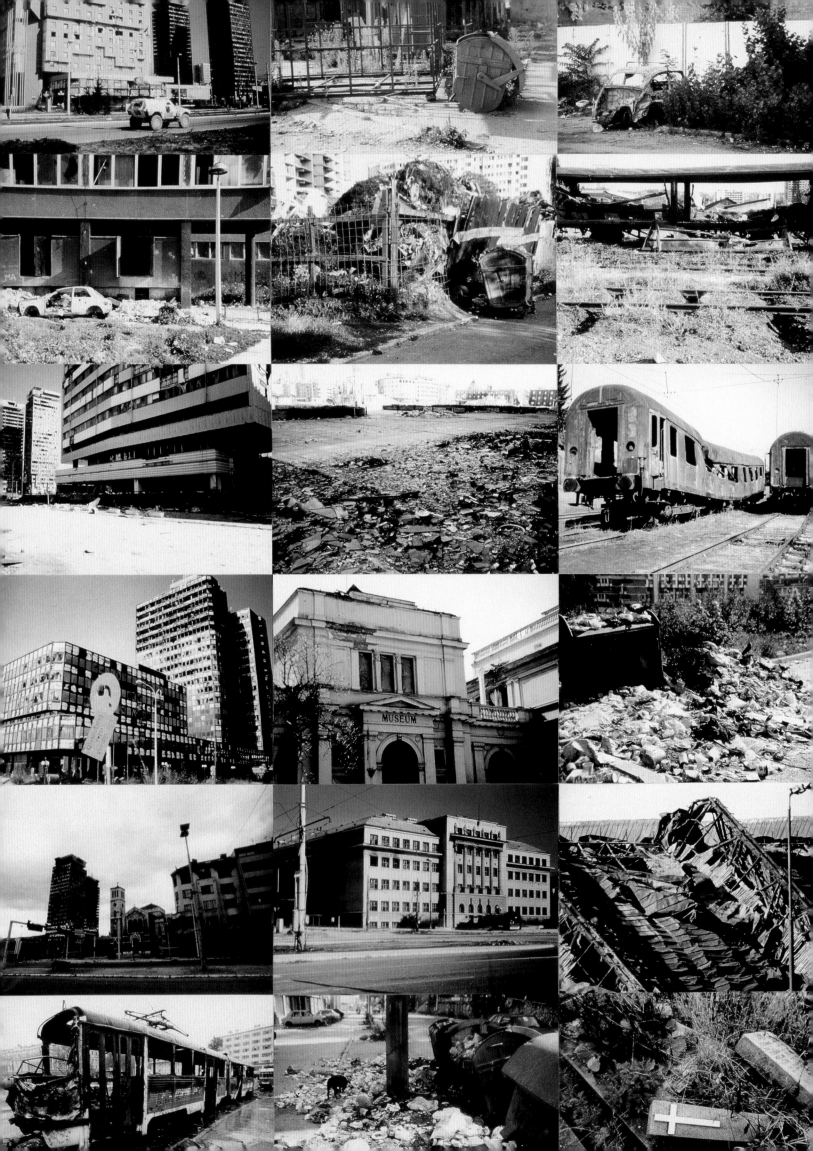

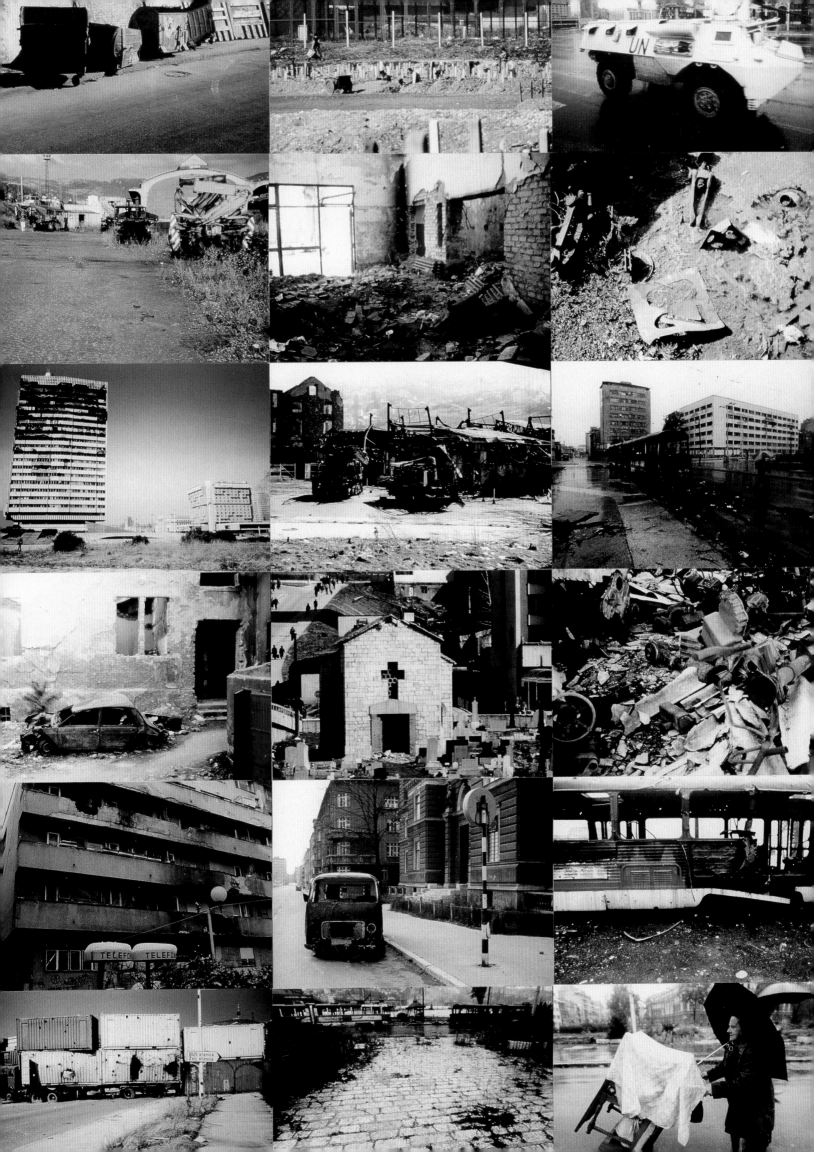

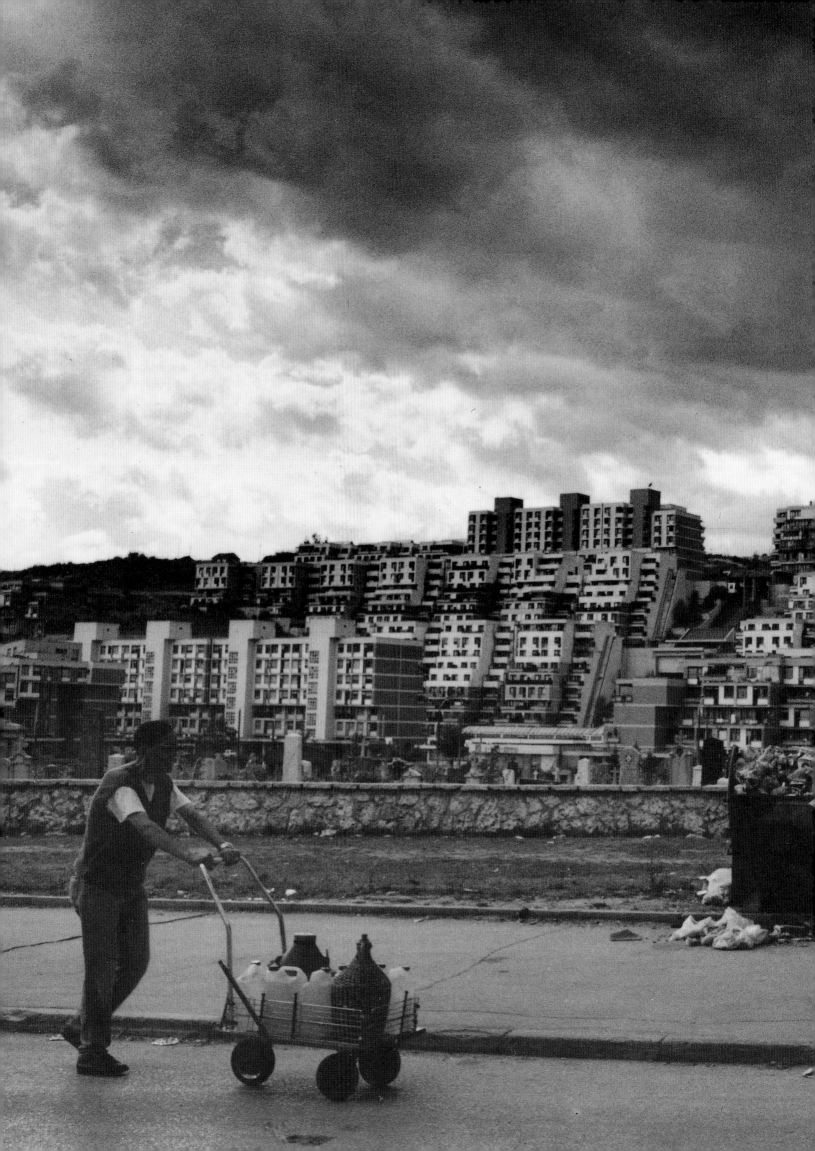

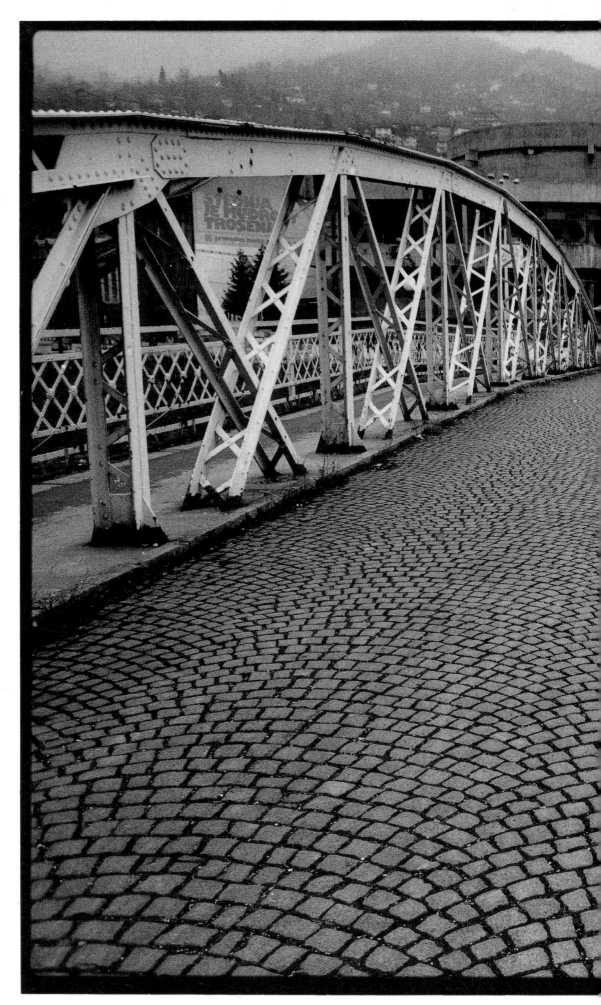

Dejan Vekić
Previous pages: Pushing a cart of water canisters through the city streets, Sarajevo, 1993

Right: *"Pazi!! Snajper"* (Beware!! Sniper), Sarajevo, 1993

This bridge was designed by the same Eiffel who built the tower in Paris.

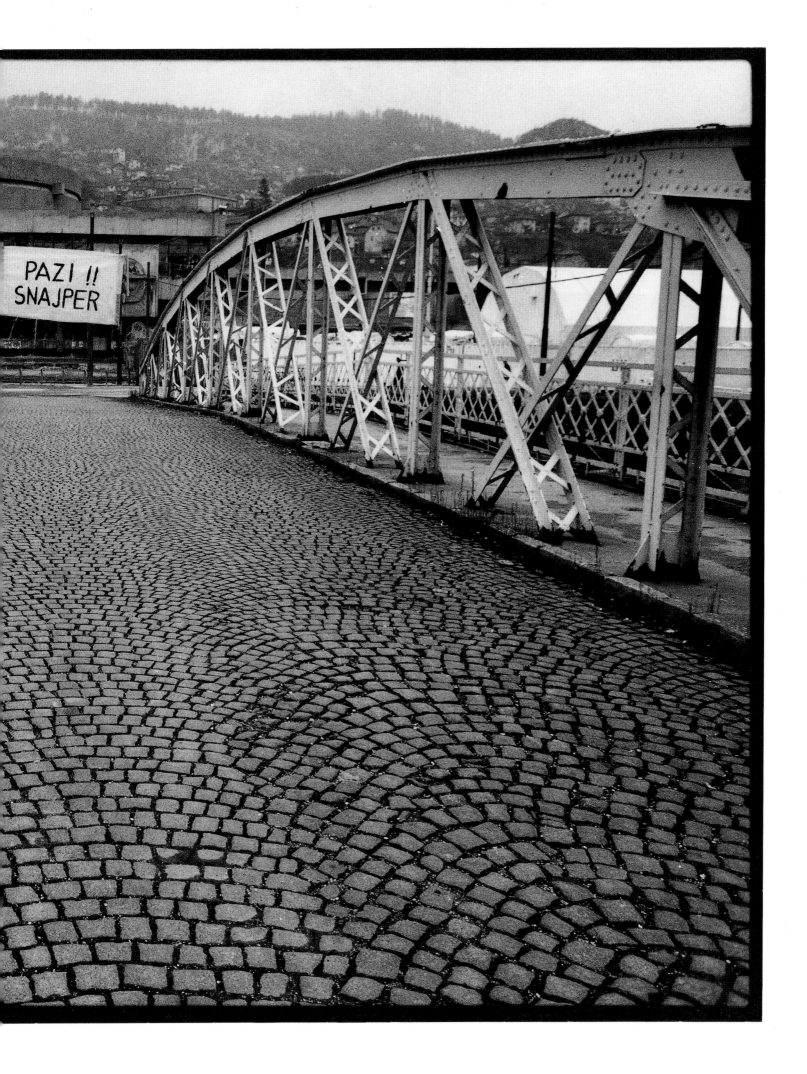

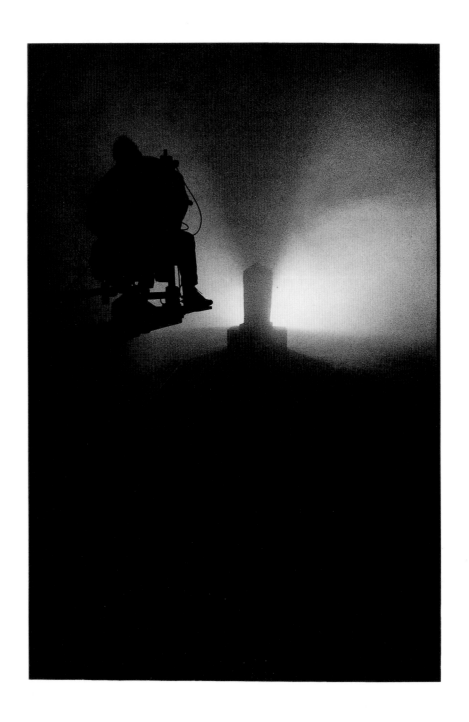

Dejan Vekić
Above: Filming a promotional television spot during the war
Sarajevo, 1993

Opposite: Rehearsal for a fashion show, Sarajevo, 1994

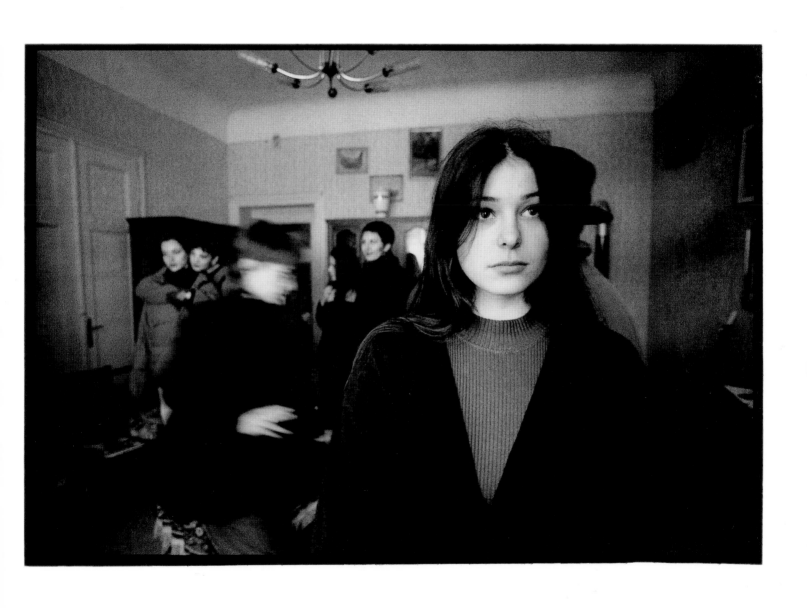

Dejan Vekić
Overleaf: Outside Sarajevo's Academy of Fine Arts,
Sarajevo, 1992

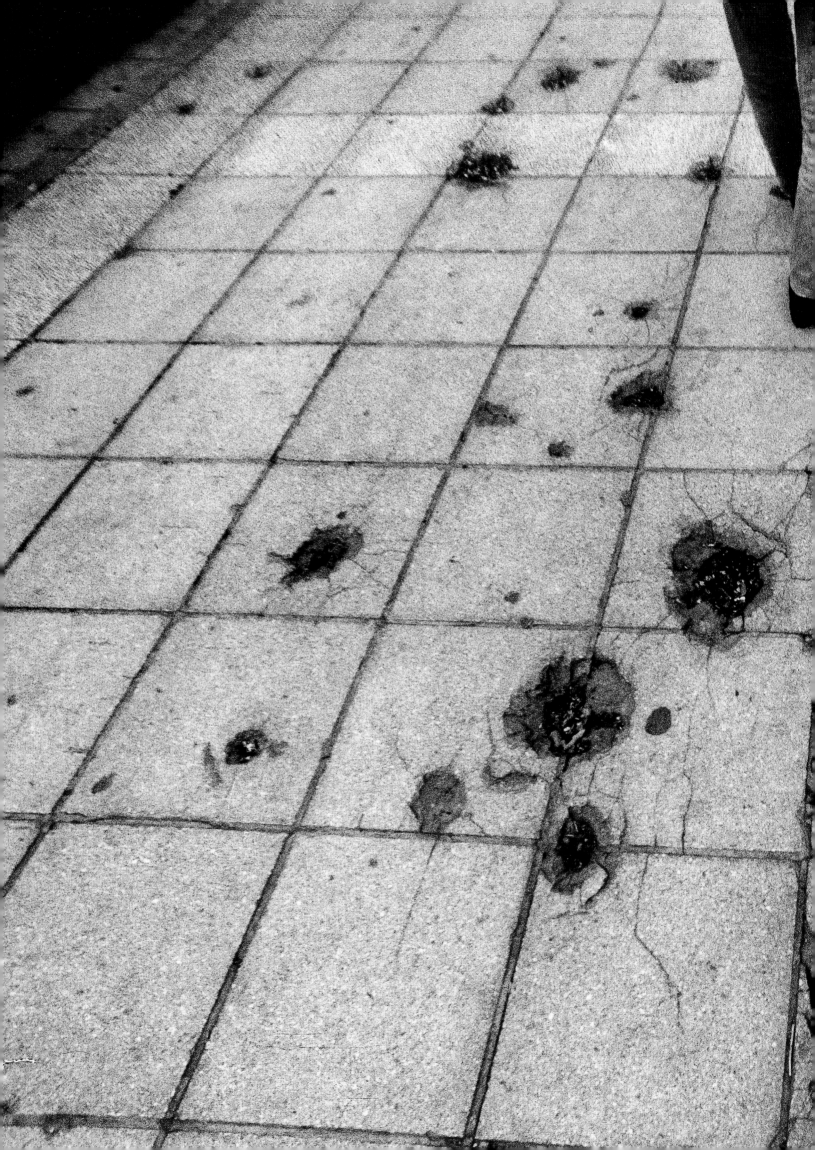

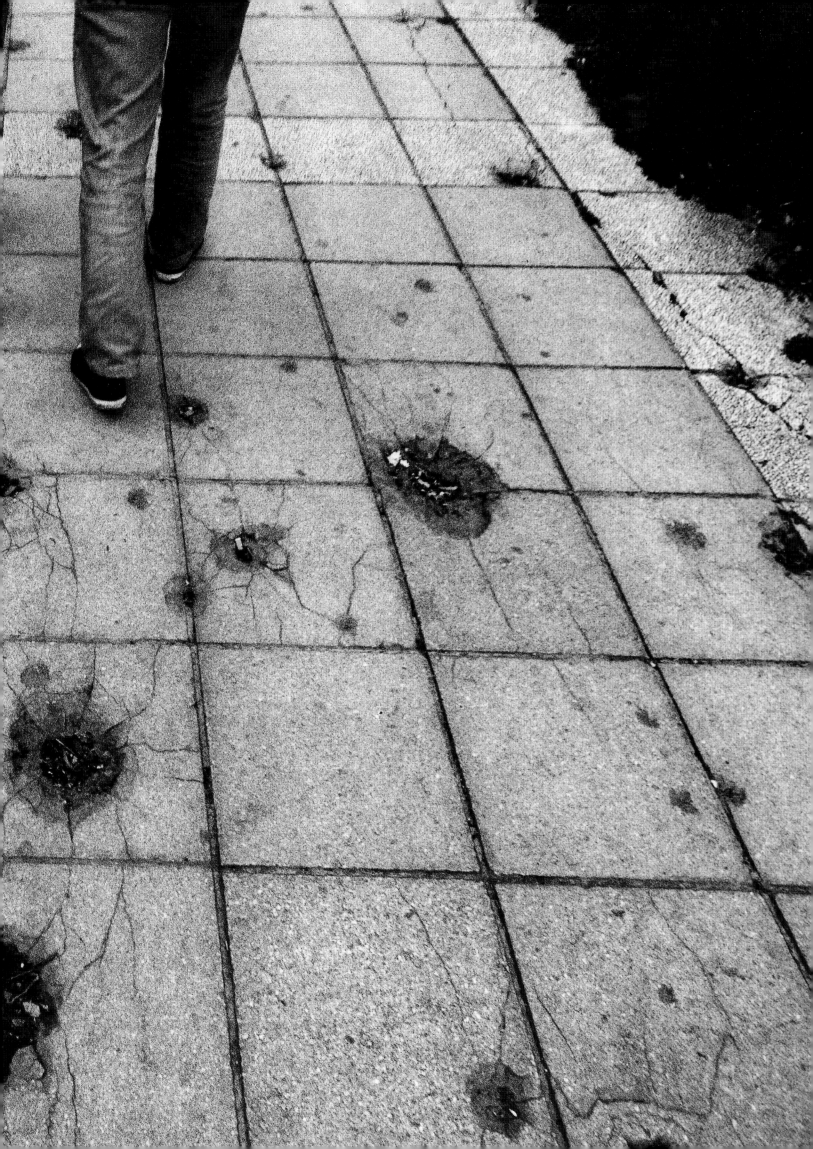

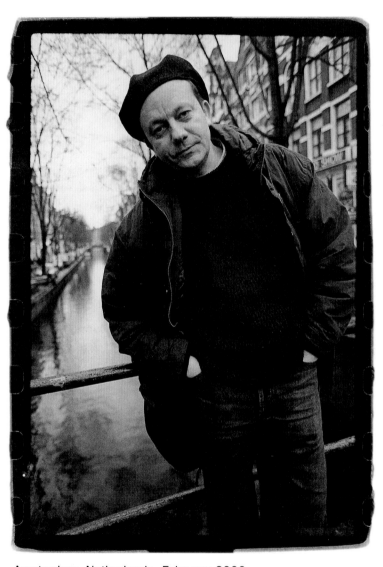

Amsterdam, Netherlands, February 2000

Mladen Pikulić
b. Slavonski Brod, Croatia, 1959

Mladen graduated with a degree in journalism from Sarajevo University. He later began work on a master's in journalism, but his studies were interrupted by the war. Pikulić joined the photo club CEDUS in 1977, and soon began working for the daily newspaper *Oslobodjenje* and other clients. He has won numerous awards for his photography, including top prize from the Society of Artists of Bosnia and Herzegovina in 1989, and again in 1991. New Year's Eve, 1992, he left Sarajevo for an assignment to the city of Zenica. He had planned to return some weeks later, but blockades surrounding Sarajevo kept him in Zenica. He eventually met his wife Amna there, and in 1994 they left Bosnia. Their son, Luka, was born soon after in Breda, Netherlands. Pikulić founded and runs a photography studio in Rotterdam. He and his family currently live in Ridderkerk, Netherlands.

Mladen Pikulić

Before the war I was living by myself in Sarajevo, in a little house that belonged to my parents. I worked at the daily newspaper *Oslobodjenje* (Liberation). I graduated from Sarajevo University with a degree in journalism. I wrote a little, sometimes on tourism or cultural matters—primarily, though, I was a photographer. I would shoot for *Oslobodjenje* during the day, and in the afternoons or at night, I would do fashion photography, as well as portraiture and other studio work. I really wanted to only do fashion or art photography, but there's so little room for that in Sarajevo, even now. Some of my colleagues are able to produce work that's more conceptual, like Kemal Hadžić. As for me or for fashion work, it's more difficult. There's no fashion industry in Sarajevo, for example, nor any fashion publications.

My brother Nino, who's also a photographer—a photojournalist—is the one who got me into photography. He also worked for *Oslobodjenje*, but it seemed very controlled there, very constrained in terms of subject matter. You'd see twenty different photos of Communist Party congresses, meetings, assemblies, and those photos were always taken in the same glorified way. You'd never see a funny photo of a leader in an awkward pose—they considered that dangerous, and it was forbidden. I couldn't do that. It had nothing to do with photography. I was lucky, though. I knew the main editor, who had been a kind of mentor for me at the university. He offered me a job and I turned it down saying that I thought the quality of the photography they published was really poor. But he convinced me that I could have a role in improving the quality. I thought it was a great opportunity. Of course, I was young and didn't realize the main editor I knew didn't call all the shots. But there I was.

Once the Communist Party collapsed and the ultra-nationalist parties began to gain power, it was obvious that something was about to happen. It seemed clear to me—but to people in Sarajevo sitting in cafés, reading the newspapers, voting for the nationalist parties, supporting the fascism of those parties, it wasn't as obvious. They never expected war to come to Sarajevo where all the clever, nice, "good" people lived—so beautiful, and well educated.

The first thing that started to happen was something called the "Balvan Revolution" (*Balvan* means log). In Krajina, in Croatia, people would create wooden roadblocks and come out with their rifles. You couldn't travel in certain areas and that's when people started to ask questions like what nationality are you, where does your allegiance lie—the stupid kinds of questions that are really a private matter. It doesn't matter to me if you go to a synagogue or a mosque or a church. I grew up in Sarajevo and I accept multiculturalism—I can't change the way I think. So it was really a surprise that everybody in Bosnia changed overnight. Yet in Krajina, when I saw people fighting with guns and knives, I knew that was the reality. And meanwhile in Sarajevo, people looked at it as though it was all happening in some exotic, faraway place. Up to the very last moment, people were still discussing: will there or won't there be a war, and mostly thinking, "No way."

In September or October of 1991, I was in Vukovar, Croatia, when the JNA troops came. I took photos of destroyed houses, the dead. It was really unbelievable to me. I had come directly from Sarajevo, where everything was in perfect order—people strolling down the streets, everything you wanted was available to you, and it was a terrible shock. It was as though I'd witnessed the bombing of Hiroshima.

So I took the pictures of that catastrophe, but I realized that photographs are nothing. And more than that, taking pictures of war and looking at those pictures are dramatically different from the reality of war. I created an exhibition in Sarajevo based on the photos I'd taken and on that realization. Nobody reacted. It was unbelievable. You take a picture of dead people, a city in ruins, hang huge prints of those images in a room, invite two, three hundred people, and they drink and dance and nobody sees anything. People were even leaning on those photos, laughing and kidding around. The exhibition made absolutely no impact at all. Nobody wanted to deal with the coming war.

After that, I realized it didn't make any sense to take those kinds of pictures. Nobody sees them. Nobody cares. Why should I risk my life to take photographs that nobody wants to see? Unfortunately, reality kept intervening. Even though I wanted to do fashion and art

photography and leave photojournalism, I kept getting stuck with it—I was still working for the newspaper, after all. That's when I decided to go to the University of Sarajevo for my master's degree and get some theoretical grounding.

In the days leading up to the war, Sarajevo was empty. Everyone was laying low waiting to see what was going to happen. At *Oslobodjenje*, I wasn't being sent out on assignments and neither were many other journalists. No one wanted to face up to what was going on, or maybe they didn't want people to think that by writing about the situation they wanted war. Everyone was very confused, so nobody did anything. I would just walk up and down the streets of the city photographing the empty streets, doing my job. I didn't think anything of it at the time. When I look back at it, I realize it was a little stupid—there was no reason for me to walk the five kilometers from downtown to go out and take pictures haphazardly of broken windows, empty shops, destroyed gas stations.

That was at the beginning, but the situation changed once things started to heat up. The old *Oslobodjenje* offices were destroyed, so we relocated to a new building downtown and I didn't have so far to walk anymore. But it was increasingly dangerous. The government started to encourage people to come out of their basements and join the defense efforts. Then the government stepped up the pressure on the Serbs in the mountains surrounding Sarajevo. There we were, surrounded by Serbs shelling every day, while meanwhile in the city, government troops were roaming around looking for some kind of revenge. You were constantly exposed to danger. Without freedom of movement, my work was really limited. Sarajevo had become a cage—the biggest cage in the world. And within that huge cage, you had a series of smaller cages. I felt really alienated from my environment and it affected my work. It affected my ability and desire to do anything.

On New Year's Eve, 1992, I had the opportunity to go to Zenica with a group of journalists to help them start their newspapers there, and to travel around Bosnian government–controlled territory. At first I didn't want to go. I had good friends, enough food, and even electricity because we were so close to the police station. But a

colleague of mine, an editor of a Bosnian magazine, approached me. He knew I was an artist and he told me that I would have more freedom, that I could have exhibitions and those kinds of things. Plus Zenica was an open door, not cut off from the rest of the world, while Sarajevo was in the dark, lacking in practically everything. You heard stories about the streets being full of people, plenty of food—even bananas. And being naïve as always, I went. It was a temporary assignment—we were being sent by the government and the army with the aim of establishing a news magazine that could print stories about the war in Bosnia. I only took a few things. I didn't think I'd be away for long, maybe a few months at most. I thought I'd be going to a more peaceful city and that I'd be under less pressure. Of course I was actually being sent into another war zone, where I was sent daily or weekly to the front line and where I could have been killed. And soon after, by April 1993, I was in the exact same situation as I had left—surrounded and trapped, no food, no electricity. Then the contract for the job got terminated, even though I continued to work, sending back pictures to Sarajevo. But I didn't have any papers or money, I didn't have friends or an apartment. Without proper documents, I couldn't even get any humanitarian aid (food). However, despite everything, I had a sense of freedom. On my own, but free. I never did get my papers. I fell in love instead. I spent my time having fun, and taking pictures. And I never did go back to Sarajevo. I went straight from Zenica to the Netherlands. And I do not want to return. There is no reason.

I couldn't shoot all the time in Zenica; it was impossible to buy film, even though I had money from selling my studio equipment back in Sarajevo. I had to be careful, evaluate every situation carefully, determine whether it was a good shot or not. But after a couple of months of that, I got numb. I really stopped being able to tell what's important and what's not—what's ordinary and what's not. Everything blurs together and you start to think, who cares if I take that picture and why should I take it? You want to take a picture for the future, but which future is that? You could die at any minute, any second. I don't have the need to leave something behind for posterity. I don't feel like an important person in history. I don't think that my pictures can change history or our mentality or anything, you know.

A lot of people think that photos of the dead can change people's minds—the thinking, history, and policies of a country. But I don't think so. Maybe they can influence a small number of people. It's like movies or art—it can't change the world, it can only change life by giving people something to feel good about, to find hope in—for that one moment, to feel special. But life goes on the next day.

I wanted to show "normal" life in Bosnia under the circumstances—the normal life of children. I observed what the children did, what games they played, what they ate, what kind of social life they had. I didn't dig into their individual situations too much, whether they had family left or not, because those are very personal questions, difficult for the children, and I didn't want to hurt them. I decided I'd take pictures of them instead of dead people or the fighting on the frontlines—you could hurt families with those pictures and I didn't want to hurt anybody. I just wanted to take pictures of the children being proud, being good, behaving normally. The children I met had a real strength and energy to them. I never took pictures of children with injuries or crying. I made that decision consciously and it was an important moral choice for me; better to give help than to photograph someone while they are bleeding.

Frequently the aim of a photographer is to get that one best shot—and everybody knows what that is. The worse the situation, the better the picture. I didn't want to contribute to that. Pictures from the beginning of the war, when everything is still intact, for example, look too normal. They don't show the war. But the fire, the broken glass, death—that's war. And that's what works for editors, maybe for readers, I don't know.

I spent a lot of time photographing this one single street in Zenica that my girlfriend—now my wife—pointed out to me. She was a huge support, going out with me everyday. The street is sort of old-fashioned—about one-hundred years old or so, which is rare in Zenica, because everything else is new—new streets, new neighborhoods, and huge buildings. But that is not where you find life. This particular street is only a few blocks down from the coal mine. And coal mining is (or was) the biggest thing going on in Zenica. So I went down to that street almost every day. There were so few people; it looked as though nobody lived there. Then I

began to realize: the men are at the front while the women are out looking for food. There were only children left.

As I poked around those streets—morning, afternoon and night—I began to recognize those children. You know, ordinary kids, nothing special. But when I looked twice at them, they started to fascinate me. I started to photograph them as I walked. I would just crouch down to be at their level, because I did not want to be looking down on them, from some higher position.

I remember this one kid in particular, who had such a typical Bosnian face. His father or somebody must have made him the gun out of wood—simple and cheap. When I started to take his picture, the boy began to laugh and to pose just as though he were in a real studio getting a real portrait done. I've noticed that people around here get this certain pose when you take their photo, because having their picture taken is important to them. They're always trying to look natural, happy, to put on a face that says, "Well, everything is A-OK here—take the picture!" I don't know if the people behind this boy are his family, but people who look at the photo tend to assume that the kid is being protective of them. Children play games and that's how they learn. Here, it's always playing at war. They were mostly just playing like regular children play, you know, imitating their parents, even though many of them must have been orphans. But there they were: the girls with their dolls and the boys with their guns. Children are actors, but for these children, it was real as well.

A few years ago I had an exhibition of this work in the Netherlands, and I called it "My Children." And even now, I think of them as my children. I think of them and I smile because those kids showed energy, the will for living, and hope for the future. In the middle of the worst situations, you can see those things in their typical Bosnian faces with their typical Bosnian smiles. That's real life. That's real hope.

Ridderkerk, Netherlands
January 4, 2000

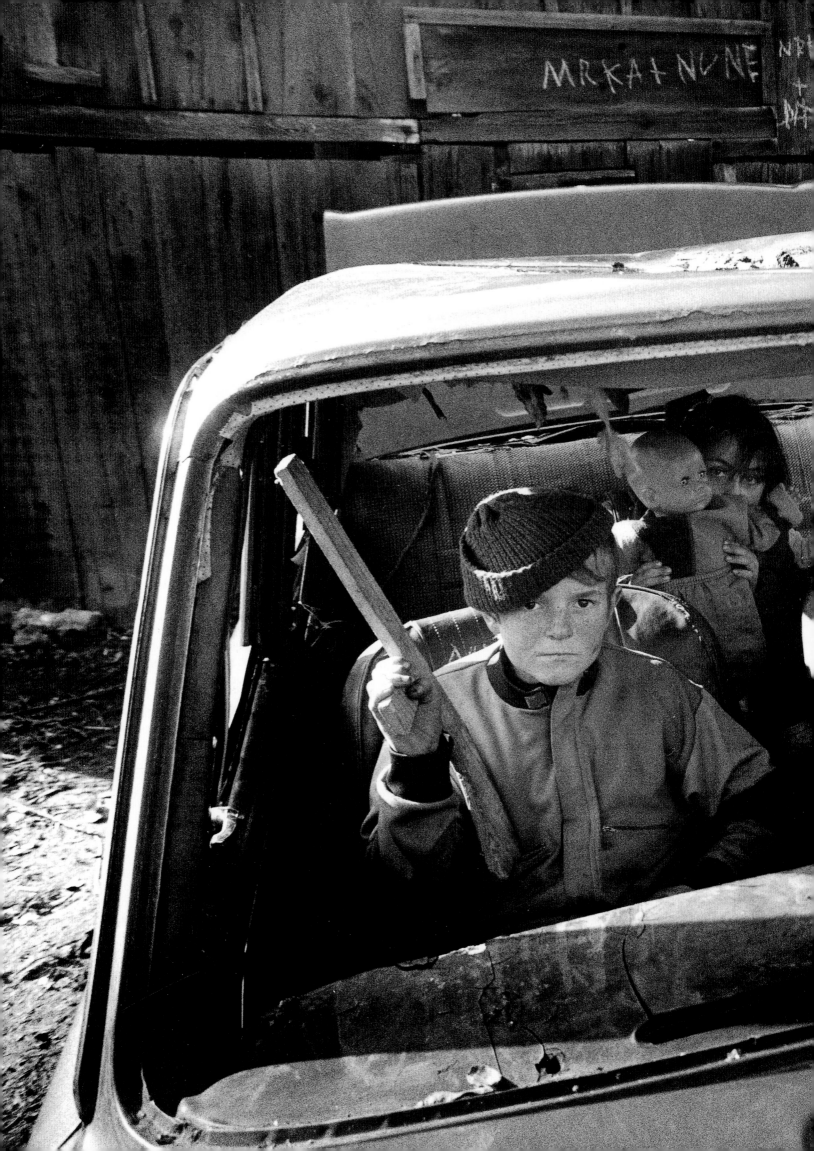

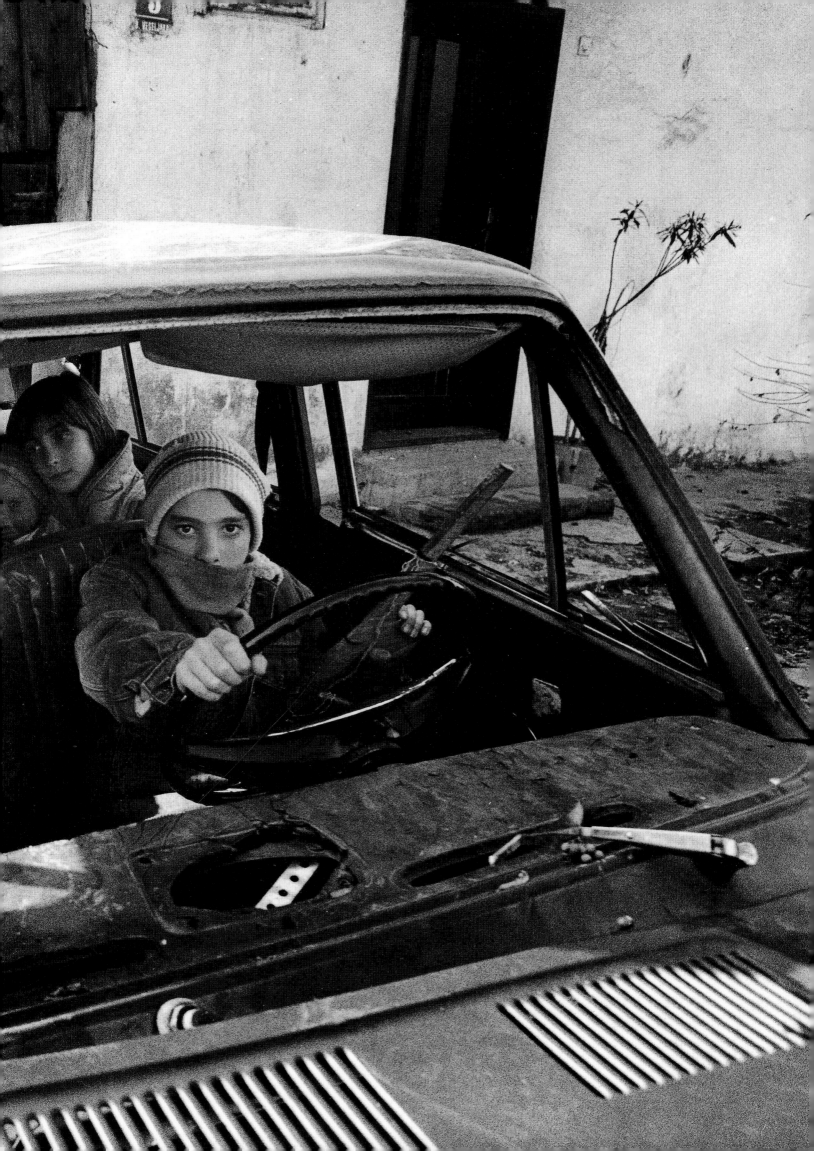

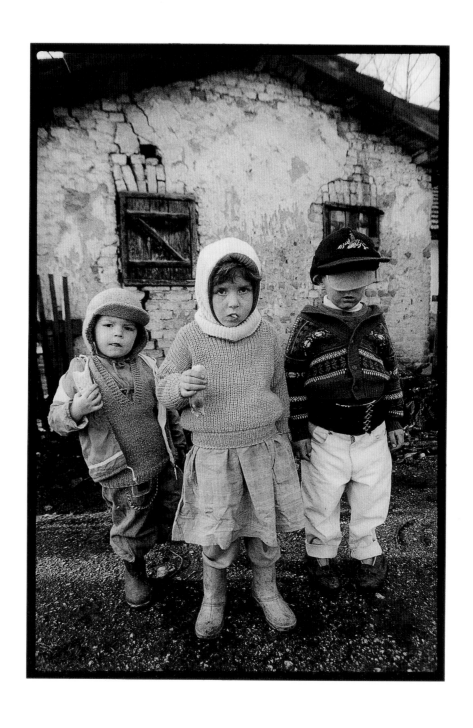

Mladen Pikulić
Previous pages and following overleafs: From the series
"My Children," Sarajevo and Zenica, 1992–1994

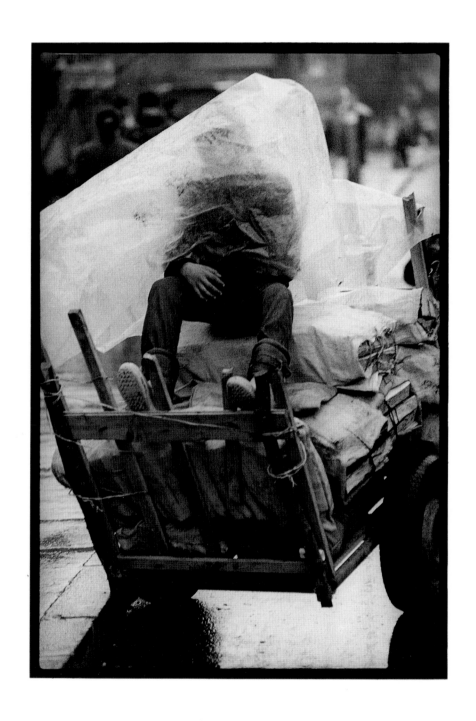

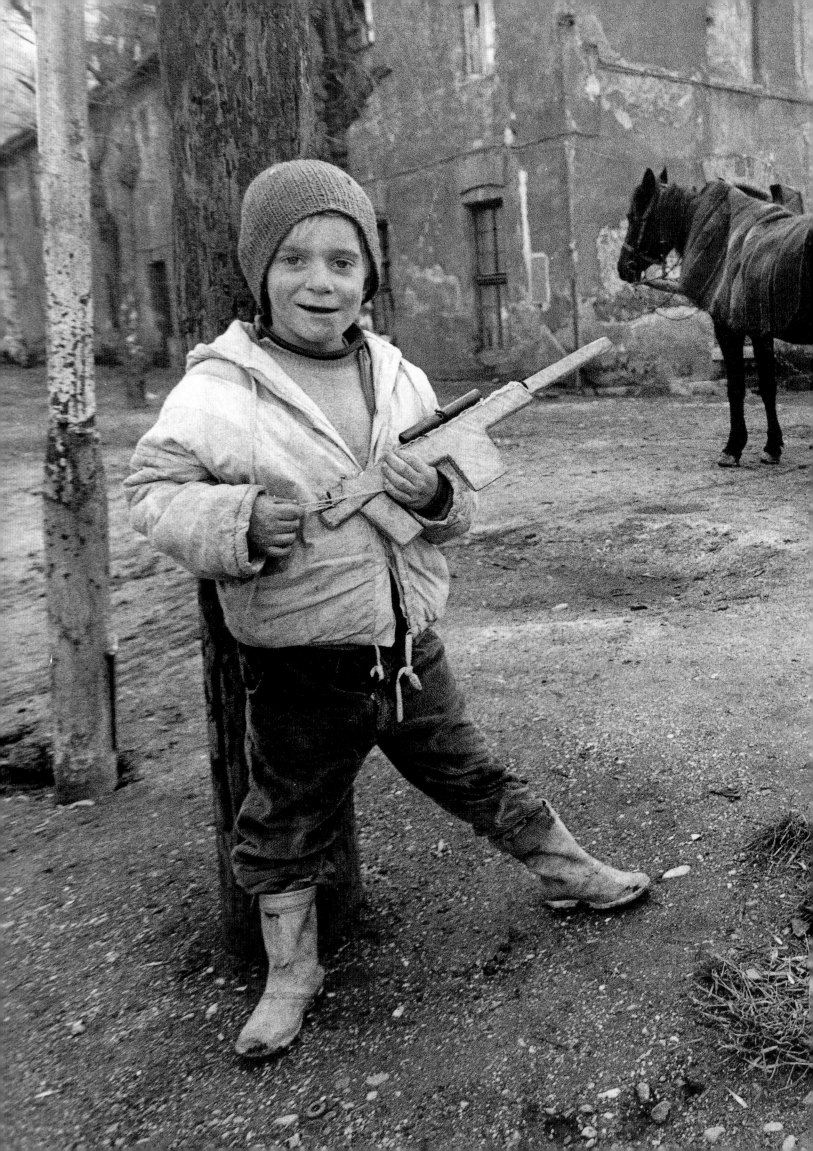

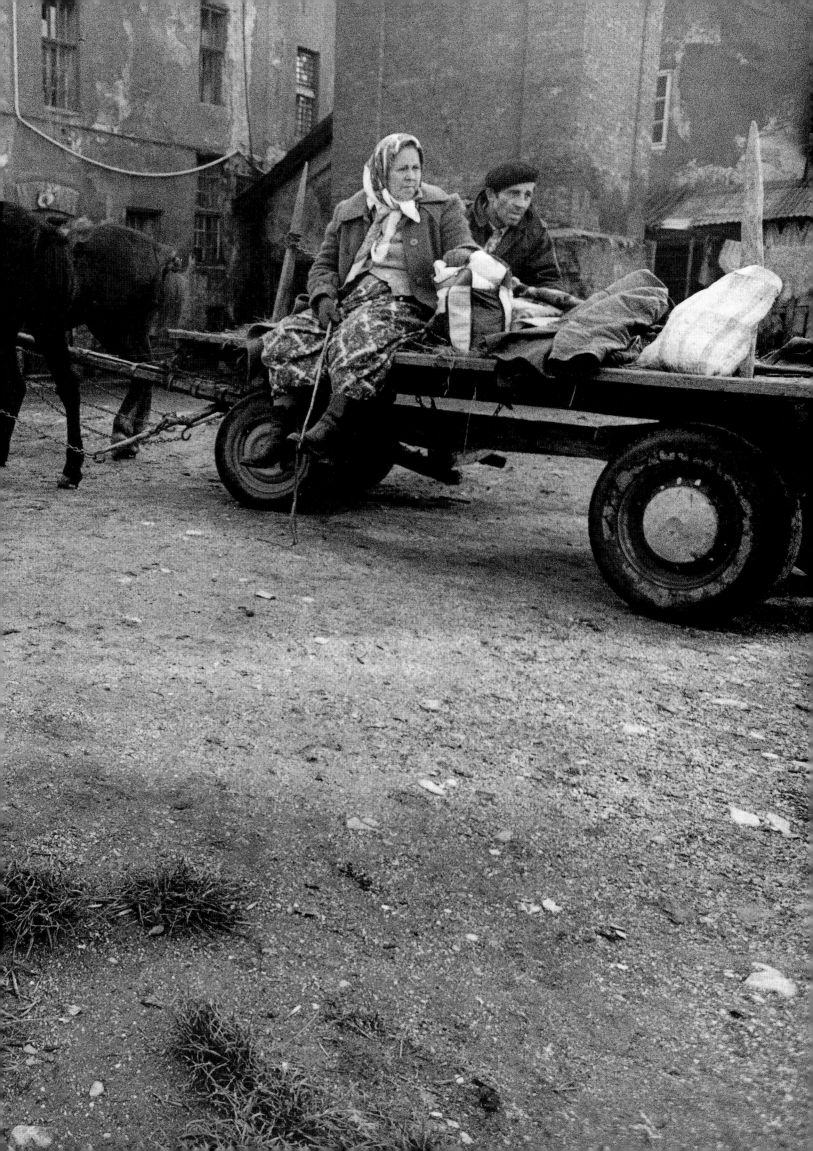

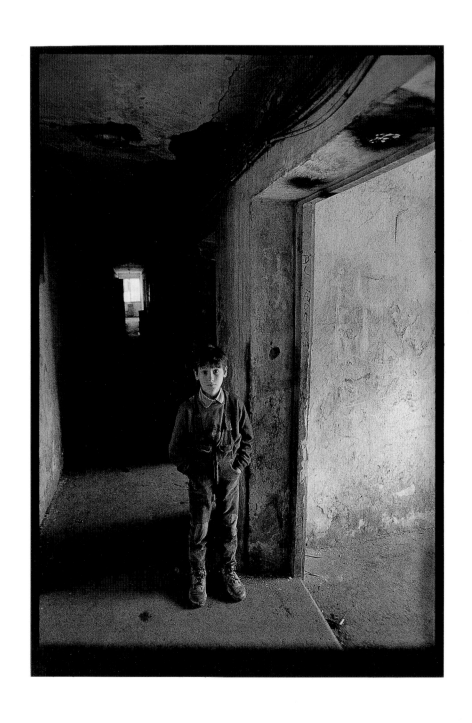

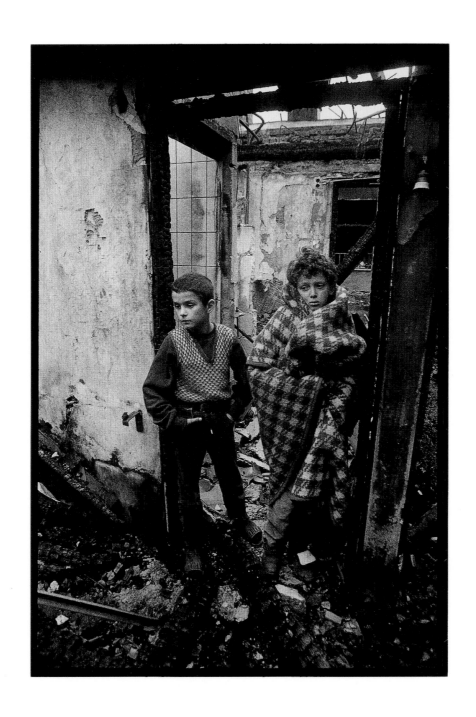

"I wanted to show 'normal' life in Bosnia under the circumstances—
the normal life of children.... I decided I'd take pictures of
them instead of dead people or fighting. I made that decision
consciously and it was an important moral choice for me."

Mladen Pikulić
A refugee driven from his
home sits in a room with his
remaining possessions,
including some firewood
stored under the bed,
Zenica, 1994

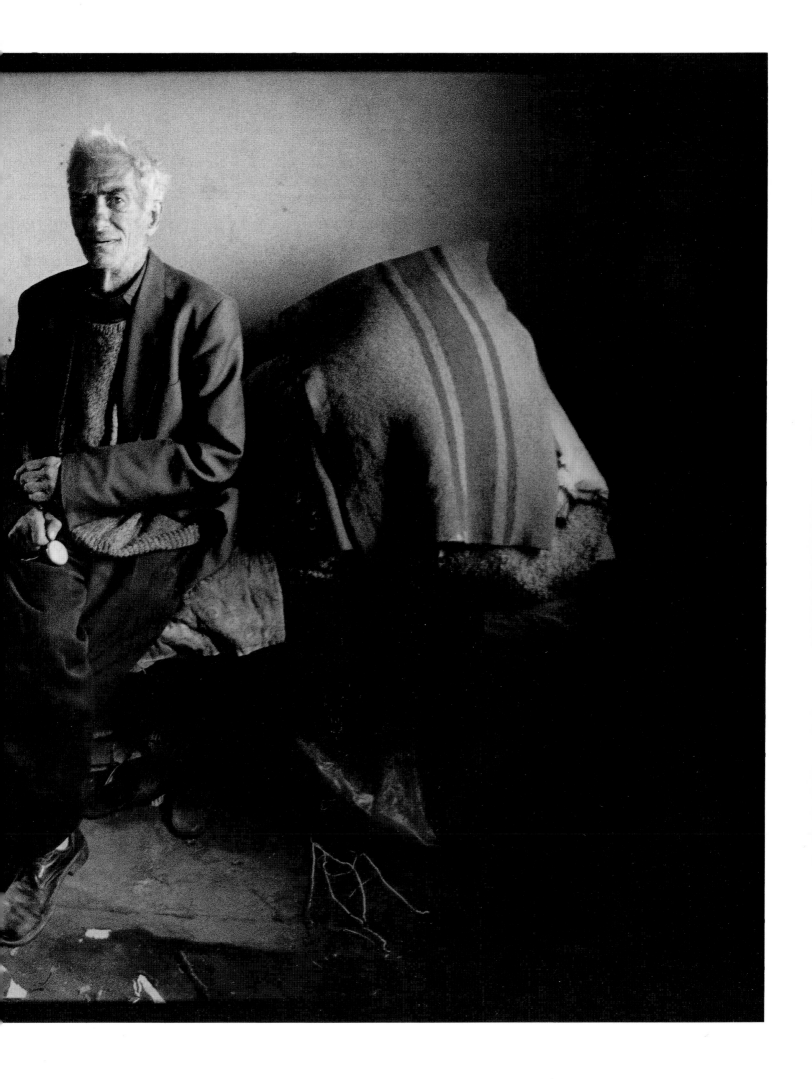

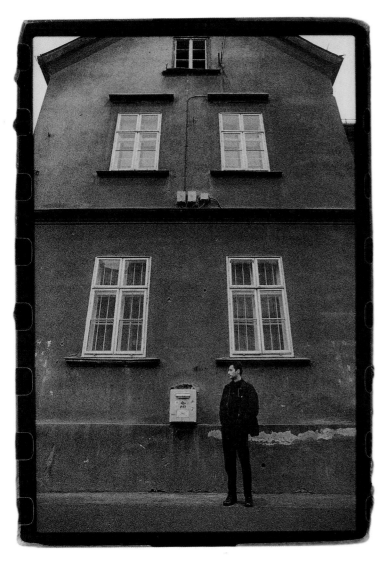

Nihad "Nino" Pušija
b. Sarajevo, Bosnia and Herzegovina, 1965

Prior to the outbreak of war in Bosnia, Pušija traveled abroad
extensively, photographing and exhibiting with both local and
international organizations. In the spring of 1992, Pušija was
offered a job taking photos for an international news agency.
Within a month, he became so disturbed by the faces of the
dead he was being paid to photograph that he could not con-
tinue. He was able to hitch a ride out of the city on board a
military plane, eventually ending up in Berlin. Pušija has devot-
ed himself to documenting the lives of Bosnian refugees and
gypsies living in Germany.

Before the war, I had been working for two years at the
daily newspaper *Oslobodjenje*. It was an independent
publication, the front page was printed alternately in
Latin one day, and the Cyrillic alphabet the next.

Things started to get complicated after Tito's death.
From 1986 on, high inflation started to cause street
demonstrations. Political leaders started tripping over
each other to gain power. I left Yugoslavia in 1988 and
went to London where I freelanced for various newspa-
pers and studied English and English literature while
working nights as a hotel receptionist. In 1990 and
1991, I traveled to the United States where I was hired
by this boys camp in Maine, "Camp America," to shoot
pictures for their yearbook. Those summers were partic-
ularly wonderful—I didn't smoke, didn't drink; I basically
led a very healthy lifestyle. I went back to Sarajevo for
about half a year in 1991, working on an alternative
fashion project. Then an opportunity to study photogra-
phy in Milan came up at a studio for special effects.

When I finally returned to Yugoslavia, I was shocked to
see how fast things were changing. As the old system
was crumbling, reform was taking place everywhere: in
the schools, in the factories, and most importantly, in
people's heads. The rise of nationalism in Serbia and
Croatia was particularly frightening and served as a cat-
aclysm for all these different anxieties: the economic
situation, the different political factions, and the com-
plex historical relations between Europe and the Balkan
countries. It's crazy to think that seven centuries ago
before the Ottoman invasion, these people were all the
same: the Muslims that arrived with the Turkish inva-
sion, the people from Northern Europe who called them-
selves Slavs, the Christians. And now the Serbs, the
Croats, and the Bosnians all insist on their differences.
It's ridiculous since these cultures are ninety percent
the same!

Above: Outside the CEDUS building, the state-subsidized pho-
tography club that once provided studios, darkrooms and a
meeting place for the citizens of Sarajevo. The club no longer
exists. Sarajevo, 1998

Nihad Pušija

My mother is Catholic Croatian and my father is Muslim. Both of them were born in Sarajevo. On my mother's side, my grandfather was Croatian, while my grandmother, who was Serb, was Greek Orthodox. When my maternal grandparents met in the thirties, they talked with a priest about having a Catholic wedding, but the priest told them that he would only marry them on the condition that my grandmother convert. My grandmother refused, so they ended up marrying in the Orthodox Church—a huge family scandal at the time.

My grandfather was always an extravagant man. He was a photographer until the fifties but then stopped because he claimed that everyone could buy a camera by then, and he was no longer necessary. He was also a musician, and played the trumpet and the guitar. I think he just wanted an excuse to leave the house and to get a break from his wife. When they had their first child, my uncle, they had him baptized in the Orthodox Church and gave him a Serbian name. But when my mother was born, they decided to baptize her in the Catholic Church. It just makes me laugh that my mother is Catholic and thus considered Croatian, and her brother is Orthodox, and thus considered Serbian.

Anyway, by early 1992, I was back in London and I remember calling my mother one day. She told me to stay where I was, not to come home, because the situation in Croatia (the war had been going on for almost a year by then) was getting worse and worse. So I traveled around Europe, working when I could get assignments, like trying to cover the Olympic Games in Barcelona.

I decided to go back to Sarajevo anyway—even though everyone was telling me that I was crazy. Things were already looking really bad; some of the streets were closed. I felt so strange being there, but I wanted to see my friends and my family, to see things with my own eyes. I was working for *Oslobodjenje* again, and I also interviewed for Reuters, since I was local and spoke English and a little Italian. Taking pictures of the war and its carnage for the wire services was so difficult at first. Not technically, but emotionally. I would be photographing some people and all of a sudden there were bombs and bullets, and then all around there were dead people. I was having a hard time working. I just couldn'-

continue photographing my people who were dying. I felt it was wrong to get paid for doing this.

I guess I just didn't want to end up with the "Bosnian syndrome" in my head, like what happened to people who had been in Vietnam. So I quit Reuters, which was terrible because I had been a professional photographer for eight years and that was the only profession I knew. Everything was just going so fast at that point in the war. It was totally insane—as if all of Europe was blowing up there in the streets of Sarajevo. You could buy a grenade in the fruit market for five bucks, along with all kinds of weapons that came from Eastern Europe: Hungarian rocket launchers, Polish bazookas, Russian kalashnikovs, everything you could imagine. And every day the newspapers reported new weapons found in crazy places, like churches, kindergartens, or old-age homes. People were already losing their minds, drowning in a △nationalist tidal wave—it washed over all of us and pulled us all down.

One day, I remember, I was waiting for the tram to go to work, and this little girl, about nine or ten years old, was shot right in front of my eyes, for no reason. There was no way the sniper could tell if that little girl was Muslim or Croatian or Serbian. I remember thinking one thing with incredible clarity at that moment: I had to get out of there. Not because I was scared; the sniper didn't want to shoot me—I was carrying a camera. No, instead I felt, I knew, that he intended it—that he shot her precisely so that I would photograph the dead body of the girl. Why? To produce more propaganda, more fear. That's all the media did: fed the beast of fear. The media always goes to war long before any real wars begin.

That's when I decided to leave and I was lucky enough to get a flight out of Sarajevo—which was difficult since the Serbs had taken over the airport. I managed to get on a waiting list. After more than eight hours at the airport, I asked someone what the prospects of leaving were, she told me I was number seven hundred and two on the waiting list. I waited, and they started to call out names, one by one, French, German, Greek names. I also raised my hand, and they barely noticed me since I was carrying around all my cameras and actually looked like a real foreigner.

I managed to make my way to Berlin via Belgrade. War broke out a couple of days later in May, and I didn't have contact with anyone back in Bosnia by then. I knew there was going to be a war. I also knew that it wasn't going to be a matter of months—more like a matter of years before it was all over. When I first moved to Berlin, I met this Lebanese guy who had a shop across the street from where I lived. He asked me where I came from, and I said, "Bosnia." I asked him where he came from, he told me, "Beirut." I asked him how long he'd been here, he said, "Ten years." When he asked me how long I wanted to stay in Berlin, I answered that I didn't know, but until it was all finished. He said, "Then you're going to be here ten years from now, too." I thought that over, thought about my newly invalid passport, and I figured I'd better get organized.

I registered for and was given *Duldung* status (temporary status for foreigners in Germany). You have to register within a certain city and you have to stay there. You can't leave. You don't have any rights. You can't work, you can't go to university or study. You can't do anything except wait until the conflict is over in your country; until Germany thinks that your life is no longer in danger. Then they send you back. But it can take years. Two months, five years, ten years. It's a horrible pressure on people. Seven years ago, thanks to some photo exhibitions I arranged, I was able to change my status to a limited-time visa.

Berlin was like an island before 1989, surrounded by the wall. And all of a sudden, the wall fell down but people still had the wall in their heads, so that even today you know exactly where East Berlin ends and West Berlin starts. I keep thinking about this in relation to my country, and wonder how long it's going to take to get over this hate. You know, people in my country think they are really something, that they are a huge part of the world, when in fact they are now "Third World." Before we were, at worst, "Second World." I discovered that we had been downgraded when I tried to get a visa to go to England recently, just to visit for a few days, and the people at the embassy said, "Sure, no problem, just fill out this form for Third World countries." I was in shock. Then they explained to me that I couldn't get a Third World visa there, that I had to go to a special division of the embassy way out in Dortmund that dealt with Third

World visas. That's what goes with lost privileges—everything becomes harder, even the simplest things like filling out a piece of paper. It's just so crazy because with my Yugoslav passport, I used to be able to travel to seventy different countries—in both the East and West—without any problem whatsoever. It was Tito's dream, but also ours; a dream that all of a sudden just exploded. Sometimes I felt like I was in a prison, like my life was so limited.

Once in Berlin, I started right away photographing the other Bosnians: the refugees, the gypsies. In these photos, most of the people are Bosnians. As a photographer, you're always shooting. You have to always have your camera and you have to be there as the stories unfold around you. This story began the moment I left Sarajevo—with the pictures I took on the plane. From that moment, I was a refugee too, you know. Once you leave a place under circumstances like that, you are always a refugee until the day you return. I knew these people—they were not strangers to me. I knew from the very start of the project that I was needed to tell the story in a way that a photographer who hadn't shared these experiences could not. A lot of people will lie to an outside photographer or journalist; especially because they've already been betrayed by so many people. I think I was able to gain more trust, get a more intimate look at people's lives. I began in the summer of 1992 and it was crazy how many Bosnian refugees had come to Berlin, over 15,000. Three years later, there were over 30,000. Altogether, Germany took in over 350,000 Bosnians.

On the recommendation of a woman I met, I went to photograph a big convoy of Bosnian refugees who were making their way to Berlin. There were thousands of Bosnians coming to Germany as *gastarbeiter,* or guest workers who had relatives or connections somehow. The train had collected the thousands of refugees coming over the Bosnian border in order to save their lives, to save their children. These people hadn't even had time to pick up their things—maybe just their passports or a bag or two.

Red Cross gave everyone a sign to wear with their destination written on it. If they lost it, there was no way to prove who they were or where they were supposed to

be going. Their accommodations and everything had already been organized in advance. Even so, there were a lot of curious people, and everyone was very scared. And it was so hot that day, people were passing out left and right. They took those people to the hospital and then to the refugee shelters where everyone else was already.

You see the children in these photographs, all of whom have been on that train for days? It was an incredibly emotional scene. The children always cry, of course. And then the women—well, that's natural too, I guess. But when you see the men, the old men crying, it's really tough. Maybe even worse are the children who are pale and quiet. As though they've finished crying and they have no more tears left.

You can see the trauma in these photographs, in the expressions of the people. They're scared, they've been separated from other members of their family. There's no air. Everyone's packed in like sardines, sweating, uncomfortable with children pissing and I don't know what. You've gone from hell into the unknown. You don't know what's going to happen. You're in a totally unknown place, unknown language, unknown country. You know you're in Berlin, in Germany, and that's it.

After I photograph something like that, it's exhausting. I feel empty. I remember sometimes that I have my friends and family, a world of my own, back in Sarajevo too, and I have no idea what's happened with them. The stories I was hearing from these people were so incredibly heavy: "They came to my village and slaughtered my son in front of my eyes," or "They killed my father and mother," and on and on. I don't know if other photographers feel the same way, but while it's usually a tremendous opportunity to jump into somebody else's world when you're immersed in a story, this was terribly different. I didn't have to jump, in this case, I was already there. And I couldn't get out, either.

In all the pictures, I let everyone pose and organize themselves. Sometimes people got aggressive about it, or wouldn't let me photograph them at all. They asked me why I was making these photos, and I told them that it's important to "register" this moment, because it's not always going to be like this. It did seem to make them happy when I brought them the prints afterwards,

and to sit down, drink some coffee, and discuss the latest news from the refugee community.

Currently, I'm working on a project photographing transvestites, lesbians, and gay men from the Berlin underground scene. A very strange mix: refugee photos, transvestites, and nudes! There was this one club I went to where some protests started over the gays and transvestites. What a total contrast to the refugees I shot by day, so it was a little like therapy, too. Like me, the transvestites don't know exactly who they are.

Those four years of war really made me reevaluate the important things in life, basic things: that it's important to eat, and important to love. The war changed my life, not just my photography. Suddenly the worst sort of things are going on around you. One moment everything is OK, the next, you've got nothing.

When I started to exhibit my work in Germany, I began to develop this idea of myself as a cultural bridge-builder—I could build something between Sarajevo and Berlin. There's a real need for a new photo club in Sarajevo right now. Sarajevo not only suffered from the tragic loss of life and homes, but it has also undergone a photo-cultural tragedy. There's no longer any real forum for discussion, or ways to learn; the photo-community needs to regroup.

There might be a message in these photographs: if you look, you may recognize yourself or your own family in them. I want to go back eventually. But I feel like for now, my place is here, on the outside. Maybe this sounds a little stupid, but I feel like I have my mission, and that when I go back, I might be able to teach what I've learned, as an outsider looking in.

Berlin, Germany
December 13, 1999

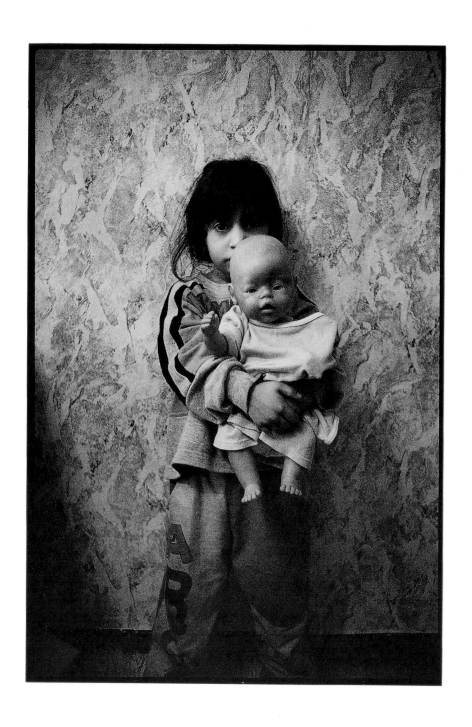

Nihad Pušija
Above: A gypsy girl and her doll, Berlin, Germany, 1996

Opposite: A woman wears two wedding rings, her own and
her dead husband's, Sarajevo, Bosnia, 1992

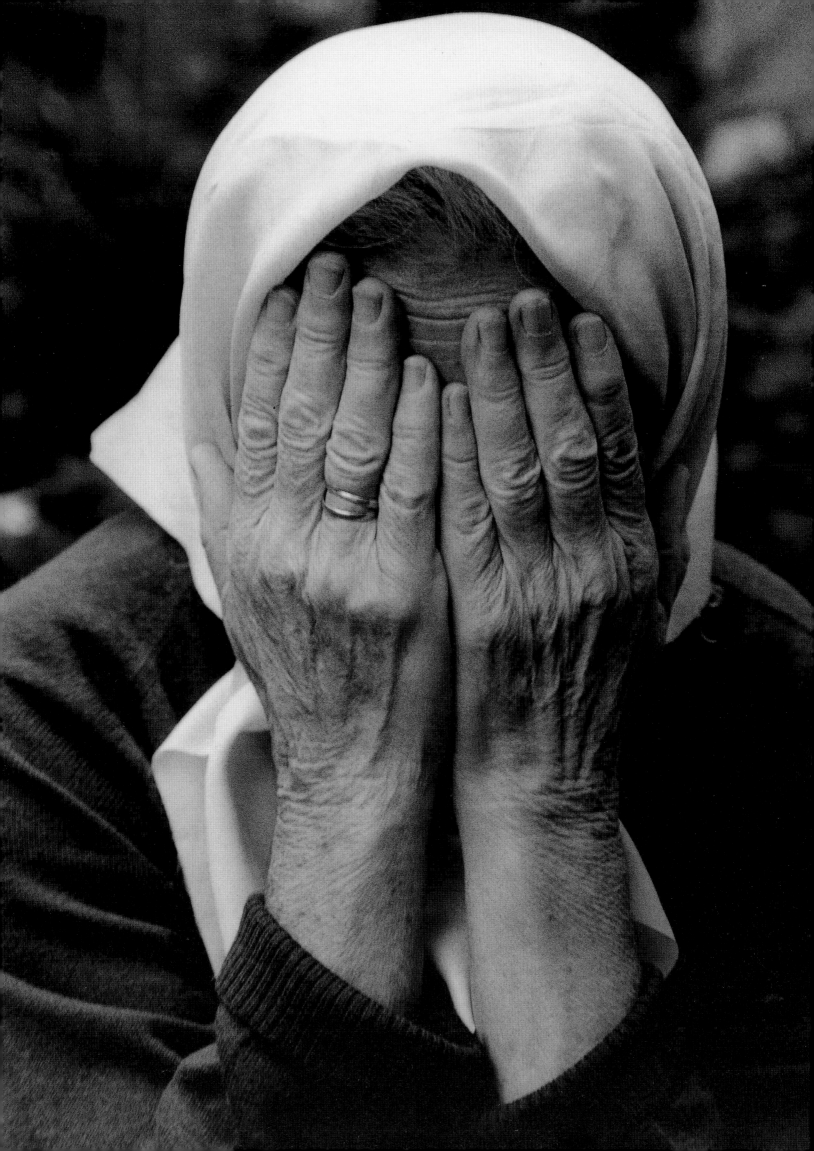

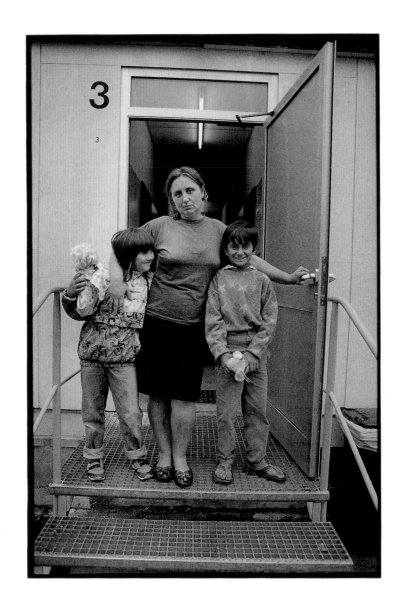

Nihad Pušija

Above: A woman and her two daughters from the Northern Bosnian city of Derventa. Their temporary home is a camp made of metal shipping containers, Berlin, Germany, 1992

Opposite: A refugee child arrives at Berlin's Lichtenberg train station, Germany, 1992

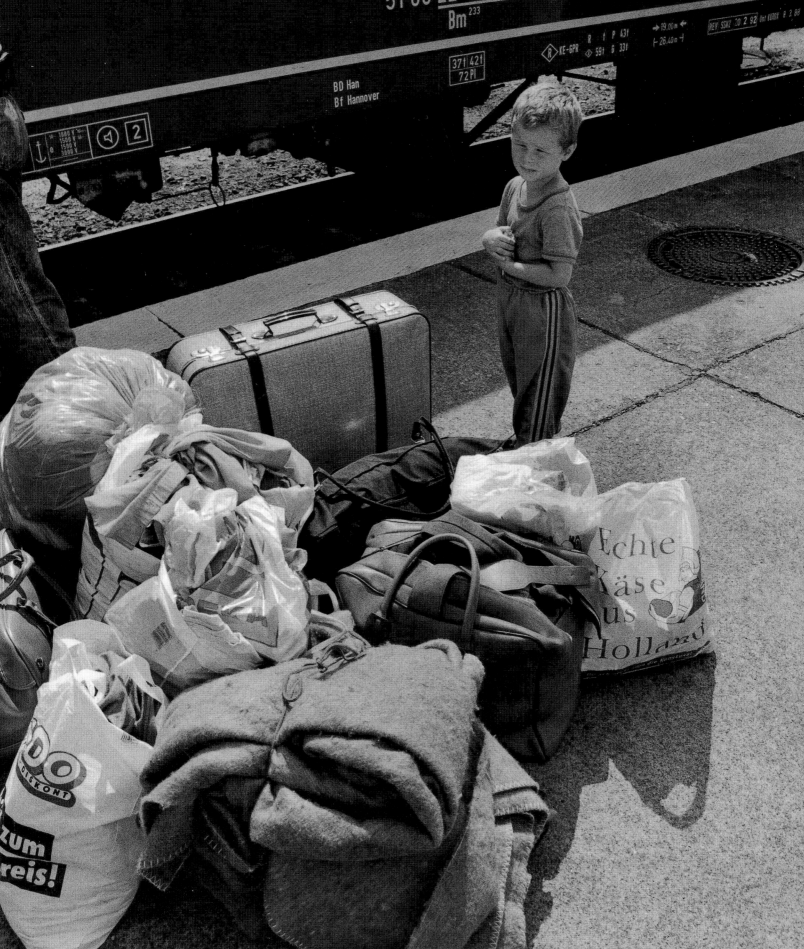

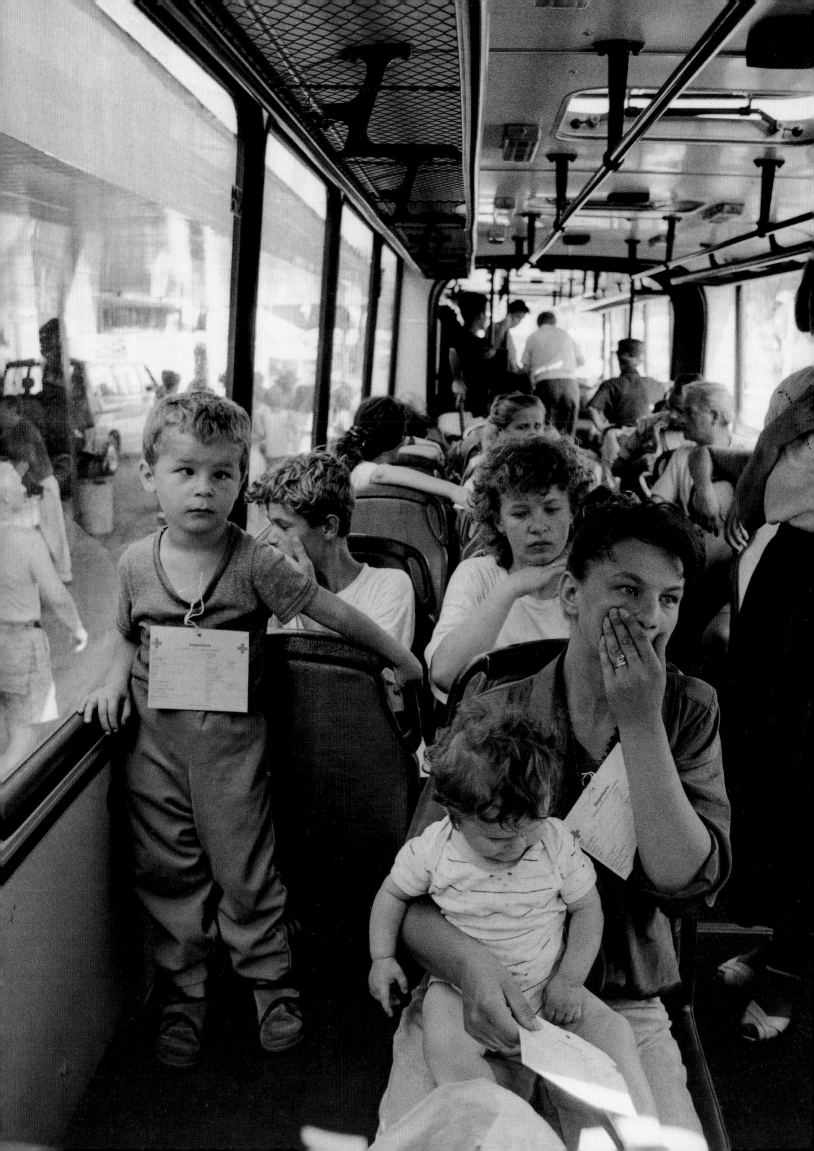

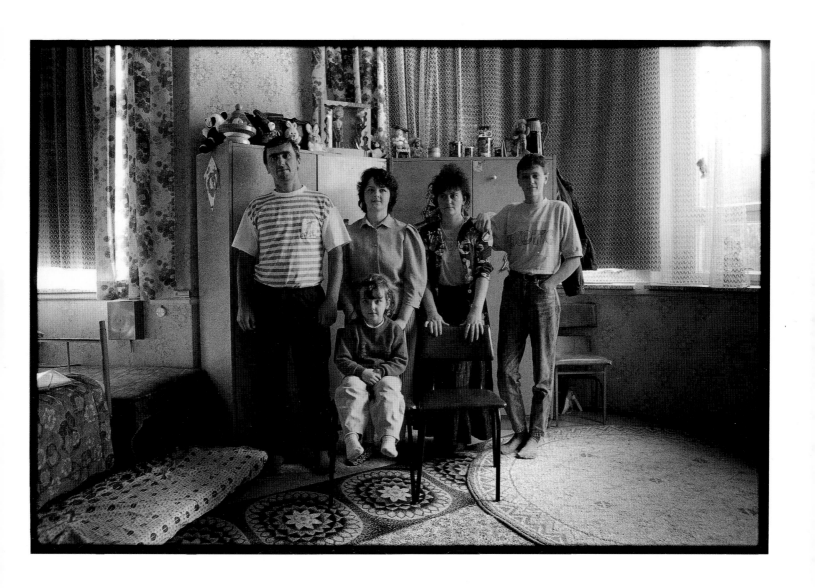

Nihad Pušija
Opposite: Women and children from northern Bosnia are bused to a shelter after spending several days on a train, Berlin, Germany, 1992

Above: A family from the town of Bosanski Novi, Bosnia. The empty chair represents the woman's missing husband, Brandenburg, Germany, 1993

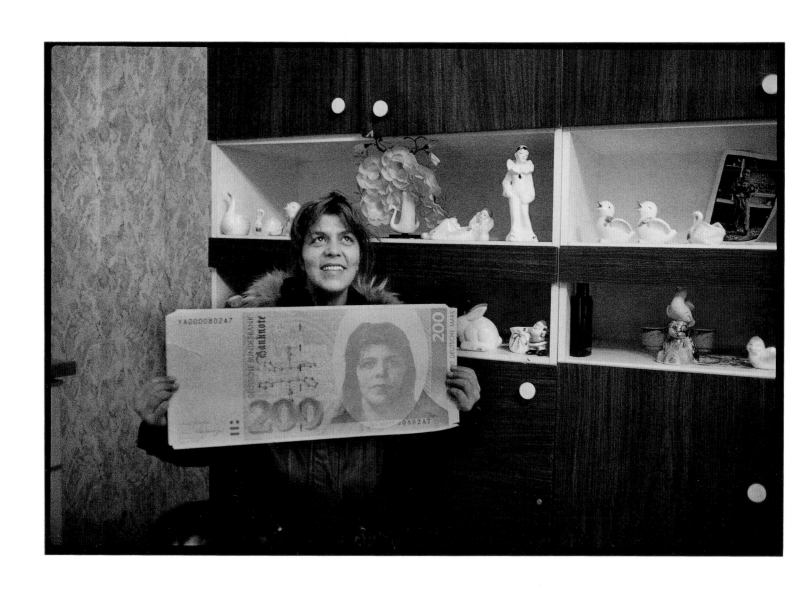

Nihad Pušija
Above: A gypsy woman with a giant deutsche mark bearing her image, Berlin, Germany, 1996

Opposite: A prominent member of the gypsy community attends a wedding with one of his two wives and their daughter, Berlin, Germany, 1996

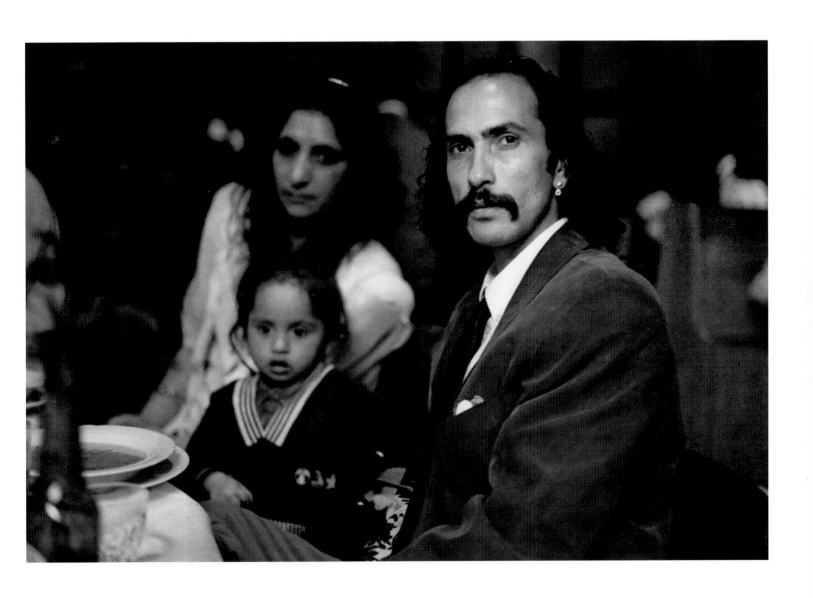

"This series began the moment I left Sarajevo—with the pictures I took on the plane. From that moment, I was a refugee too. I knew these people. They were not strangers to me."

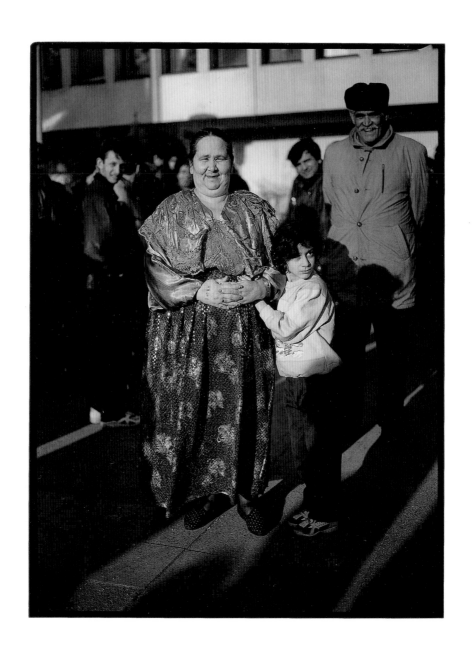

Nihad Pušija
Above: Berlin, Germany, 1996

Opposite: A fourteen-year-old gypsy bride
 Berlin, Germany, 1996

120

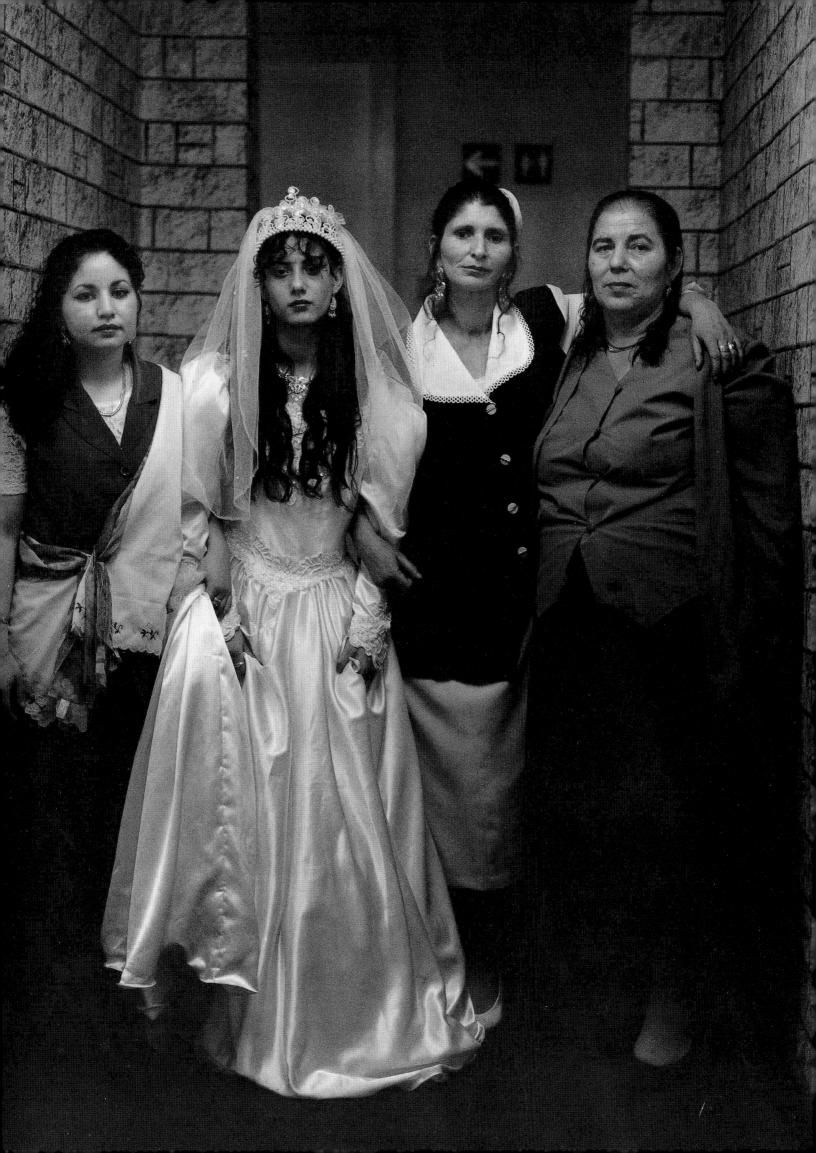

Nihad Pušija
A gypsy woman holds
up her nephew
Berlin, Germany, 1996

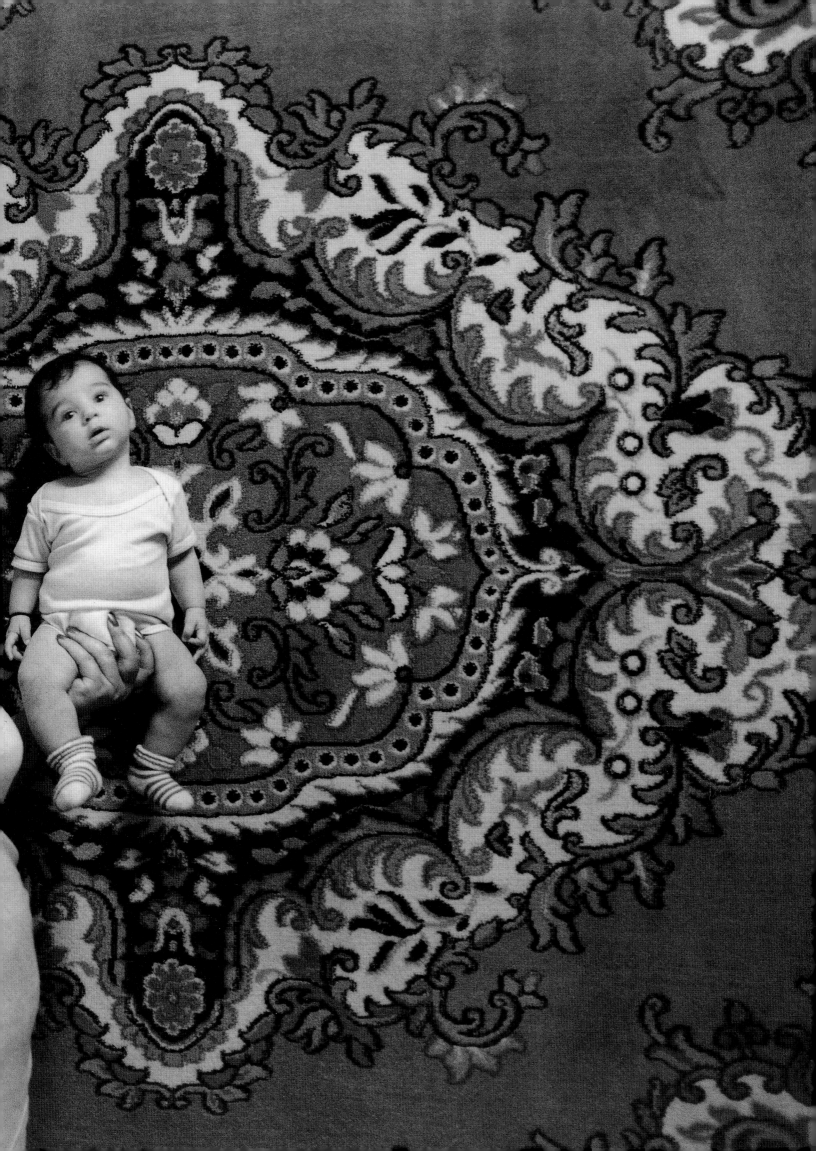

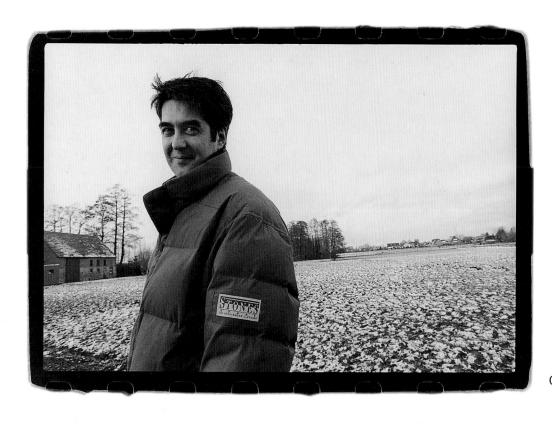

Outside Verl, Germany, February, 2000

Nermin Muhić
b. Sarajevo, Bosnia and Herzegovina, 1962

Nermin took his first photography class in 1983 and fell in love with the craft. A year later he got his first photography job, taking I.D. photos of athletes for Sarajevo's 1984 Winter Olympic Games. He went on to study law, but continued to take pictures for both *Večernje Novine* and *Oslobodjenje*, and to exhibit his work in both group and solo exhibitions across Yugoslavia and abroad. When the war started in Bosnia, Nermin began working full time for *Večernje Novine*. He left Bosnia in 1993 and now resides in Germany with his wife, Rehana, and son, Mak.

The first course I took in photography was in 1983, a workshop put together by CEDUS, a photo group based in Sarajevo. That was the first time I started to take pictures seriously and to meet other photographers. I met most of the people still working out there now—Šahin Šišić, Mladen Pikulić, and others. Everybody was already there. Most of them are still photographing—teaching and photographing. It was the CEDUS group that got me going, but for the most part I'm self-taught. Just as in life, with photography you learn from your mistakes and hopefully, you don't repeat them. You just try to get better and to make your own style.

I talked to a lot of people about photography when I was just starting out. I read magazines, books, and then there was the group. But most of the time, it was just me working it out by myself. My first job was for the Olympic Games. I was working for the Olympic Committee as the Olympic Village photographer. I did basic things like photos for the participant's I.D.s and photos of famous athletes who had come as honorary Olympians. As my first gig, it was exciting. I've always been interested in sports.

Nermin Muhić

Those were good times—you could buy Coca-Cola! You'd just open up the fridge, grab a Coke, pop it open and drink. So easy! And there was a lot of it, too—enough for everyone. A friend of mine has this funny story about his first can of Coke. He had tasted Coca-Cola before, but not in a can, you know. And when the Olympics came to town, he finally got his first can. He was so excited. He took it home and it sat on his shelf for months and months. He just never wanted to open it. One day he finally let himself open it, and it was terrible. It had gone bad from sitting there too long. He was so disappointed!

After the Olympics, I continued to hang around with the CEDUS group. Photography was still interesting to me and whoever wanted could stay on, work on their photos and what not. I got a job with the newspaper *Večernje Novine* (The Evening News). Eventually, I also started volunteering for *Oslobodjenje*.

While I was taking pictures, I was also studying law. I wasn't much of a law student, however, as I was much more interested in photography. The main problem was that with my lousy equipment, I wasted a lot of time. Even before the war it was tough to really practice without enough film, paper, or anything. This is what forced me to develop a talent for improvisation. I'd build my own filters, mix my own developers from whatever I could get my hands on. You had to know photo-chemistry. This proved to be helpful during the war.

Film was particularly tough to come by. You had to ration yourself. I tried to shoot about two rolls a day, which was very restricting. It's hard to concentrate on doing something good when you're always counting how many frames you have left.

Once the war began, I stopped shooting for *Oslobodjenje* and started full time at *Večernje Novine*. It was a great paper, even though it's the smaller one of the two. Everyone was really tight, very friendly. Especially during the war, everyone got to be very close.

I wasn't really aware that there was going to be a war. Most of us were simply living a good life. I just wasn't interested in the talk going on around me: will there be war, won't there be war. I was, as always, an optimist.

Even though everyone else knew there was going to be a war, I didn't believe it. Then suddenly, we were in the midst of it. It was like waking up one morning with fire and thunder all around you. And because it was all new, we didn't know how to behave. I led a normal, quiet life up to the start of the war. But as soon as it began, you also began to learn. It was just like being in school. You had to learn to survive. You had to learn how to protect yourself—just like a child. In those situations, you had to be on your toes all the time. It's very emotional because suddenly, you don't know anything anymore. You're afraid. It's natural. Even the stupid people who claimed not to be afraid, had to have felt some fear—even just a tiny bit. They just wanted to hide it. It's like that old war joke with Mujo and Suljo—such classic, typical Bosnian names! So these two guys are taking a dump and there's a lot of shelling close by. Mujo keeps asking Suljo, "Are you scared, are you scared?" And every time, Suljo answers, "No." Finally Mujo says, "Then how come you've been wiping my ass this whole time!" It's like that. You know—so scared you don't even know where your own ass is!

A typical day during wartime would mean getting up at around seven or eight in the morning to start a fire, boil some water for tea, get dressed. I would usually have an assignment meeting between eight or nine o'clock then... wherever the day took me. Or sometimes I'd get up earlier and go take pictures on my own before going into the paper to see if they had something for me. They'd frequently give assignments earlier, but still you'd go in to check if they had anything for you, maybe show the pictures you'd already taken. If they liked what you had, they'd send you out to take more—and those were always the most real, the most beautiful ones. We were all locals. We knew where to find things, we felt free just ambling around, following our instincts. A lot of my photographs were featured in the paper as big photos with short captions accompanying them because they didn't need a lot of commentary. That was one of the really great things about *Večernje Novine*. Big on pictures, light on text. I worked with an amazing editor who fought for the news, and he is considered one of the legends—been there at least thirty years as a journalist.

I was born and raised in Sarajevo. I left the city in February 1993—almost one year after the war started.

I was sent to Zenica on assignment, and I was supposed to take my photos and go back but Sarajevo had been blockaded. I got stuck in Konjic, between Sarajevo and Mostar, and wound up staying there for about three days before deciding to go to Croatia. I didn't have a clue what to do. The only thing I had with me was my camera.

My family was as scared for me as I was for them. I called them from Konjic once I finally arrived. I told them I'd stay put for a few days, then would see if the situation had cleared up any. But it just kept getting worse. I ended up staying with friends, people I barely knew. I tried never to stay in one place for over three days. I never wanted to outstay my welcome. Finally, one of the people I was staying with offered to drive me to Metković in Croatia, though he couldn't guarantee anything. We had to prepare papers for both the Bosnian army and for the Croatian army. As we approached each roadblock, he said, "This is really important. Don't mix up the papers. Got it? You make a mistake and they take you out of the car and that's it. You're never seen again." We came to a roadblock and I looked at the guard and he looked at me. I said to him, "I know you, I know you from the coffee bar." He said, "Yeah." It got very quiet, very suspenseful. Finally, he said, "Go." I got back into the car. "That was close," I said to the driver. He looked at me and said. "I don't know how you got away with that either." We finally made it to Metković, which at that time, seemed as far away as New York.

I had never thought about leaving Sarajevo before that. We were too busy to even think about it. And to a certain extent, I missed Sarajevo once I left, but it was also a case of "out of sight, out of mind." I'd like to go back to visit but my status as a refugee doesn't allow me to. And anyway—so much time has passed. That was almost eight years ago. And Sarajevo is pervaded by a very pessimistic attitude, especially when you have kids. At least here, if you haven't made it, you can build something for your kids. Of course, I still help out the family I left behind. I send them money.

I love that city as much as ever, but it's a bad situation right now. Even without any shooting, it's no good. People are not dying directly, but everyone suffers slowly. Everything is at a standstill—there's no industry. No

jobs. They should have fixed the factories first. People need jobs to have something to focus on. It's not just important to have the money, it's equally important to have something to do with yourself, to keep from thinking about things too much.

As far as I know, there's nobody over in Bosnia doing serious art photography. It's all commercial. It's not that there aren't a lot of ideas or people wanting to do art photography. But you have to have money to survive. It's so difficult. Plus there's nobody there to organize it. Someone—and I know the very person for it—should start a club. I've heard the new photographers are pretty bad, but then they're young. They could learn. Most of the good photographers left or were killed. The new people who are on their way up need some encouragement, they need to be pushed.

Many of the people in my family stayed behind, but a lot went to the U.S., a lot went to Germany, to Austria. My parents, were in Sarajevo at the time. They're both originally from Bijeljina, the Serb half of Bosnia. It's a horrible place. It was the first town to be attacked by Arkan, the infamous Serbian paramilitary leader. For a big family, we're very lucky. None of us got hurt. I did lose a lot of friends, however. And there are probably more that I don't know about yet. Some of our best, most talented people were killed.

During the war, I met a number of foreign journalists and photographers. We more or less served as guides for them. They didn't have a clue about what was going on. They were smart to ask us, the local photographers. They were always a little on edge—maybe from their guilty consciences. They were only there because of the war. We were making nice photos, and then they were sent in looking for gore: blood, flesh, and more blood. They wanted to testify about the reality of war, how horrible it is. And after all, war isn't a war without dead bodies. But war is a whole set of other things too.

The foreign photographers would come in for a week or so, then they'd be out of there. Not that being in Sarajevo for even a short period of time wasn't risky. But they'd have film to burn, they'd get the shots and the money. They would be able to do whatever they wanted. As for us local photographers, we never thought about

big success as a photographer—about building a big house, buying a boat, or any of that. It makes me a little angry, a little sad. But that's the way it is. If they do want to take the risks, then they should make money, sure. But it's not the same, even though there were a lot of good photographers who came in to shoot. I think if we could pit ten of our photographers against ten of theirs, we'd have a pretty even fight!

I'd say that compared to the bloody photos that foreigners came in and shot, mine breathe differently. There's something personal about them. They have their own life. I still think of myself as an art photographer. I'm interested in something else. Even the photos I took in the war have a different angle—they're more interesting to me.

The strange thing is, that I have to admit that during the war I gained a certain self-assurance. I got to know in an instant if a shot I'd taken was good or not. It opened my eyes, helped me to frame more carefully. The shortage of film made me a better editor—I had to make sure that each frame would count. In short, it was an education and a great opportunity to improve. It was positive in that respect, but tragic at the same time. That type of ordeal sharpens your senses. Your instincts get stronger out of necessity. I don't shoot as much film, but I get better results, better photographs now. You learn to smell what's going to be a good shot, how to pre-visualize. Now in my studio, I go in with a concept, outlined or sketched out on paper. I go in and just make those shots. I know what I want.

Overall I'm satisfied with the photographs I took at that time. They represent one life that managed to survive. They can be horrific, but at the same time, they're life. You didn't really have time to contemplate the shots you'd taken. You just had to go out and shoot more. I look at them now and I feel like they make a certain sense, they have a soul and you can feel that there's something else behind them. I hope people will look at my photographs and be drawn to them. I hope that they'll feel the mix of sadness and joy behind them, that they'll take some time to study them. There are many small details to notice. Like my photograph of the legs of people—they're just waiting in line for humanitarian aid, but at that time, there were so many people missing their legs because of

the bombing, it took on a whole other significance. And that photograph of the star lying on the sidewalk, that was taken the day after the Yugoslav army left their barracks in Sarajevo. This star would have been a JNA symbol. They must have ripped it down before leaving. Or in the photograph of men carrying a pane of glass—glass that size was a rare and precious find—everything had been broken. These are the type of details that wouldn't necessarily mean anything in a different context, but here, they become something else.

When I moved to Germany, I could only get a three- or six-month permit. Without a real visa, I can't get a full-time job. I've gone on some interviews and everything goes well until they look at my passport and see that my visa expires within a few months. It's very frustrating. The competition is pretty fierce among the photojournalists here. Here I'm the one who's the outsider. Basically, what I was doing back home, working as a press photographer, isn't available to me here.

So these days, I do pretty boring stuff. Industrial photography. It's so different. I use a lot of different cameras, large formats, so I'm learning. You never know what you're going to need to know. But it's very slow. You spend hours setting up a shot. I also take pictures of nature. I may try some nudes. My wife doesn't understand why I'm not satisfied with the situation—why I get depressed about not doing the work I want to do.

My life is radically different now. This is not my world—it's another world entirely. You have to adjust, to adapt to the system here and learn new ways of thinking. It's a little bit like looking over a fence and seeing into someone else's garden. We were never aware of those other gardens before, we were only tending our own. Yugoslavia was a closed system. You heard about things on the outside, but it didn't mean much. Maybe people wouldn't fight so much if they learned or cared about what was going on in other people's gardens.

Verl, Germany
January 6, 2000

Nermin Muhić
Overleaf: Waiting in a food line behind a sniper screen
Sarajevo, 1992

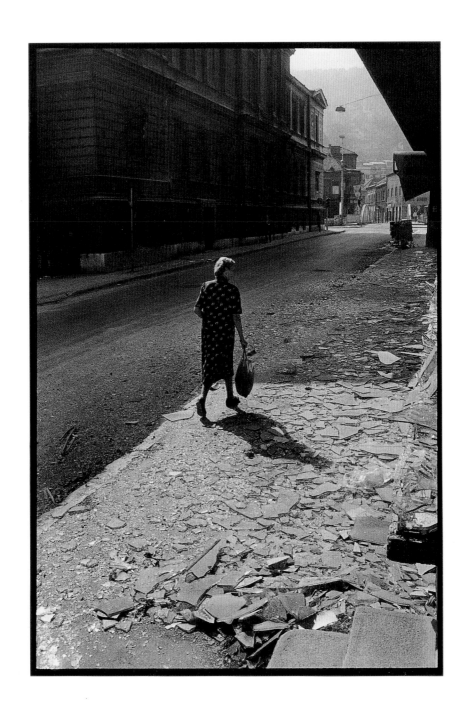

Nermin Muhić
Above: Sarajevo, 1992

Opposite: Sarajevo, 1992

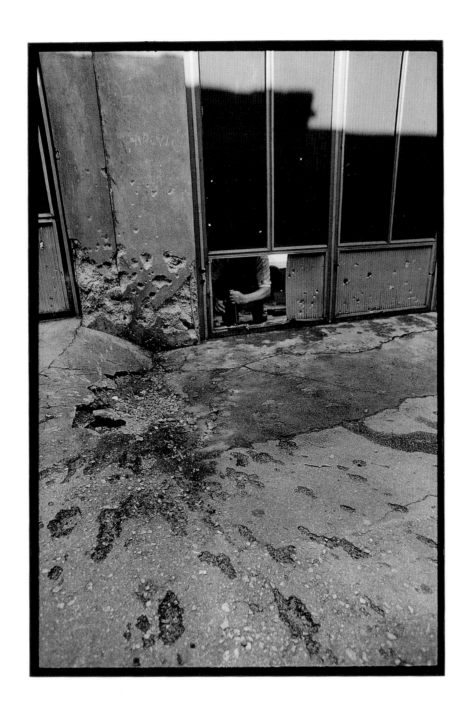

Nermin Muhić
Overleaf: A morgue in Sarajevo's old town, 1992

Muhić walked past this morgue every day. "I always looked inside," he said, "It reminded me of the danger we were all in every day in Sarajevo. I would think to myself, 'Maybe today I will end up here.' "

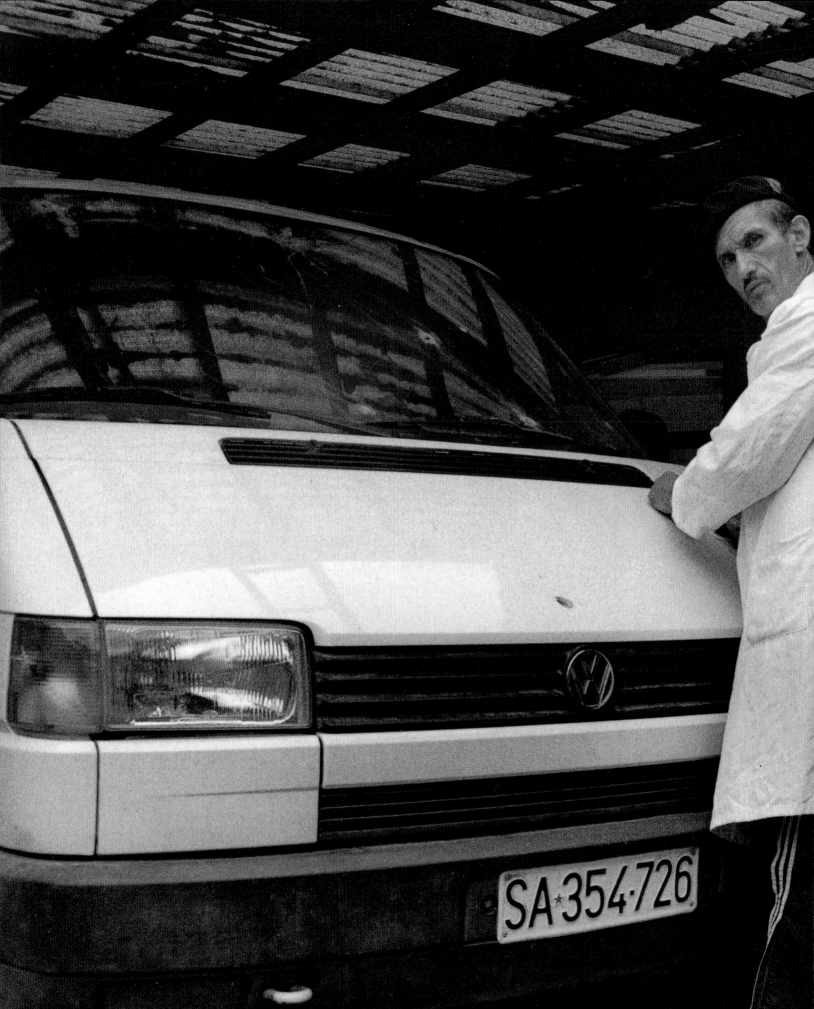

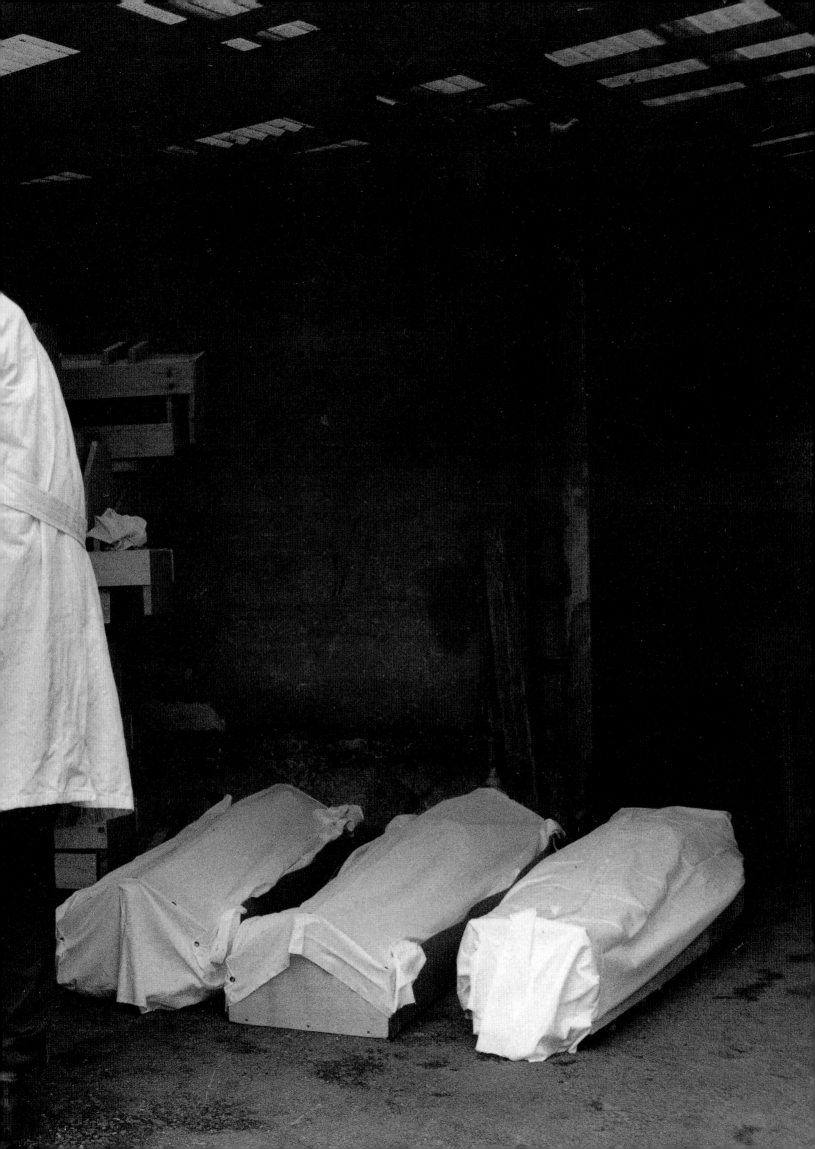

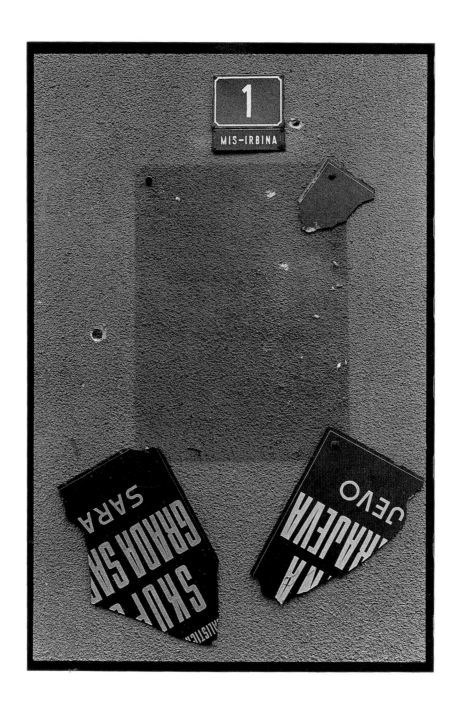

Nermin Muhić
Above: Sarajevo, 1992

Opposite: The Economy Bank of Sarajevo, 1992

"These are the types of details that wouldn't necessarily mean anything in a different context, but here, they become something else."

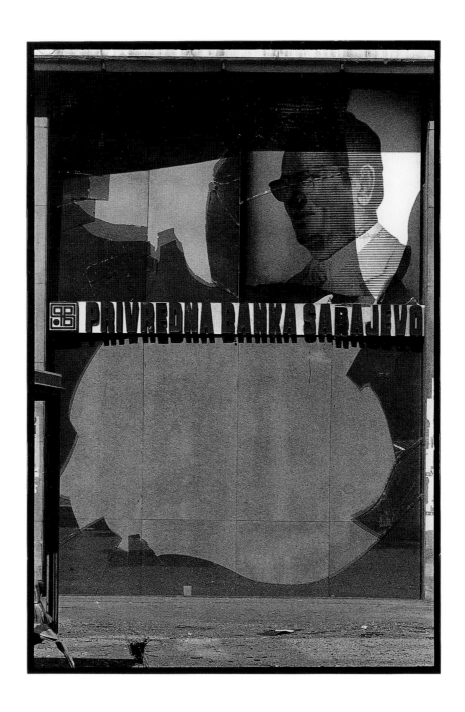

Nermin Muhić
Overleaf: Sarajevo, 1992

A full sheet of glass was a very unusual sight after months of heavy shelling had destroyed virtually every window in the city.

Nermin Muhić
Above: Sarajevo, 1992

Opposite: Sarajevo, 1992

The red star, symbol of the Yugoslav National Army, ripped
from the wall of the army's barracks the day after the army
abandoned the city.

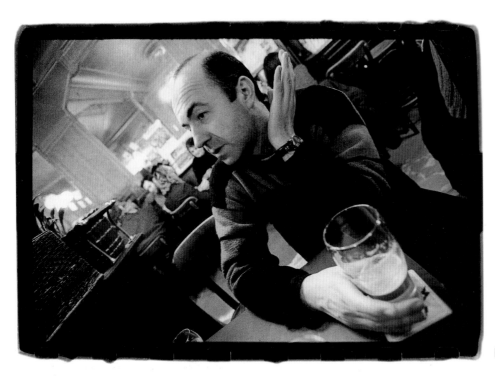

Paris, France, February 2000

Milomir "Strašni" Kovačević
b. Čajniče, Bosnia and Herzegovina, 1961

During the siege of Sarajevo, Milomir Kovačević took over 30,000 pictures. He has been a member of the Association of Professional Journalists since 1986, and a member of the photography section of the Artist Association since 1989. Kovačević's first photographic exhibit was in Sarajevo in 1993. Since then, he has published and exhibited extensively in Belgrade and other cities in the former Yugoslavia, as well as abroad. In 1998, Kovačević received an award from the Crédit Commercial de France (CCF) Foundation for Photography. Today he lives and works as a photographer in Paris.

Either you have luck in your life or you don't. I've only been wounded once in my life, hit by a piece of shrapnel or something. I wasn't even aware at the time—I just heard the clang, looked down and saw that my jacket was torn. I felt inside and found my auto-focus lens—180mm, f. 2.8 aperture. Very expensive, and very strong! You can see where the bullet hit it and bounced off. I almost forgot about that—there was always so much going on. I can't remember when that actually happened, but you can still see the ding in the lens.

I have this other lucky talisman, an old sweater my mother knit me, which has since fallen apart, that had holes from rubbing against the lenses I carried in my jacket. It was like an amulet, a good-luck charm, better than a bullet-proof vest. I also wore it out of spite in those days. Everything was dark and gray and gloomy, and someone walking around in a brightly colored sweater was like, you know…"before." I wore it in protest against those black, dreary war days, and people came to know me by it. There were so many crazy things that people did to cope. To me, that sweater is more important than the Eiffel Tower! In fact, I had my mother make me another one so that I could have two—I had to wash it sometime, right?

Milomir Kovačević

A lot of people thought I had nothing else to wear. They'd bring me an Armani sweater and I'd tell them it meant nothing to me. Actually, the role of the sweater was to set myself off from all those photographers in fancy clothes who strutted around all dressed up, but whose photographs were terrible.

Before the war actually started, we didn't get what was going on. We totally didn't get it. On the fourth of April 1992, we had just celebrated Bajram at the CEDUS club, and we were out on the terrace when we heard the tanks on the move. Before that there were some conflicts, some small-scale shelling in the suburbs, but we just didn't realize what it meant. We didn't know what the fuss was all about: what war in Sarajevo? What siege? What army? But little by little, it started: a grenade here and there, not being able to go to certain areas because of your name. Slowly you just felt it on your skin, you couldn't grasp it, but you certainly felt it.

For me personally, it was the death of my father that finally made me realize how serious the situation was. My father was killed right at the beginning of the war, in our own home. I grew up in that house; I had known most of the people in the neighborhood, but there had been an influx of new people. One night, the twenty-fourth of May, someone broke into the house and searched it for my negatives, destroying all of them, including my photos. Then they killed my father. It was horrible. I couldn't get there until the next morning when I could go with an army police patrol. When I got there the next day, he was still lying in front of the house. No one dared to come close. The very same people are still there, although none of my original neighbors live there anymore. Today that area is more or less ethnically cleansed. People just left or they were harassed to leave. It was an ugly affair, heavily manipulated by all sides, but it happened so fast, one had to move forward in life, fight to survive, get some food every day, take care of the family that's left.

In every village throughout Bosnia, people remember the exact location of every cow killed or stolen, of every house looted, but nobody does anything about it. I'm not saying this to accuse anyone. For each of us, the worst tragedy is his own; it's very difficult to determine whose loss is bigger. A few days after my father's death, I was at the site of the Vase Miskina massacre. You walk among the pools of blood of so many people and think, what is one death in all of this? First they kill a couple hundred people in a suburb, then the other side shells the city as a revenge . You see the sheer madness. There were no rules anymore and that was very difficult to take. So we had to leave our house, but even that wasn't easy because there were people from the Bosnian army who insisted that they could guarantee our safety, which unfortunately was not true.

My whole family history is pretty tragic, but it really doesn't matter if it is only a drop in the sea or that history is merely repeating itself when it hurts you. In fact, we are all just pawns in someone else's game. Fifty thousand died, one hundred thousand fled, here and there. We really were just numbers. That was our identity. People felt themselves no longer as individuals but as puppets manipulated by everybody: by the world, the UN, or I don't know who.

There are a lot of things we don't talk about that happened during the war. We don't want to. That just happened to be our fate and we managed to pull through. There are many things that are much more important. We keep our stories to ourselves and occasionally we can share them with someone who's been through the same ordeal. A lot of things that happened could only be understood by those who were actually there. It's not that there's no need to talk about it, but it's really difficult to explain. The things that happened were extreme, ranging from banal, survival stuff to some enlightening events, some very surreal experiences. Life often had these dimensions. I know from my parents, from a lot of people who lived through it; they talk about it, but they always say at the end you will never understand how it really was. You had this incredibly heavy feeling all the time.

Also, you don't want to build a myth. We weren't just witnesses, we had an active part in everything that happened. It's especially difficult to a photographer; how do you fit your personal life in all of that? What is the role of a photographer in those situations? How objective can you be as a photographer; how much of your work is subjective? Those are all hard questions.

People who have never been to Sarajevo are always trying to show that it was like this or like that. People who were from Sarajevo and there throughout the war, were trying to make something out of nothing, to somehow find beauty in it—something, anything just to survive. We were always trying to find something different—that certain "smile," stains and all. Those things tell us more about ourselves during war than all the other photographs. There was a lot of destruction and demolition, but there was also something else, too.

In essence, the war did not change my photography. I was never doing it for money or stardom. I had always been a photographer of Sarajevo, chronicling everything. I just took photos of what surrounded me and I continued doing just that in war, although, of course, the conditions were different. People have always been my primary focus. In the beginning, I was like others, taking pictures of death, of destruction. But after a while, you become kind of saturated with such sights. You see it every day and it becomes a norm; you're not moved by it anymore and you start seeing and doing different things. These are the things that are not necessarily obvious to western eyes, to the people who came to that hell of war from somewhere else. To me, it was the end of civilization, but for them it was par for the course. They expected to take photos of dead people. For me, photography was about the only thing that enabled me to satisfy some of my psychological needs in those days; perhaps I created my own world in my photographs, which essentially helped me survive, mentally. I know it helped a number of photographers who hung out together and supported one another. Those photos boosted their morale, gave them a desire to live, to have a future and to overcome the moment. I think the most positive thing was the work itself, because the work helped you forget a little. Through this work you were resisting. As a photographer, I don't belong anywhere else except in the world of photography. Of course, there's pressure to fit in here or there, to this cause or that cause, but I am my own person. I have my own vision, which you can see throughout my work, and it all makes sense. Perhaps it means more to the people from Sarajevo who surrounded me; they get it. They understand what the work is all about and I don't feel the need to go further than that. If one doesn't work during such times, all you have is the horror.

Conversely, the majority of photojournalists came here to make money first, or they came with images already made in their mind, images they needed as proof of certain politics or whatever. I mean, there was a range of visiting photographers, from the very good ones with the noblest of intentions, to those who were just opportunistic adventurers, but as in every other war, that's to be expected. Some of the foreign photographers I met were very encouraging and supportive. There were also photographers from Sarajevo who worked for foreign photo agencies, who were mostly looking for a way to make money off it; some of them followed closely what was published in the foreign press. I didn't even want to look at it. I just did how I felt at the moment—not a deep philosophy. But I knew and photographed every corner of Sarajevo, I knew a lot of people, I suffered as others suffered: shelling, being wounded, family loss, scavenging for food every day, fetching the water, walking around everywhere, all of the things that make up life in war, as opposed to those who are accommodated in a hotel, there's food, they have transportation, they don't worry about their I.D.s. That's a completely different experience.

So my photographs may be different because; I was a participant in the war—a victim, or whatever. But on the other hand, I really didn't fit in because most people were full of hatred, of resentment. Instead, I was working and trying to keep my family's and my friend's spirits high, to energize people. I didn't have any restrictions on my work, I could do whatever I wanted. I gave away a lot of photos to people around me. Was it brave or stupid that I was taking those photos, I don't know. After all, it wasn't for three or four years after my exhibition of the unidentified graves series that the truth about those events started being examined and published. I photographed instinctively, even against my better judgment. For that series, I had to go under cover of fog, early in the morning, before the raids and everything, so that no one would see me. It was a big challenge and I'm very fond of that series.

Many of the photos in that series are of grave sites of babies that died during birth or a few days later. They mostly died because they didn't have a chance, a consequence of lousy hygiene or a lack of water, or electricity, or whatever. In some cases, the parents didn't have the

time to give them a name or report their birth to the authorities. There were different ways that deaths were registered and labeled during the war. The number is the number under which the victim was filed in the books. Sometimes there is a number for the location as well so they know when and where the person died. But again, this is the story of the war. In this war, a transformation of victims occurred. In the end, it doesn't matter if they were Serbs or Muslims. People died all the time in World War I and World War II, but they still got headstones with names and even photos on them. Now it's just a mass of human beings with just numbers or a piece of wood marking that they never had a chance. I could have easily ended up in that cemetery. I know that somewhere in there is Zoran, the man from the photo-club who taught me photography.

When I exhibited those photos of unidentified graves in Sarajevo during the war, each photo had a candle in front of it. There was no electricity, but at least we had candles. I thought we owed them that much—a requiem of sorts. The exhibition of each photograph lasted only as long as the candle in front of it burned. A lot of people came to see it, even though we couldn't put up posters with the date and time printed on it for fear of the exhibition being shelled. But I think it meant a lot to those who came. At one of my exhibitions, you literally had to risk your life to get there. People had to cross a bridge where snipers were shooting and where there were regular raids. Nevertheless the place was packed, with perhaps about five hundred people. It was very encouraging—I mean it's nice when you have an exhibition, like they do in the West, and people show up, have a drink and chat; but when they risk their lives to get to the exhibition, it means much, much more. That really gives you a will to continue because that proves that it means something to other people.

I was born in Tito's time, Tito's era, in Yugoslavia. For us, Tito was a symbol of everything good. We were not so religious, but we always had Tito's photos around, in schools, in public spaces. It was our national religion in a way. So, the whole concept of Yugoslavia was closely connected to the image and work of Tito. This is what inspired me to photograph the ruined Tito portraits during the war. I had done another series of pictures of Tito, which were on display in the shop windows earlier,

before the war. In those images, the very background elements of the pictures are revealing. As the times changed, so did the way in which the photographs were displayed. Those photos reflect what was coming: no aggression yet, but you can sense the nationalism surging forward. You ask how it felt to see these images of Tito ruined? Well, they are not completely destroyed for me, the image is still living. But they do have a different meaning now. The fact is, the country that was behind Tito's image was also destroyed. When the country was destroyed, symbolically those photos shattered as well. And both were destroyed by the same weapons Tito had used to hold things together and to keep him in power. His own army, his own weapons, his own machinery. They were meant to defend the country from the outside and to serve different politics, but they fell into the wrong hands. Maybe that's our history, the consequence of our politics. I mean, when someone here in the Balkans dares to "fly high," we like to drag him down once he's gone.

We need to realize that political systems do not last forever, and history is a flow. How people see this history depends on how firmly they have embedded in their minds the information and pictures from their own government and CNN; they have a certain image of war and it's very difficult to change those concepts. History is already written, it is not necessarily truthful, and it's different coming from someone who was actually in that war. But I wonder how willing people are to change their views. Maybe the idea of Yugoslavia in a new form—based on new principles, with everything new—maybe that provides hope that this madness may bring something good after all.

Paris, France
May 31, 2000

Milomir Kovačević
Overleaf: From the series of photographs of anonymous graves, Sarajevo, 1994

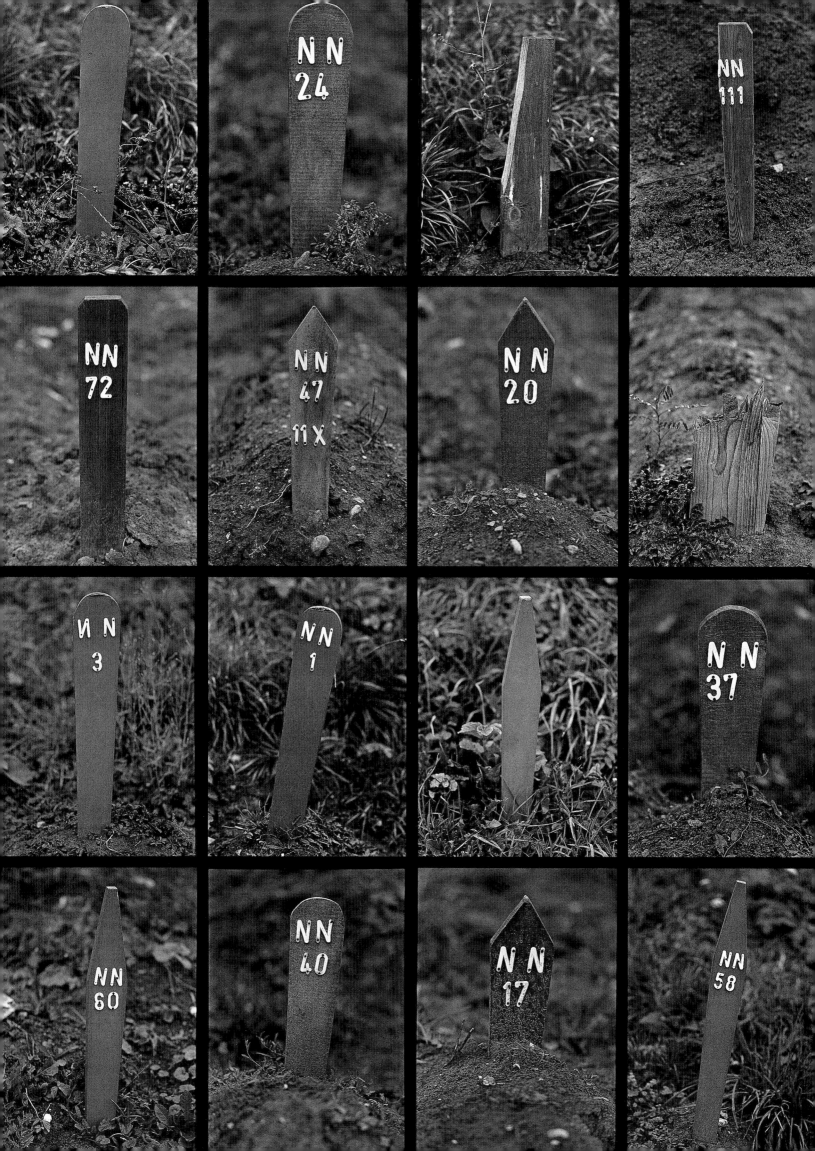

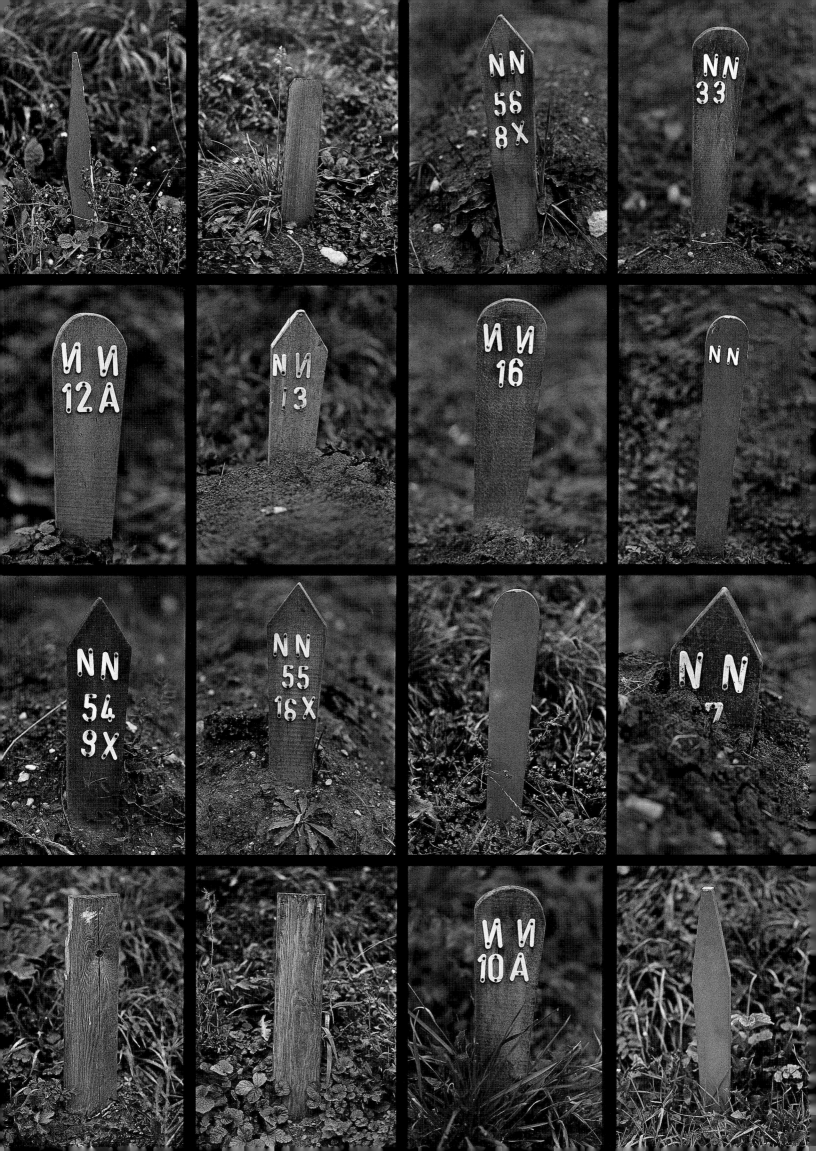

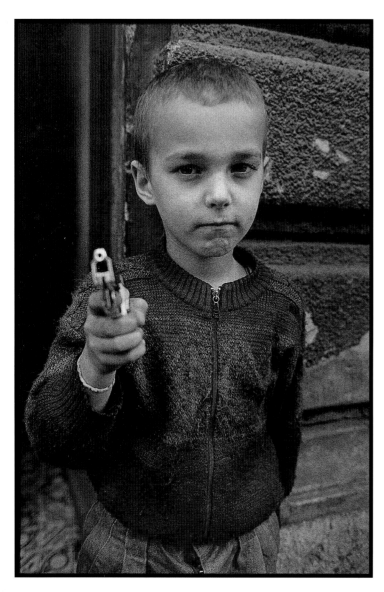 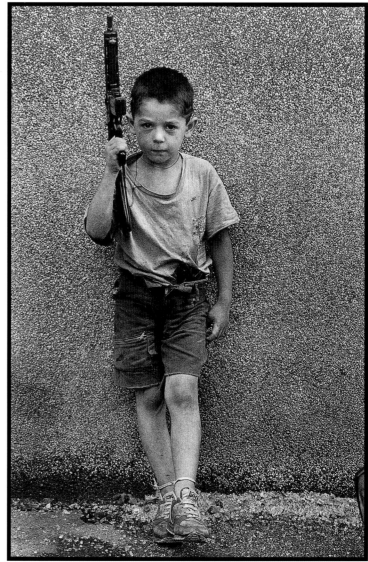

Milomir Kovačević
From the series "Children with Guns," 1994
From left to right: *Mržnja* (hate); *Solčić* (Little Soli);
Frank Canton; *Dječak sa Mitraljezom* (Boy with machine gun)

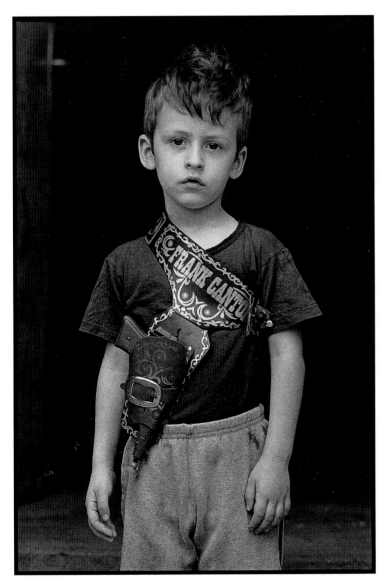
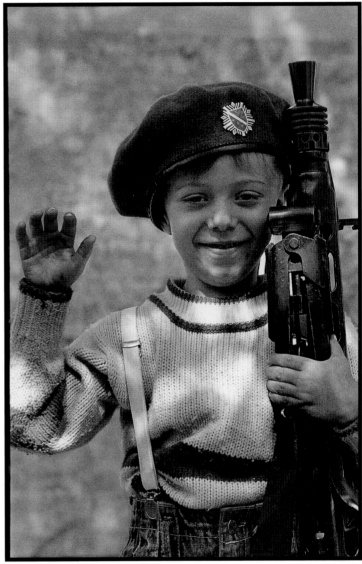

"The kids from families whose members were killed with guns like these, are the same kids playing with guns.... Maybe that's the horrible story from this war. Maybe in ten, fifteen, twenty, years, when these kids grow up to be men, these same things will happen again."

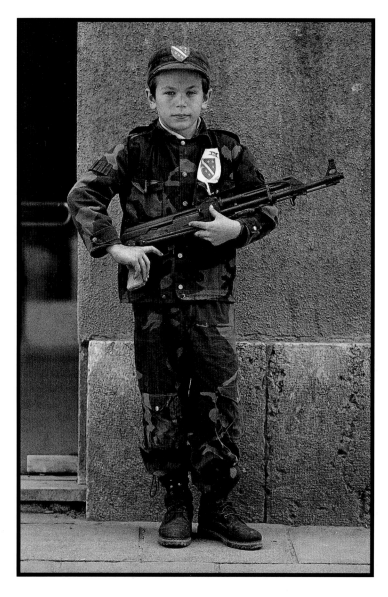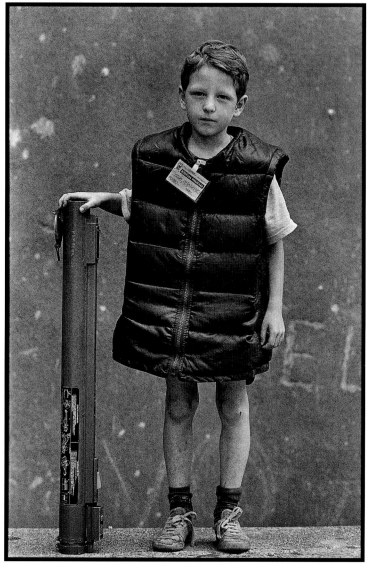

Milomir Kovačević
From left to right: *Mali Vojnik* (Little soldier); *Vanja*; *Jasa*;
Miki Maus (Mickey Mouse)

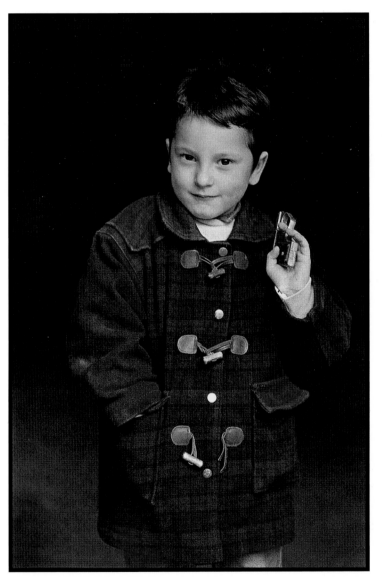

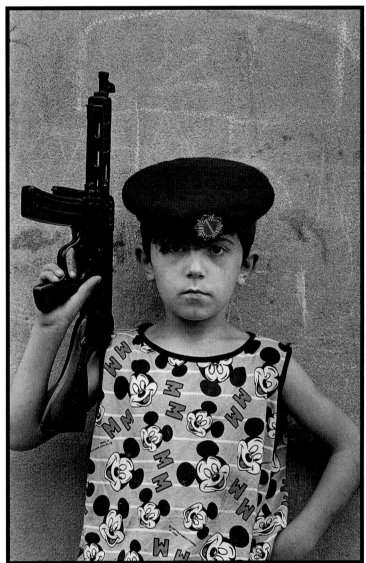

Following pages: From the series "Tito," Sarajevo, 1992–1995
Portraits of Tito, found in the ruins of homes, offices, and
schools throughout Sarajevo.

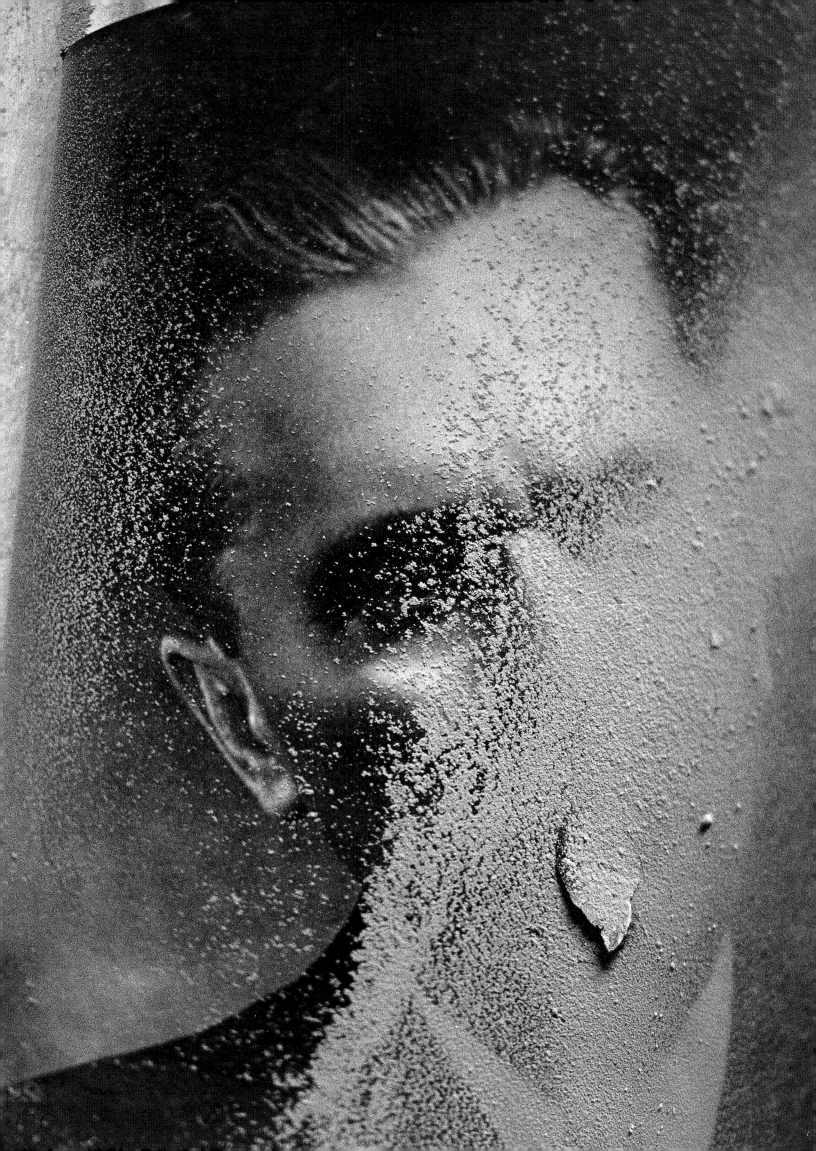

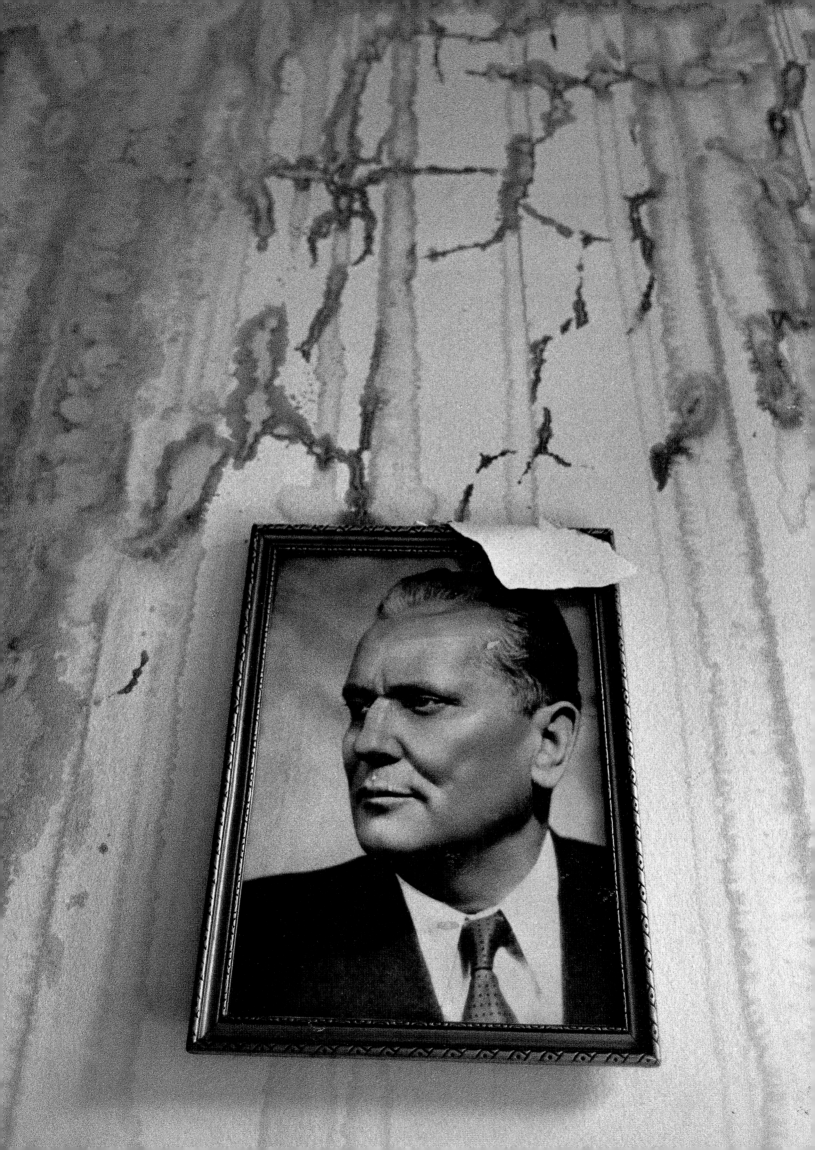

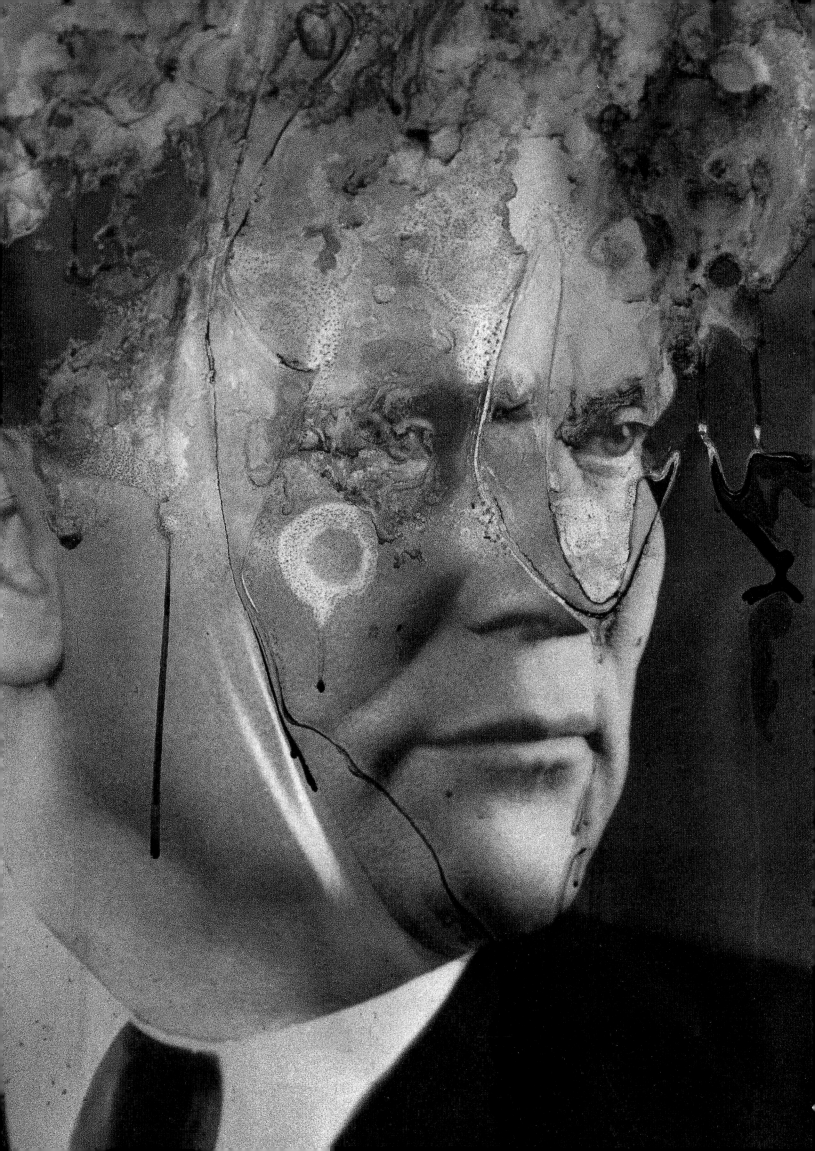

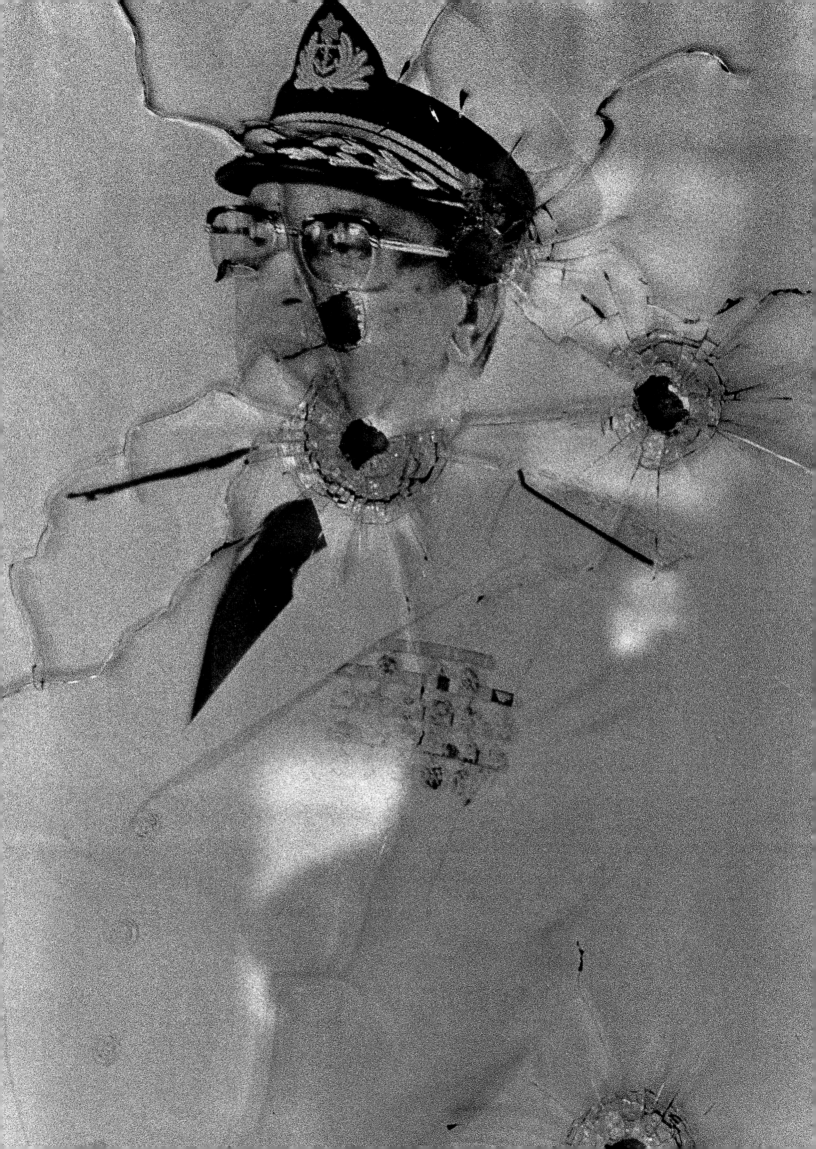

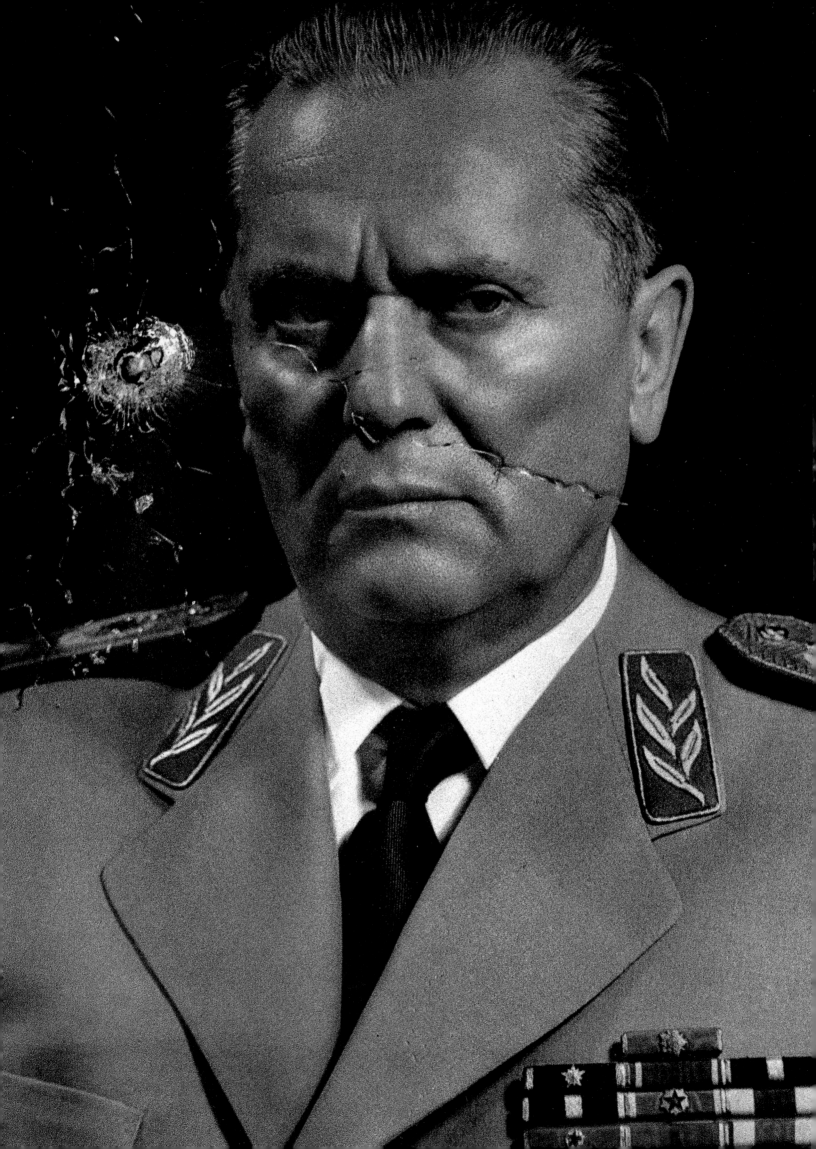

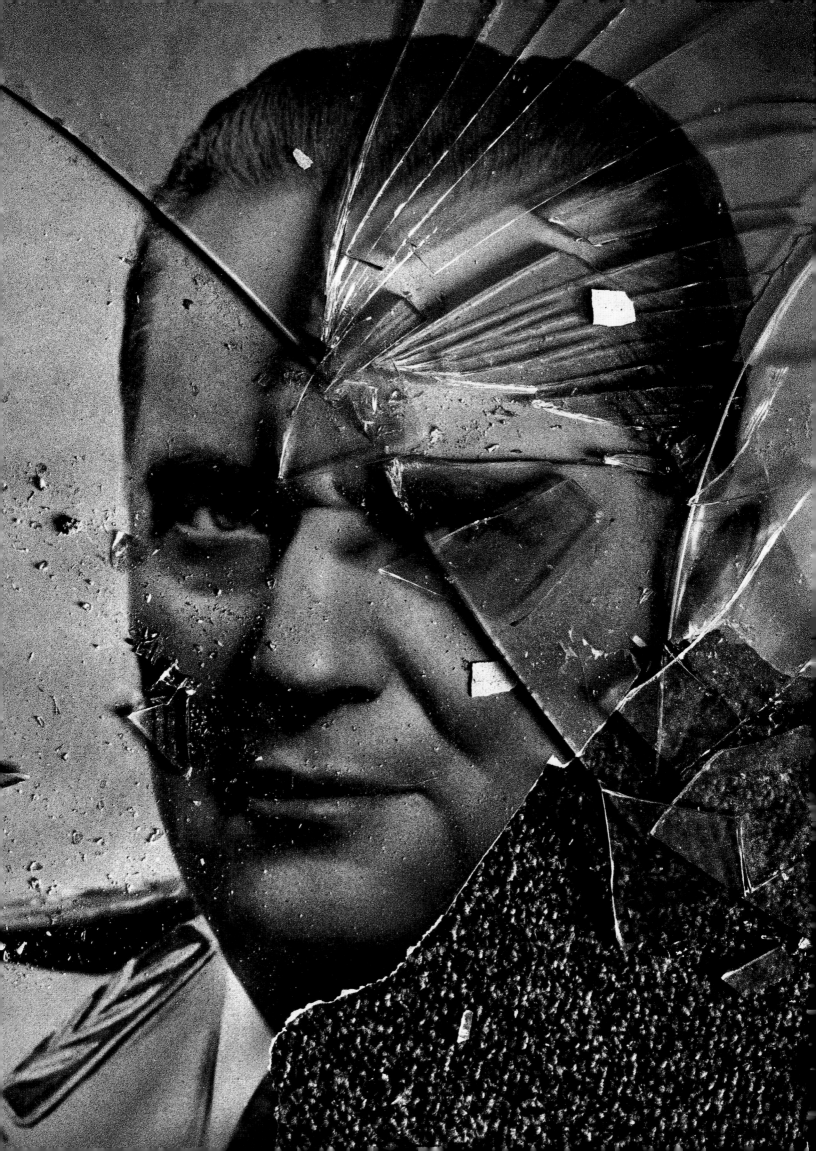

HISTORICAL BACKGROUND

6th to 14th century:

Slavic tribes, including the forefathers of today's Serbs, Croats, and Bosnian Muslims, cross southward over the Danube River and settle in the Balkans, a mountainous region partially populated by Illyrian tribesmen who are the forefathers of today's Albanians. Many settle around the mineral springs at Ilidza, a suburb of modern-day Sarajevo. A number of substantial but ephemeral Slavic states are created during medieval times. The largest of these is the Serbian Nemanjić dynasty, which flourishes from the mid 12th to the mid 14th century. Modern-day Serbs consider the Nemanjić dynasty to be the "Golden Age" of Serbian culture and political power.

14th century:

The Ottoman Turks begin their advance into the Balkans. The region's Christian principalities fail to muster an effective combined resistance or secure sufficient military support from the larger European powers. On June 28, 1389, Serbia's Prince Lazar and his allies, including Albanians and Bosnians, fight the invading Ottoman Turks to a draw at Kosovo Polje. The battle, however, deals a fatal blow to the medieval Serbian state, and the Ottoman Empire eventually completes its conquest of Serbia in 1459. Among the Serbian people, however, a mythological cycle develops around the Battle of Kosovo, depicting it as a cataclysmic defeat in which the flower of the medieval Serbian aristocracy, including Prince Lazar, died as martyrs. According to legend, at the opening of the Kosovo bat-

tle, the Turks offered Lazar the choice between surrender and a fight to the death. Lazar chose to fight. Six hundred years later, Serbs still recall the epic poems about the battle and make pilgrimages to pray before Lazar's mortal remains at Gračanica monastery in Kosovo.

15th to 17th century:

The Ottoman Turks seize Constantinople in 1453 and extinguish the Byzantine Empire. In 1463, they conquer most of Bosnia and make Sarajevo the capital. In 1521, they take Belgrade. In 1526, they conquer Hungary. And in 1529, they push to the gates of Vienna before being repulsed. Ottoman sultans rule the Balkans for most of the next 400 years. The stability, prosperity, religious tolerance, and administrative efficiency of their regime are initially far superior to the conditions that had existed within the petty feudal principalities conquered by the Ottoman armies. After a few decades many Bosnian and Albanian Christians have converted to Islam. But the Ottoman Empire's stability is dependent upon wealth acquired through constant military expansion, and this expansion is halted in 1683 with the rout of an Ottoman army before Vienna. The Ottoman ruling elite subsequently proves to be incapable of engineering effective changes in the empire's system of government. Law and order gradually break down. Corruption and inefficient administration become the rule. Local rebellions present the rising European powers, Austria and Russia, with opportunities to intervene in the Balkans.

At the conclusion of the war of 1683–99, Austria forces the Ottoman Empire to sign the Treaty of Karlowitz, in which the Ottomans surrender most of Hungary, Croatia, and Slavonia. This agreement establishes a relatively stable Austrian-Ottoman frontier along the Danube, Sava, and Una rivers for more than the next two centuries.

18th century:

Russia extends its borders southward to the Black Sea at the expense of the Ottoman Empire. With a treaty in 1774, Russia wins the right to intervene on behalf of the Ottoman Empire's Christians in their relations with the sultan's government. Ottoman authority in the Balkans continues to erode.

19th century:

Supported by Russia, Serbs living in central Serbia rebel in 1804 and 1815 and win autonomy within the Ottoman Empire. The principality of Serbia is created after Russia deals yet another defeat to Ottoman forces in 1829. Thereafter, the disposition of the collapsing Ottoman Empire's remaining Balkan territories becomes a bone of contention between Austria, which looks to expand toward the southeast, and Russia's ally, Serbia, which wants to expand its territory to include regions within the Ottoman Empire that have significant Serb or Slavic populations. These regions include Kosovo and swathes of northern Albania, Bosnia and Herzegovina, and the lands that today make up Macedonia. A feudal uprising against Ottoman landlords in Herzegovina in 1875 sparks a major European war. Serbia, Montenegro, Romania,

and Russia join the fighting, which lasts until 1878 and ends with the Ottoman Empire's defeat. The subsequent Congress of Berlin in 1878 enlarges both Serbia and Montenegro but, to Serbia's chagrin, allows Austria to occupy Bosnia and Herzegovina. Austria ignites a major international crisis in 1908 by annexing Bosnia outright. Macedonia, Albania, Kosovo, the Sandžak of Novi Pazar, and parts of northern Greece and Bulgaria are now the only Balkan lands left within the Ottoman Empire.

1912–1913:

By the turn of the century, the power of the Ottoman Empire has waned dramatically. In 1912, the Albanians of Kosovo mount an uprising and throw off their Ottoman overlords. But before they can join with the Albanian clans of Albania itself and form a united Albanian nation-state, Serbia's rulers spot their chance to avenge the mythical defeat at Kosovo Polje in 1389. The government in Belgrade quickly bolts together an alliance with Bulgaria, Greece, and Montenegro. They attack Ottoman forces all across the northern Balkans and drive them almost to the gates of Constantinople. Serbia wins control of Kosovo and other lands; Macedonia is divided between Greece and Serbia; and an independent Albania is formed.

The borders drawn in 1913 become the basis for the modern map of the Balkans. But instability will continue to plague the region, largely due to conflicting Austro-Hungarian and Serbian claims over Bosnia and Herzegovina and discontent among the Albanians of Kosovo,

Chronology

who suffer repression under heavy-handed Serb rule.

1914:

On June 28, 1914, a young Serb revolutionary assassinates the Austrian archduke, Franz Ferdinand, and his wife in front of Sarajevo's national library. The killing gives Austria a pretext to settle scores with Serbia. Austria issues an ultimatum demanding that Vienna be allowed to join the murder investigation and suppress secret nationalist societies within Serbia. When Serbia refuses to comply, Austria declares war. Russia rushes to Serbia's defense and Europe's great military alliances face off in World War I. After four years of brutal trench warfare, Germany is defeated and Austria-Hungary destroyed.

Interwar years:

The dissolution of the Austrio-Hungarian Empire necessitates a redrawing of the borders in the Balkans. Slovenia, Croatia, Vojvodina, Bosnia and Herzegovina, and Montenegro become unified under the Serb-dominated Kingdom of Serbs, Croats, and Slovenes. Nationalist animosities, religious rivalries, economic disparities, language barriers, and cultural conflicts plague the Kingdom from its inception, and the question of central rule from Belgrade versus local rule from Zagreb bitterly splits the Serbs and Croats. After a period of political chaos, King Aleksandar Karadjordjević declares a royal dictatorship in 1929 and renames the country the Kingdom of Yugoslavia. He is assassinated on the streets of Marseilles in a plot hatched by nationalist Croat extremists in 1934.

World War II:

During World War II, Europe's Great Powers once again fight for control of the Balkan Peninsula. After a failed attempt to remain neutral, Yugoslavia is invaded and dismembered by Nazi Germany. The Germans, looking for an inexpensive and easy way to manage the country, create an independent Croatian state, which includes Bosnia and Herzegovina and barely enjoys a fifty-percent ethnic-Croat population. Hitler gives control of this Croatian state to the same extremists who had killed King Aleksandar, and they promptly set out to create an ethnically pure country by lashing out at minority Serbs, Jews, and Gypsies, killing them wholesale along with communists and homosexuals. This unleashes an interethnic bloodbath that claims hundreds of thousands of lives. After gaining support from Great Britain, the communist Partizans of Marshal Tito emerge as the victors in Yugoslavia's civil war without significant help from the Soviet Red Army.

1945–1979:

Yugoslavia is reborn as a communist federation on November 29, 1945. Tito's communists remain loyal to the leader of the communist world, Stalin, until a dramatic split with Moscow in 1948. A Soviet-led economic blockade compels the Yugoslav communists to devise a hybrid economic system, known as socialist self-management, and seek economic support from the capitalist nations of the West. In the 1950s, the self-management system produces one of the most rapid developmental take-offs in recorded history. But within a decade Yugoslavia's

growth curve levels out and the economy does not create enough jobs to absorb an expanding work force. In an effort to reduce rising unemployment and attract foreign-currency income, Tito opens Yugoslavia's borders so its workers can seek jobs abroad.

1980–1990:

Marshal Tito dies on May 4, 1980. Despite large foreign loans and hard-currency remittances from Yugoslavs working abroad, the country's economy nears total collapse. It is briefly energized in 1984 when Sarajevo hosts the Fourteenth Winter Olympic Games. The republic's Muslims, Croats and Serbs work together to transform the Bosnian capital, clearing trees from the wild mountains surrounding Sarajevo and building chair lifts, ski jumps, and Olympic housing. Despite pulling off engineering feats on time to Olympic perfection, Sarajevo fails to burst onto the international scene as a ski resort and by the late 1980s, with inflation driving up prices by the hour, the entire country is on the verge of economic collapse.

The economic chaos brings political instability. With the rise of Mikhail Gorbachev in Russia and the opening of Soviet society in the late 1980s, it becomes clear to the communist leaders of Yugoslavia that sooner or later they will have to surrender their monopoly on political power and allow free elections. Slovenia's communists begin demanding democratization of the country. Serbia's communists, led by Slobodan Milošević, oppose it. Milošević rose to power by exploiting the anger of minority Serbs in Kosovo, who have been

complaining for years of discrimination and repression by the region's ethnic-Albanian authorities. Milošević forces out the ethnic-Albanian leaders of Kosovo and introduces a repressive Serbian regime. Serb riot police crush Albanian protests. An explosion of nationalist hysteria in Serbia, stage-managed by Milošević, leads to a nationalist backlash in Croatia and calls for Croatia's independence. In Bosnia, too, the Muslims and Croats form nationalist parties and advocate splitting from a Yugoslavia that looks more and more like it will become a Serb-dominated dictatorship under Milošević. Serbs in Croatia and Bosnia are loath to become part of an independent Croatia or Bosnia. They see their future with Serbia.

The War

1991
June:

Slovenia and Croatia declare independence and European Union nations recognize the newly-created states. The Serb-dominated Yugoslav army mounts a half-hearted effort to stop Slovenia from breaking away, but it fails within ten days. Fighting begins in Croatia within days.

September:

The United Nations imposes an arms embargo on all the republics of the former Yugoslavia, thereby locking in the firepower advantage of the Serbs, who had taken control of the weapons stocks of the Yugoslav army.

December:

After four months of fighting, including attacks on the historic

old town of Dubrovnik and the destruction of the town of Vukovar, Yugoslav Army and Serb irregulars take a third of Croatia's territory.

1992
January:
United Nations negotiators broker a cease-fire between the Croatian government and the Serbs. The United Nations Protection Force (UNPROFOR) is created with its headquarters in Sarajevo, which is believed to be the safest place because Bosnia is perceived as neutral in the war between Serbia and Croatia. Eventually 14,000 peacekeeping troops are deployed in United Nations Protected Areas, whose boundaries line up with those of the Serb-held areas of Croatia. Thus, the United Nations acts as a protection force for the Serbs. This allows Milošević to transfer his military forces to Bosnia.

March:
Passionately opposed to becoming second-class citizens in a Milošević-dominated rump Yugoslavia, Bosnia's Muslims and Croats vote for independence in a referendum boycotted by most Bosnian Serbs.

April:
The United States and European Union nations recognize Bosnia and Herzegovina as an independent state. Serbia and Montenegro form a new Yugoslav federation with Slobodan Milošević as its paramount leader. Serbs under Milošević's control launch a war in Bosnia aimed at carving away Bosnian territory for a Greater Serbian state. Thousands of people stage a peace march in Sarajevo but Serb snipers sta-

tioned in the Holiday Inn open fire on them. Within a matter of weeks, the Bosnian capital is under siege and suffering daily artillery barrages. The Bosnian government, arguing that it is now the legitimate government of a recognized, United Nations member-state facing foreign aggression, calls for a lifting of the United Nations arms embargo against it.

May:
The United Nations Security Council imposes economic sanctions on Serbia for backing the rebel Serbs' carve up of Bosnia. Sarajevo is repeatedly shelled; on May 27, the crowded Vase Miskina marketplace is hit.

August:
Viewers worldwide are shocked by television pictures of emaciated Muslim prisoners in Serb-run concentration camps in Bosnia. But at a conference in London, world leaders decide neither to lift the United Nations arms embargo nor to intervene militarily to stop the Bosnian war. Instead, they agree to send "peacekeeping" troops to Bosnia to protect deliveries of humanitarian aid to the war's victims. The Bosnian Muslims come to be called the "well-fed dead."

1993
January:
The Serb siege of Sarajevo continues. Bosnia's Prime Minister, Hakija Turajlić, is pulled from a UN vehicle and executed by Serb forces in front of French peacekeepers near Sarajevo's airport. Meanwhile, a United Nations–European Union peace plan is unveiled. The Muslims and Croats agree to sign it, but the Serbs refuse and the peace plan eventually collapses. With sup-

port from Croatia, nationalist Bosnian Croats—who sense that the international community will no longer back a united Bosnian state—launch ethnic cleansing operations against Muslims in Herzegovina and central Bosnia.

February:
A large-scale offensive against the eastern Bosnian town of Srebrenica begins a concerted Serb effort to drive the last of the Muslims from the Drina river valley. Thousands of refugees are sent fleeing through deep snow. The government of Bosnia-Herzegovina begins blocking distribution of food in Sarajevo in a protest against ineffective international attempts to call a cease-fire.

April:
NATO begins combat patrols over Bosnia to enforce a United Nations ban on flights.

May:
The United Nations Security Council declares six towns in Bosnia, including besieged Sarajevo and Srebrenica, to be "safe areas" and promises to protect them. Serb forces mount one last drive to take Srebrenica, but are stymied by the Muslim resistance.

June:
NATO offers "close air support" to the United Nations troops in the "safe areas," but the Security Council fails to find countries willing to deploy significant numbers of peacekeeping troops.

1994
February 6:
A shell kills 68 people in Sarajevo's downtown marketplace. NATO threatens air strikes

against Serb artillery positions unless they are withdrawn from around the city. Within minutes of the deadline for withdrawal, the United Nations announces that the Serbs have complied. Numerous violations of the ultimatum are reported, but a temporary pause in the shelling of the city begins and no new NATO air action is ordered.

March:
A US-brokered "federation-agreement" ends the fighting between the Muslims and Croats.

April 10:
NATO launches the first attack in its history, carrying out pin-prick air strikes against Serbs conducting an offensive against the Muslims in the eastern enclave of Gorazde, another of the six United Nations "safe areas."

November:
After Muslim forces from the "safe area" of Bihać overrun surrounding Bosnian Serb positions, the Serb army launches a counterattack that goes unanswered by NATO.

1995
January:
Serb and Bosnian government leaders begin what is supposed to be a four-month truce. They use the respite to refresh their forces and replenish munitions stocks.

March:
The Bosnian army, now almost all Muslim, joins with Bosnian Croat forces and units of Croatia's army in a major offensive in the northwestern corner of Bosnia.

May:
The Croatian army captures the Serb enclave of Western Slavonia, a United Nations Protected Area under the January 1992 cease-fire agreement. The Serbs bombard Sarajevo. NATO launches retaliatory air strikes, and the Serbs take more than 350 United Nations peacekeepers hostage. United Nations commanders and Western diplomats carry on secret negotiations with the Serbs for the release of the hostages and agree to maintain strict neutrality in the future. Serbia, trying to improve its relations with the West in order to win an easing of United Nations economic sanctions, helps to expedite the hostages' release.

July:
The Bosnian Serbs overrun the United Nations "safe area" of Srebrenica after United Nations diplomats and military commanders refuse to call in NATO air action that could have repulsed the attack. Some 7,000 Muslim men are captured and executed by Serbs under the command of Serb General Ratko Mladić. Srebrenica's entire population is expelled. Serb forces overrun Žepa, another United Nations "safe area" two weeks later. More executions result and the United Nations does nothing.

August 1:
NATO threatens to launch major air strikes against the Serbs if the remaining "safe areas" are attacked.

August 4:
After receiving planning support from the United States, Croatia launches a four-day offensive that captures the Serb-held Krajina region, another United Nations Protected Area. Serb refugees flee the area in droves as Croat soldiers kill stragglers.

August 11:
President Bill Clinton vetoes a bill to end the arms embargo against Bosnia and sends his special envoy, Richard Holbrooke, to negotiate a peace treaty.

August 28:
A Serb shell hits the market area of Sarajevo, killing 37 people and wounding 85 others. NATO prepares for air strikes.

August 30–31:
NATO planes and United Nations artillery blast Serb targets in Bosnia. The attacks destroy ammunition depots, roads and bridges, and communications facilities and give the Muslims and Croats the strategic advantage for the first time in the war. Humbled Bosnian Serb leaders grant Slobodan Milošević authority to negotiate on their behalf with Western diplomats. The Bosnian Serbs agree to move heavy weapons and tanks away from Sarajevo. NATO halts its bombing.

September–October:
A Muslim-Croat offensive recaptures 1,500 square miles of land, roughly a third of the territory held by Serb forces. Tens of thousands of Serbs flee toward Serbia from northwestern Bosnia. The United States halts the Muslim-Croat offensive that threatens to unleash an uncontrolled wave of Serb refugees and retreating soldiers that would have threatened the position of Slobodan Milošević. On October 5, President Clinton announces that the Muslims, Serbs, and Croats had agreed to begin a cease-fire and attend peace talks. After a two-day delay, the cease-fire takes effect.

November 1:
Peace talks begin in Dayton, Ohio.

November 21:
A comprehensive peace agreement is reached.

December 14:
The peace agreement is signed in Paris by Franjo Tudjman of Croatia, Alija Izetbegović of Bosnia, and Slobodan Milošević of Serbia. Compliance with the accord is to be assured by a 60,000-strong military force under NATO's command. Troop deployments begin in late 1995.

1996–2000:
NATO troops ensure that the military aspects of the Dayton Accord are fulfilled, but they refuse to assist in the return of refugees to their homes, but rather stated that it was up to the "warring factions" to create the conditions in which refugees could return in safety. By November 1996, one year after the signing of the Dayton Peace Agreement, only 250,000 refugees and displaced persons had returned to their homes, virtually all to areas where their ethnic group formed the majority.

By 1997, little progress had been made and states that had given refugees "temporary protection" status were questioning how much longer they should play host to Bosnians. Some countries began forcibly repatriating Bosnian refugees. Two years after the Peace Agreement was signed, Bosnia had no properly functioning common institutions, no legal definition of citizenship, no strong multi-ethnic political parties and no structured civil societies.

Thus far, over half a million people who left the country during the war have returned to Bosnia from abroad but only an estimated 6,000 minorities have returned to the Serb half of Bosnia. At the same time, Serb authorities have continued to expel remaining minorities as well. Overall, since the Peace Agreement was signed, there has been a net increase in ethnic separation inside Bosnia. Moreover, 1.7 million people affected by the war in Bosnia still remain displaced.

Sarajevo, meanwhile, became home to tens of thousands of villagers who were displaced from across the country. At the same time, many of the city's urban dwellers fled the country and have remained abroad since the war ended.

This book is dedicated to the thousands who lost their lives during the siege of Sarajevo, and the many thousands more who survived it.

■

So many people are responsible for allowing this book to be made, but none are as important as each of the nine photographers featured in these pages. Without their willingness to participate so completely, and their dedication to making it right, this book would not exist. My deep gratitude goes to each—Kemal Hadžić, Milomir Kovačević, Danilo Krstanović, Nermin Muhić, Mladen Pikulić, Nihad Pušija, Damir Šagolj, Šahin Šišić, and Dejan Vekić—for allowing me into their lives.

A special thanks to the photographers' families as well, for so graciously welcoming me into their homes: Amna and Luka Pikulić, Suada and Amina Šišić, Rehana and Mak Muhić, Miza Hadžić, Patricia Rissmann, Nina and Renata Krstanović, and especially Katarina Vranješ-Pašić and Dr. Muzafer Pašić, Nino's parents and my wonderful hosts whenever I am in Sarajevo.

I am grateful to so many in Sarajevo, for all their counsel, patience, and support over the years, most especially Miro Purivatra, director of the Sarajevo Film Festival—his invitation to Sarajevo is what started it all—and also Marija Livančić, for providing my very first home in Sarajevo, and Igor Vrceh, for getting me there safely. Thanks also to Izeta Gradjević, Srdjan Vuletić, Dunja Blažević, Branko Vekić, Zvonimir Šubić, Boba Lizdek, Dada and Bojan Hadžihalilović, Aćif Hodović, Mike O'Connor and Alexandra Stiglmayer. Boro Kontić and Dragan Golubović at the Soros Media Center provided crucial documents and information; Emin Ajeti and Haris Huseinbegović's wonderful baščaršija shop supplied objects and artifacts. And I cannot thank Bimbo (Ivica Pinjuh) enough, for helping to shape these photographers' voices into such powerful words.

Many photographers, artists, writers and journalists have helped make this project a reality over the years—I am deeply grateful to you all, especially Zoran Božicević, for his huge help very early on, and also Zoran Filipović, Marina Grabavić and Neda Popović, for their help along the way. My fellow Bosniacs Ed Vulliamy and Stacy Sullivan gave their words and wisdom generously—and they went beyond the call for me on more occasions than I can even count. My fellow OSI Fellows Gilles Peress, Karen Furth, Bruce Davidson, and especially Laura Silber have each offered huge helpings of encouragement and advice. Many thanks to Joe Sacco, whose talent for both telling stories and listening to them is enormous. Thanks also go to Ron Haviv, Steve Lehman, David Rieff, Laura Hubber, Elizabeth Rueben, Christiane Amanpour, Susan Meiselas, Paul Lowe, Stanley Greene, Richard Holbrooke, Elie Wiesel—especially to Roy Gutman, for his extraordinary dedication to the hunt for solutions. I owe a very special thanks to Tom Gjelten as well, for writing such powerful words for this book.

Sarajevo Self-portrait could not have happened without the support of the people who believed in this project from its beginning, and showed that faith by funding it so generously. A very special thanks to the Open Society Institute, especially Individual Projects Fellowships former program director Karma Kreizenbeck, for making the call that both kick-started this project and marked the beginning of a wonderful friendship. Many thanks also to the others I've gotten to know at Open Society Institute over the years: Aryeh Neier, Gara LaMarche, Gail Goodman, Talie Blumm, Joanna Cohen, Ari Korpivaara, Edin Rudić, and the man behind it all, George Soros. I am also deeply grateful to Richard Lanier and Wendy Newton at the Trust for Mutual Understanding, for their unwavering belief in this project, and for their seemingly limitless input and advice—worth far more than any dollar amount. And I cannot thank Jeanne Donovan and Dick Fisher enough, for helping out so generously, and at a time when I needed that help the very most. My sincerest gratitude goes to Steven Spielberg as well, and to Margery Tabankin, Rachel Levin, and Holly Jacobson at The Righteous Persons Foundation, for recognizing the need to expose these voices of Sarajevo to the world. Many grateful thanks also to Ken Roth, Barbara Guglielmo, and Mei Tang at Human Rights Watch, for backing me up and allowing me to continue my work.

I am indebted to so many people who worked tirelessly to bring the pieces of this book and its accompanying exhibition and website together: top on the list is Nan Richardson who, along with Lesley Martin and the incredible team at Umbrage Editions, brought a level of insight and expertise unmatched by any to the project. Many

Acknowledgments

thanks also to Lev Zeitlin and Nadine Hajjar at Red Square Design, for allowing the pages of this book to spring to life. Vojin Mitrović, David Applegate, Nancy Healy, Ben and Louis Diep at Hong Color, and, most especially, Brian Young, are responsible for making the beautiful prints seen in this book. Thanks also to Bill Orcutt and Elanka Van der Putten, Briss Prashed and the gang at U.S. Color, Walter Lew at Photo Habitat and, for all their technical support, Jay Nubile, Chick Bills, and Chris Lidrbauch. And a very special thank you to Tom Kennedy and Jane Menyawi at Washington Post.com/Cameraworks, for sharing my vision early on and creatively translating that vision to new media.

Many thanks to the following editors, for hearing me out, and giving me the crucial advice and support that has kept me going over the years: Robert Stevens at *Time* magazine, Lisa Lytton and Susan Welchman at *National Geographic*, Nell Hupman at *National Geographic Adventure*, Cornelia Tucker and Jennifer Kirkpatrick at National Geographic Photography Online, Elisabeth Biondi at *The New Yorker*, Julie Claire at Time Inc., David Friend at *Life* magazine, Julie Lasky at *Interiors* magazine, Eamonn McCabe and Ian Katz at *The Guardian*, Tiberio Cardu at *Das Magazin*, Colin Jacobson at *Reportage*, Roger Conover at MIT Press, Jim Mairs at W.W. Norton, Anthony Shugaar at Paraculture, Michael Sand at Bulfinch and Melissa Harris at Aperture.

Many are responsible for helping to pull the infinite pieces of this complicated puzzle together—I am indebted especially to my dear and patient friends Paul Roth, fellow photographer and mentor Pam Parlapiano, Martha Moran, whose strong shoulders have supported me for so long, and of course Dave Lindsay (you, too, are absolutely right). A big thanks also to Goran Djordjević and Lazar Stojanović, for patiently helping me to understand so many new things; Larisa Satara, for listening so well and showing me all sides; my new neighbors and instant best friends Melanie Ron and Seth Agatstein; my early co-conspirator Martin Kunz; Anita Goffman, who kept me on track; Mike Shatzkin, for his invaluable publishing advice, and his sister Karen Shatzkin, my lawyer and my friend. For their input along the way my thanks go to Thom and Leela Powers, Mirsad Krijestorac, Nick Benson and Lili Dyer, Gail Alexander, Meryl Levin, Karen Love, Daniel Meadows, Marc Spritzer, for his expert accounting skills, and Jerry Mirza, for putting up with my incredibly complicated travel needs. Thanks also

to Sulemon Kurmemović, and to Aggie Markowitz, purveyor of solid food, sound advice and strong hugs for many years. Monique Goldstrom showed my own early work from Bosnia in her gallery; she helped me see the importance of presenting the work and words in this book. Philip Brookman at the Corcoran Gallery of Art and Pari Stave at the AXI Gallery have both helped me stay focused with their invaluable insight and experience. I am grateful to Frits Gierstberg at the Nederlands Foto Instituut in Rotterdam and Henning Steen Wettendorff in Copenhagen for their enthusiasm and support. Big thanks to Kevin Duggan at the New York Foundation for the Arts; Karl Katz at MUSE; Paul Licata at Canon USA; and the generous folks at Iomega Corporation and Pearl Paint in New York. Dejan Kovačević and Bojana Žeželj-Kovačević tirelessly transcribed tapes and lent expert advice—my sincere thanks to you both. I also want to thank Muhamed Šaćirbey, UN Ambassador for Bosnia and Herzegovina, and Lidija Topić and Klaudia Juniewicz at the Bosnian Mission to the UN in New York. In Dayton, Ohio, I owe a great deal of thanks to Bruce Hitchner at the University of Ohio, Jim Clark at Culture Works, and Alexander Nyerges and Richard Townsend at the Dayton Art Institute, who hosted the premiere of the exhibition. At the Carr Center for Human Rights at Harvard University, thanks also to Greg Carr, Samantha Power, and Jasmine Friedman, for bringing the exhibition there.

To my dear friends and gracious hosts in foreign cities, a huge thanks goes out to you all, especially Tanja Romić and Emmanuel Rein in Paris; Leslie Browne, Ademir Arapović and Biljana Komljenović, Anniek Mauser, Lidija Zelović and Sara Hermanides in Amsterdam; Miroslav Marsenić and Josipa Marić, and Juriša Boras and Ivana Vukelić in Zagreb; Biljana Ružičanin, Anne McNaught and Sue Nelson in London; David Salamun and Maruša and Metka Krese in Ljubljana and Berlin; and Margareta Orreblad and Caroline and Hepziba Haux in Sweden. And to Riki Larma, now living in Jerusalem, who collaborated early on—I wish he was included in these pages now.

Special thanks to my family, who are always there for me even when far away: my mother Barbara and her husband Larry, my father Ed, my brother and sister Michael and Beth, my very special grandma Ida and her husband Mac, and especially my great-aunt Fanny, who didn't live to see this book completed but who never stopped believing it would get made.

And to my other, adopted, family in Sarajevo—Gordana, Šerkan, Tamara and Muniba Šerić—thank you so much for feeding me, and for giving me a place I can call home.

This book and exhibition simply would not exist without the enormous effort and input of Stuart Alexander—curator, all-around photographic expert, and perhaps most important of all, my very dear friend.

My truly special thanks to Mike Benson and Melita Gabrić, for allowing me to ride along on the adventure of a life-time, and for patiently teaching me so much along the way.

And, finally, Šoba, who has held me up and carried me through some of the very roughest moments of all. There aren't enough words—in any language—to thank you for all you've done.

Leslie Fratkin
Sarajevo, November 1995

162

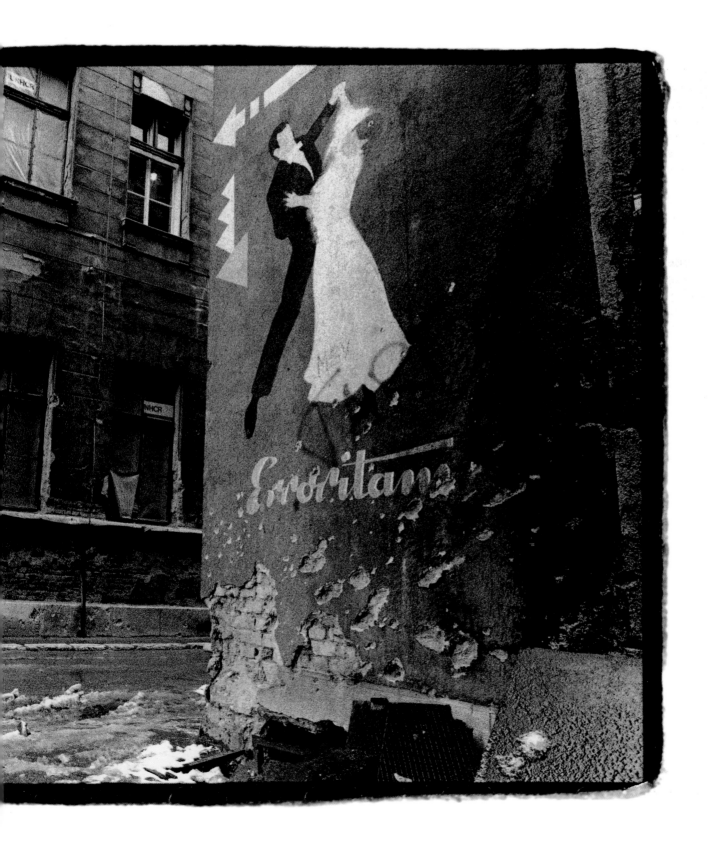

Project Director: Leslie Fratkin
Curator: Stuart Alexander
Editors: Nan Richardson and Lesley A. Martin
Assistant Editors: Camille Robcis, Sophie Fenwick
Editorial Assistants: Tim Bazzle, LauraBeth Bravo, and Charlotte Hamilton
Designer: Red Square Design
Produced by Umbrage Editions, New York

First Edition
ISBN 1-884167-03-09X

Printed and bound by Poligrafiche Bolis, Bergamo, Italy

Sarajevo Self-portrait is accompanied by a traveling
exhibition and film series. The exhibit will open at the
Dayton Art Institute in November 2000 and travel to the
Carr Center for Human Rights at Harvard University, Boston,
among other venues. Selections from the book and exhi-
bition can be seen on WashingtonPost.com/Cameraworks.